Marc Muench

Exploring North American Landscapes

Visions and Lessons in Digital Photography

Marc Muench (www.muenchphotography.com)

Editor: Joan Dixon
Copyeditors: Lisa Danhi, Joan Dixon
Layout and Type: Petra Strauch, just-in-print@gmx.de
Cover design: Helmut Kraus, www.exclam.de
Printer: Tara TPS Co., Ltd. through Four Colour Print Group
Printed in Korea

ISBN 978-1-933952-53-6

1st Edition
© 2011 by Marc Muench
Rocky Nook Inc.
26 West Mission Street Ste 3
Santa Barbara, CA 93101

www.rockynook.com

Library of Congress Cataloging-in-Publication Data

Muench, Marc.
 Exploring North American landscapes : visions and lessons in digital photography / Marc Muench. -- 1st ed.
 p. cm.
 ISBN 978-1-933952-53-6 (soft cover : alk. paper)
1. Landscape photography--Technique. 2. Landforms--North America. I. Title.
 TR660.M845 2011
 778.9'36--dc22
 2010028854

Distributed by O'Reilly Media
1005 Gravenstein Highway North
Sebastopol, CA 95472

This book is printed on acid-free paper.

This book is dedicated to my wife Stefanie
and our three children, Trevor, Skyler and Connor,
who proved to me that loving is the best part of living.

TABLE OF CONTENTS

Acknowledgments . vii
Foreword by Katrin Eismann . viii
Introduction . x

PART I: EXPLORATIONS AND VISIONS 3

Chapter 1 Philosophy of Photography 5

Chapter 2 The Secret Gene . 15

Chapter 3 The Decisive Placement 31
The Warm-Up . 32
The Divine Angle . 34
Catching the Perfect Wave . 36
Inspired Moments . 37
As Good as It Gets! . 44
Heli Skiing in the Rockies . 44
Risks and Rewards . 48

Chapter 4 Chasing the Light . 51
Getting Lucky . 52
Catching the Light . 52
Change . 56
Chasing the Light . 60
Shooting Directly into the Sun . 62
Revealing the Light . 65

Chapter 5 Evolving Methods . 71
Panoramic Imagery . 71
Tilt/Shift for More . 83
Still Time Lapses . 88
Shooting Into the Sun . 93

Chapter 6 Favorite Places . 97
Sierra Nevada . 97
Santa Barbara County . 114

PART II: THE LESSONS . 133

Lesson #1 Making the Exposure . 135
Regarding Contrast . 137

Lesson #2 The Workflow . 143
Step 1 – Logging . 145
Step 2 – Selecting the Images . 146
Step 3 – Post-Processing . 148

Lesson #3 Setting the Range . 155

Lesson #4 Massaging the Middle . 161
All Those Sliders . 161
Two More Great Tools . 166

Lesson #5 Quick Masking for Regional Dynamics 171
Learning to Decipher the Dynamic Range of a Scene 173
Calibrations and Profiles . 174
Does Your Image Need Quick Masking? 176

Lesson #6 Real Color . 187

Lesson #7 Manual HDR . 195
What does HDR Mean: Hyper Digital Reflexes or
High Dynamic Range? . 195
Manual HDR: Is There Any Other Way? 195
HDR vs. SBR . 197

Shooting for HDR Images. 197

Camera Settings and Setup for Manually Exposing HDR . . 197

Camera Settings and Setup for Exposing HDR with

Auto Bracket Feature. 198

Capturing the Scene Manually. 198

Capturing the Scene with the Auto Exposure Bracketing

Feature . 198

Combining Your Exposures . 199

Brush Settings . 202

Foreground and Background Colors. 203

Lesson #8 **More HDR**. **207**

Quick and Easy Manual Override . 209

Auto Pixel Smashing with Photomatix or CS5 HDR Pro . . . 213

One Final Tip. 215

The First Two Generations of Muench Photographers 218

Epilogue . **219**

Index of Feature Images . **220**

ACKNOWLEDGMENTS

I have been blessed to have so much help and encouragement from so many people. I would like to thank my mom, Bonnie, for a lifetime of encouragement and creative energy; my dad, David, for introducing me to the world through photography; my sister, Zandria, who helps me keep it real! Thank you to my wife, Stefanie, and my mother-in-law, Sue Hein, for proofreading the entire book without complaint.

I am forever indebted to my editor Joanie Dixon who has spent countless hours making sure that what I was attempting to say or illustrate made sense, and to the entire Rocky Nook team, especially Gerhard Rossbach for publishing this book.

Thank you to many friends including Andy Williams, Dave Porter, Ron Luxemburg, and Tom Dietrich for their time and helpful input; and a special thanks to David Rosenthal who, way back at the beginning of this project, poured some special mojo into my mind which helped take my wild ideas and turn them into actual sensible concepts.

Thank you to Katrin Eisman who opened my eyes to the wonderful world of Photoshop. Thank you to several color specialists who pointed me in the right direction back in the dark ages of color correction: John Panozzo of ColorByte, author Dan Margulis, and Trevor Reinart of ICG. Thank you to many other photographers for providing inspiration, especially George Lepp, William Neil, Gordon Wiltsie, Chris Noble, Jim Brandenburg, and Frans Lanting.

And of course, my thanks go to my grandfather, Josef Muench, and father, David Muench, for blazing the path less traveled.

FOREWORD BY KATRIN EISMANN

Landscape photography has a long and enduring tradition in American history. As practiced by Carleton Watkins and William Henry Jackson, photography was instrumental in creating the National Parks that countless Americans and international visitors identify as the indelible expression of the American ideal. In 1864, Watkins's photographs of Yosemite in California were the tangible impetus for the U.S. Congress to enact a bill signed by Abraham Lincoln that established Yosemite as the nation's first legislated nature preserve. A few years later Jackson's photographs gave witness to the grandeur of the Yellowstone, Wyoming territory. They were displayed in the U.S. Capitol's Rotunda and can be credited for preserving over two million acres of majestic landscape from destructive logging and private gain exploitation. In 1872, President Ulysses S. Grant signed the Yellowstone Act to create the first National Park. Well into the 20th century, nature photography continued to influence national decision makers as the photographs of Kings Canyon by a young Ansel Adams were shown to President Roosevelt, who signed the bill to create the Kings Canyon National Park in 1936.

Photography has been used to preserve vast tracts of Tasmania (Australia), Gabon (Africa), and Mexico, as described in Carlton Ward's (Jr) Master of Science thesis dissertation *Conservation Photography,* which succinctly presents the importance of bearing witness to nature in order to preserve and protect it.

The best nature photography allows us a relationship with the mystery of the greater universal that cannot be expressed with merely rational vocabulary. As I page through the world as Marc Muench sees it, I am in awe of his subject matter, hard work, photographic skills, and generosity in sharing his personal history, professional experiences, and photographic techniques. For Marc, it is always what is in front of his lens that is important. This volume is not an egotistical device to proclaim his brilliance: rather it is a deeply caring testimony to the importance of generations passing values and passion from one to another—from grandfather to father to son—which, in the Muench family, is a deep passion for nature photography that requires long days of hiking, longer nights of solitude, and tenacious devotion to craft. The Muench family understands that creating something truly exceptional relies upon curiosity, dedication, time, and, as Marc explains, the importance of luck in the pursuit of what he refers to as "great light." I doubt that luck formed the majority of Marc's images, but rather preparation, awareness, and

skill allows Marc to portray and share the fleeting moments that most of us are simply not able to experience.

I first met Marc at a digital photography seminar in Los Osos, California that George Lepp (the well-recognized nature and bird photographer) created to bring together the developers of digital technology with leading practitioners and photographic educators. We were fortunate to spend the week with engineers from Adobe, Canon, Nikon, and Epson in the gracious hospitality of Arlie and George Lepp's home as we shared experiences, questions, and concerns about the future impact and development of digital photographic technology and practices. During that week I was exposed to and gained a tremendous respect for Marc, who was exploring and expanding upon the subjects and formats that had led to the inclusion of his father David on Richard Wong's list of the "top 10 most influential nature photographers to have left a lasting impact either on society or on future photographers."[1] As Wong explains, "Like Ansel Adams did with black and white landscape photography a generation prior, David Muench is synonymous with color landscape photography. The use of prominent foreground elements leading the eye through the frame to the background in the distance was a style that Muench became known for in the 50s and 60s. You would walk into any library or bookstore in America in the past 40 years and be hard-pressed to not see his books or calendars even if you don't know his name."

During that intensive week in the small town of Los Osos, the New York cynic (that would be me) was taken aback by how humble the amazingly talented West Coast photographer (that would be Marc) was. I admire Marc for pursuing and extending the art form of his grandfather and father. By working with the latest digital technology he is expanding upon and enriching a great American tradition and ideal—one which proves that the witness of a few can endure to allow millions to enjoy the natural splendor that we are all responsible to preserve and protect.

Katrin Eismann
Artist, Author, Educator
Chair, Masters of Digital Photography at the School of Visual Arts
in New York City

1 http://www.rwongphoto.com/blog/top-10-influential-nature-photographers-alltime.

INTRODUCTION

More than photography, the blood in my veins is full of grit from the Southwest, moss from the Northwest, Lyme disease from the Northeast, and humidity from the Southeast. What could possibly help me more with my photography than getting dirty, sick, and hot?

In hindsight, I realize the most important factor in my career as a landscape photographer is not simply that my father and grandfather were landscape photographers, but rather that my grandfather included my father in his pursuit of photography and my father did the same for me. I don't mean to say that my father took me aside and said, "Here's how to do it." Actually, what he gave me were opportunities for unconscious observation. My father had been included in my grandparents' travels from an early age, and I was included in my parents' travels as well. It was this time spent traveling that spawned my intrigue in the movement, attitude, and experiences of photography.

We all like creature comforts, but it's possible to develop a threshold for scarcity of comforts so that odd sleeping surfaces, lack of running water, and long hours seem less troublesome. I must admit that a beautiful, clean, fancy hotel room with a great restaurant close by is wonderful, but camping at the end of a dirt road or trail in the middle of nowhere, by a gurgling stream, is better.

Once, about 10,000 feet above sea level in a rather thick forest, my father stopped along the trail. He put down his leather camera case, which was filled with several large format lenses, film holders, and some other stuff. He walked about 30 feet off the path, bent over, and began studying the ground. I was young, maybe six or seven, wondering why my feet hurt in my hiking shoes and what my father was doing.

Next, he began setting up his tripod in a rhythmic pattern that was molded out of thousands of repetitions, giving each step a smooth measure of confidence. Then he pulled the metal brick (otherwise known as a Linhoff Master Technika field camera) out of the bag and unwrapped it from the dark cloth where it had been carefully snuggled like a fresh pie. Then he unfolded the camera—again, each step done rhythmically from years of experience—until it changed shape into what most children nowadays would call a "transformer." Finally, he reached back into the bag, grabbed one of the lenses, unwrapped it from its own leather bag, and placed it within the camera.

What happened following the construction of the camera was a mystery to me. In fact, why my father stopped where he did on the trail, why he chose to use the camera he did, and so on, were all mysteries.

We were in the ancient bristlecone pine forest near Wheeler Peak, which has since become a national park. He was working on a book titled *Timberline Ancients,* and my mother, sister, and I all found a place to rest while he went to work. The vague memory I have of that particular moment swims in a sea of others, all very similar, in various locations around the United States at various times of the year, various elevations, and various ages. What always remained the same was the dark brown leather camera bag. There really was not much space in that thing, and the shoulder strap was stained with sweat like the rigging on a pack mule. It was just large enough to contain about 15 holders, which worked out to 30 sheets of 4×5 film.

As involved in photography as my parents were, they never forced it upon me. My own curiosity pulled me in even when I didn't realize it. After all, how was I supposed to know that I could find so much fulfillment later in life doing many of the same complex technical and creative procedures, most of which came to me naturally, as if there were some magic gene? This book is about what I learned along the way and

Figure I-1: Vermillion Cliffs Wilderness, Arizona.

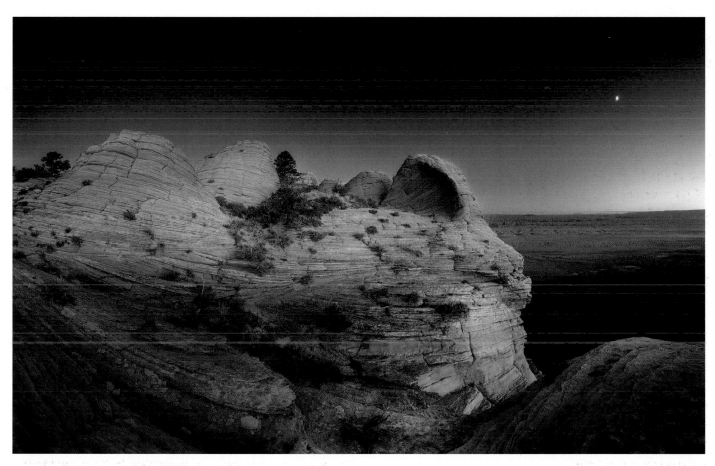

what I learned on my own, why certain lessons mattered so much to the pictures I created, and more importantly, why I am still, to this day, so inspired by my profession.

The first half of this book deals with the question *why,* and the second half explains *how.* I chose various assignments or trips that became important steps in my exploration into both creative thinking and photography. With most of my youth spent traveling in North America, I wanted to focus on the United States—especially due to the abundance of beauty,

light, and inspiration within such a small area, considering the entire planet.

Photography is a very powerful communication tool, allowing the photographer the pleasure not only of a lifetime's worth of challenges, but also the inspiration to explore and share. This is a look at my explorations and lessons learned from the influence of two generations.

— Marc Muench, January 2011

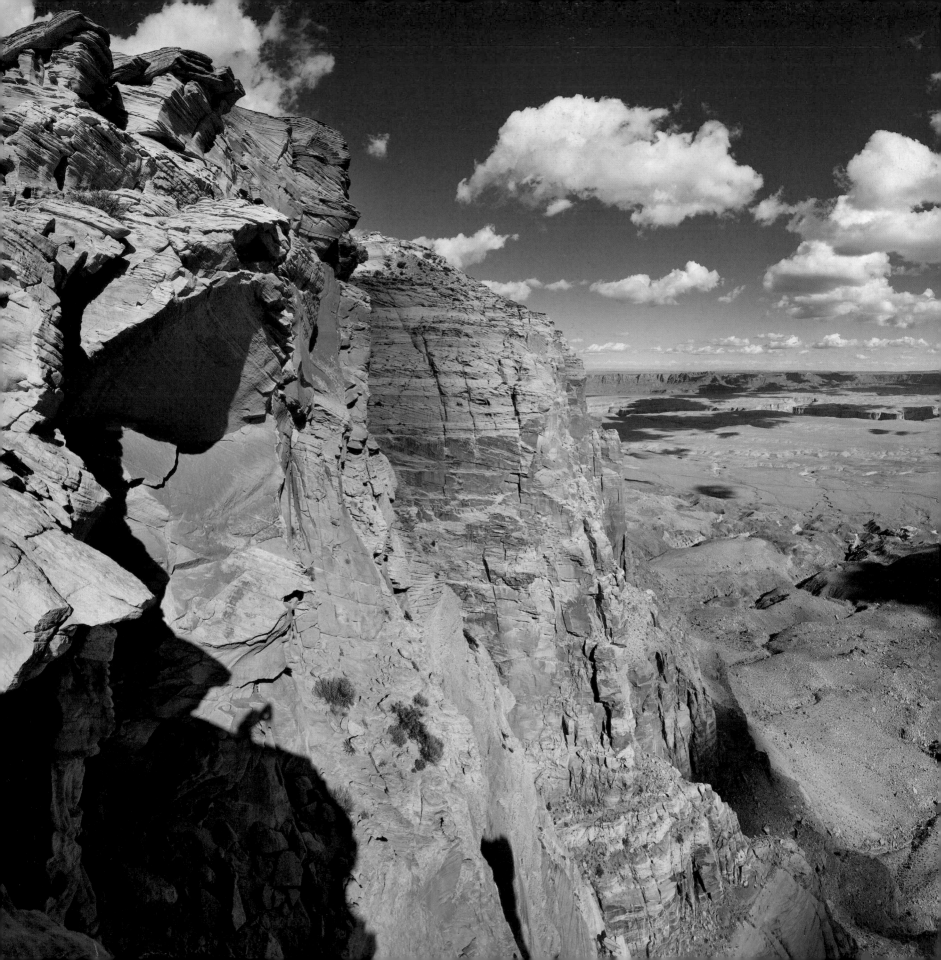

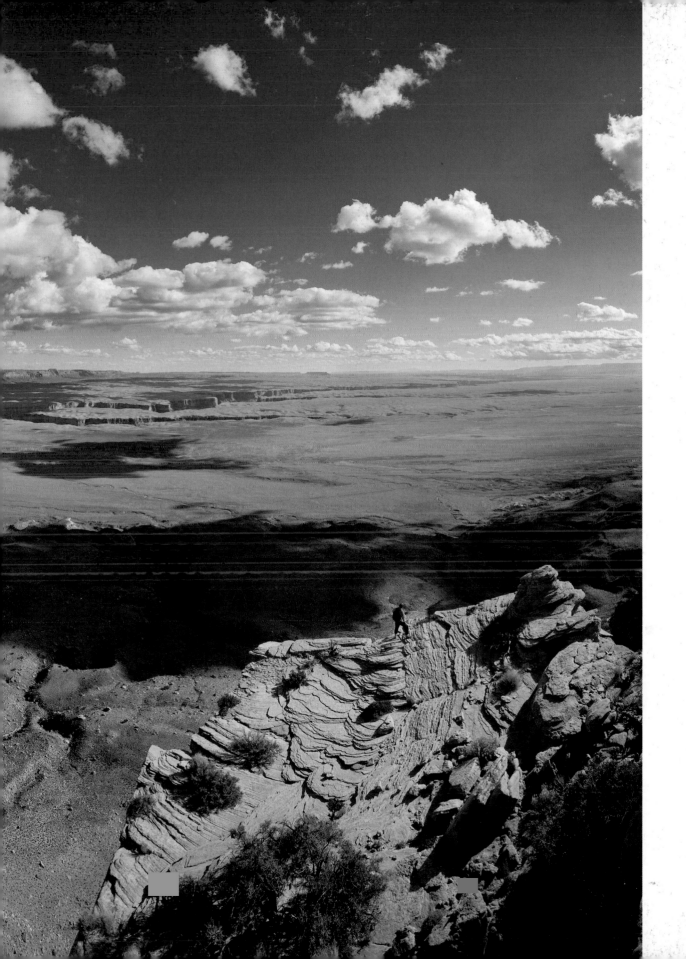

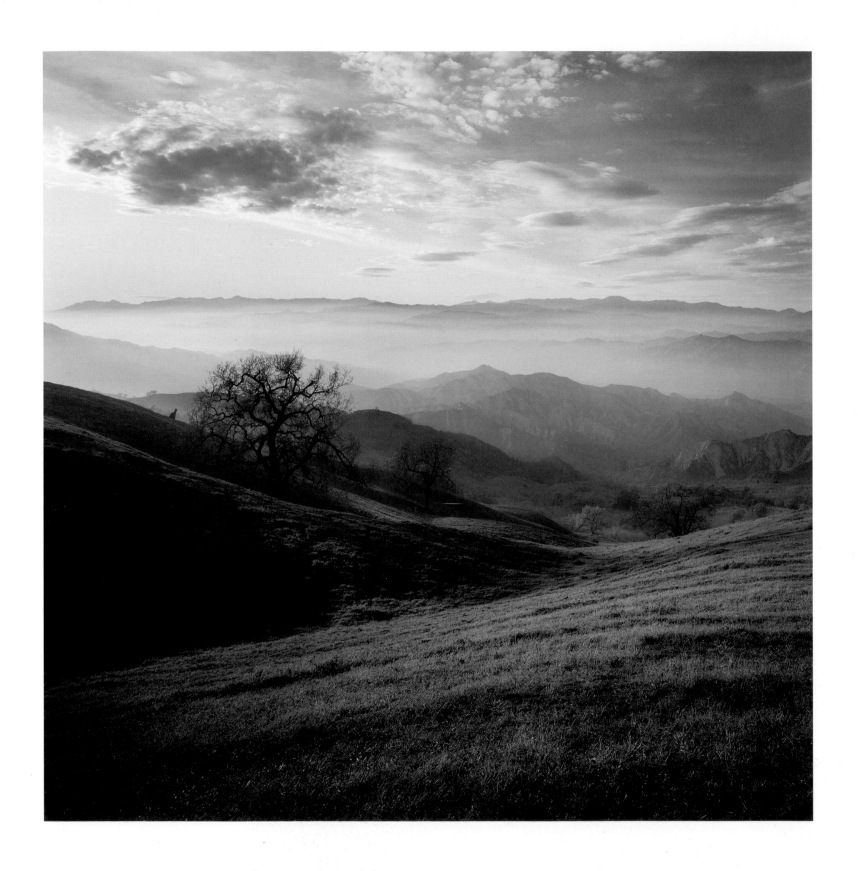

CHAPTER 1
PHILOSOPHY OF PHOTOGRAPHY

No matter how you come to photography it's all good! Personally, I arrived a little late, given the fact both my father and grandfather were photographers. Most would think I knew how to take a picture before I could walk. But the ability to make a living at photography didn't come to me until I could appreciate and understand the things I actually wanted to photograph. Since then, many magical moments in my life have occurred while photographing. The more time I spend in pursuit of images, the more I acknowledge life, love, family, friends, and the world around me.

It is very difficult to avoid the clutter and chatter of modern-day life. We all know how influential the Internet and television can be with their continual bombardment of short-lived fads and trends. Photography has given me the ability to focus on more permanent elements, such as the wilderness and our relationship to it. My faith, family, friends, teachers, clients, experiences, and hometown have shaped my beliefs and the decisions I make, resulting in the images I ultimately create. It takes constant energy and determination to eliminate the mundane in hopes of discovering the extraordinary.

At the age of 43, I am now beginning to comprehend the limited amount of time we have on Earth. If photography is a window into a photographer's thinking, I want people to see more than a few pretty pictures. Many of my images carry special personal memories about the events that occurred during their creation; however, I hope that they lead viewers to ask questions, generate ideas, and maybe even to take action. I do understand that to reach a viewer through imagery, many elements must be present in the pictures: most importantly, an emotion that evolves from the subject's story and how I tell it with my technique.

For this process to make more sense in my life, I have broken down my study of photography into two separate fields: subjective and technical. My relationship to the subject can easily become pure documentary if I'm not aware of myself in the context. By this, I mean my ability to involve myself in the images I produce.

Creativity, subjectivity, and emotion form a kind of symbiotic relationship with the science and technique of photography. They are completely different from one another but must coexist, just like good and bad, up and down, and of course, light and dark. Technology seems to be changing photography at a faster pace

▫ **It takes constant energy and determination to eliminate the mundane in hopes of discovering the extraordinary.**

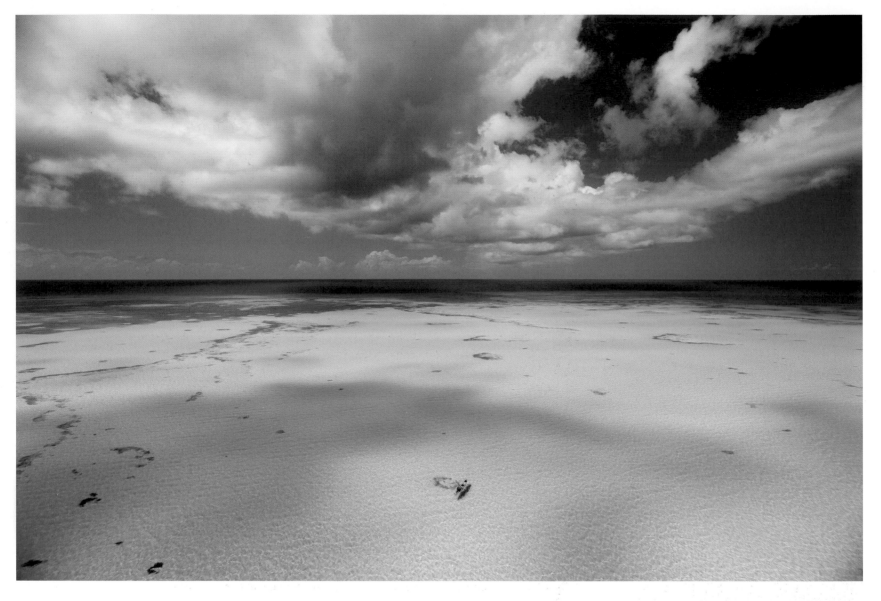

⬆

Figure 1-1: Kayaker, sand flats Bahamas. View from helicopter.

than subjectivity. For example, the study of creativity, composition, and psychology are as ancient as the Greeks, but recent technology has not changed these concepts and beliefs nearly as much as it has influenced our ability to illustrate them. This is the main reason I separate the two aspects of my research.

The subjective side of photography requires inward study, the technical side outward study. When dealing with rapidly evolving technology, I often feel reactive rather than proactive. It's true that positive changes in camera equipment, e.g., ISO, have made certain types of captures possible. This type of change is very influential on the creative side of image making.

I recall riding in the back of a powerboat, watching the full moon rise over the towering buttes surrounding Lake Powell. The experience was surreal, and my thought was, "Someday, I'll be able to take a picture of that." Now it would be possible with 100,000 ISO! At the time, I had 100 ISO Fujichrome Velvia loaded in my camera.

Speedy technological advancements can trip me up because, in order to work effectively, my equipment and I must be one. The camera should be like my third arm, allowing me to work in second-nature mode. However, since new cameras arrive every year with incredible new features, I find it more

↑

Figure 1-2: The annual shootout.

↑

Figure 1-3: Santa Ynez Mountains, California. Comparison images enlarged to 100%, Top: taken with Zone 6, 4×5 camera. Bottom: taken with a Canon 1Ds Mark II camera and enlarged from optical resolution in order to match the other file. Software called "Alien Skin Blow Up" was used for the enlargement.

challenging to develop that equipment into the appendage it could become.

Software moves along at the same rapid pace. Improved methods of HDR imaging, Content Aware tools, and many other possibilities have recently emerged. By the time you read this, CS5 will have been out for many months, and along with it, better methods of improving images technically. I used to believe these developments would lead to more creativity. But what I'm realizing is that the real power of photography lies not in new technology but rather in old and true emotions, values, beliefs, and most of all, stories.

If asked what I like better, creativity or technology, my answer would be both. In order to better communicate through photography, I must constantly exercise my technical skills in order to improve. I have taken many images for no other reason than to try out new technology or simply achieve what at one time was impossible. I understand how difficult some types of photography can be when the technology employed is groundbreaking. In those situations there is no manual, no calling 1–800 tech support. My quest is to take technology and use it to push image-making into a realm of communication that supersedes the technical aspects. I will forever be on a quest to create work that not only moves the viewer but also initiates thought processes, either with old technology or new.

Experimenting with technology can be exciting and fun, and I will be the first to admit, I can become obsessed. I used to conduct an experiment that I called a *shootout,* in which my friend, Tom Dietrich, and I would line up all the film and digital cameras we could get our hands on and "shoot 'em up" in the hopes of discovering how the cameras' various resolutions would print. We did this three years in a row at the time digital was approaching the resolution of film.

These experiments, as techno-crazed as they may appear, did lead to knowledge that positively influenced the quality of my work. In addition to the differences in resolution, the tests

Figure 1-4: Fireweed flowers, San Juan Mountains, Colorado.

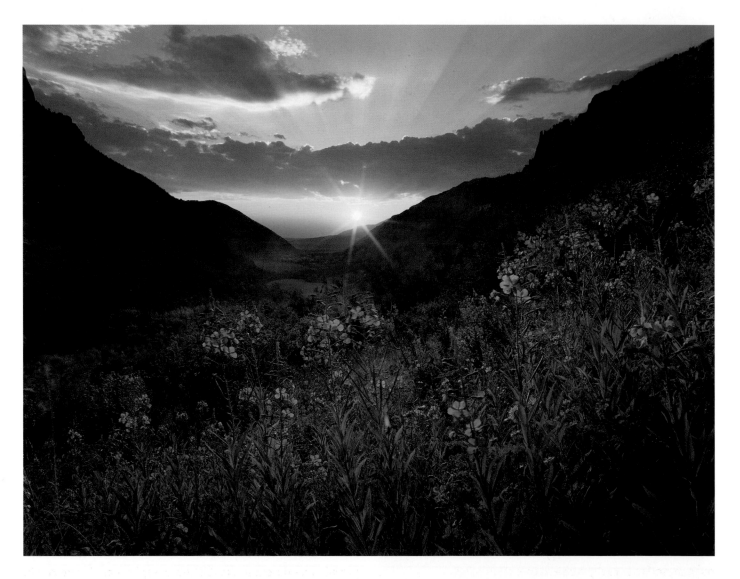

influenced my technique for digital post-processing, which I explain in the lessons.

There are some photographic methods that take years to master and others that require only a few moments to comprehend and apply. Either way, any new technology can be applied to old work. Imagine taking several bracketed Ansel Adams negatives and applying some HDR post-processing to create a totally modern print. Many photographers would consider this outrageous. My guess is that Adams would get a kick out of it. Though it was far from my mind at the time, the following image (figure 1-5) was created a year ago in Photoshop with scanned files from two sheets of film that were taken about eight years earlier. Thankfully, I kept the bracketed exposures for all those years.

As technology improves and new methods arise, so do my personal expectations. I realize that I can't wait forever to produce my work, but rather I complete what I'm doing with the tools I have at the time. The bar will continually rise, challenging everyone to learn new technical methods. It's up to me to apply them in personal and innovative ways.

Not too many years ago, much high-end technical knowledge was kept secret in the minds of wise and accomplished technicians, who were paid good salaries to complete very specific and tricky tasks. These days, the smoke and mirrors have cleared, allowing more transparency into just how to create a technically acceptable image and reproduce it. What used to be confusing for all but a few professionals is now almost common sense.

I believe that the war over film vs. digital now looks like a tumbleweed in the rearview mirror. In the past, most of the discussion around the topic was geared towards an exclusionary end, forcing an either/or decision. I always did, and still do, appreciate the differences between digital and film and therefore incorporated both in my work until 2005—at which time I switched to 100 percent digital.

This book is an example of the variety of technical methods I have incorporated into my work. Quicker than digital replaced film, my digital workflow continues to change, demanding my constant attention. However, there always comes a time when I must take what I know and apply it to a body of work, not concerning myself with every new technique. By doing this, I can begin to delve into the subjective side of photography and push myself to actually create rather than react.

With computers, technology is at the whim of our imagination. However, the rather grounding news is that certain aspects of post-processing have remained the same: for example, regional dynamics, which I explain in this book; the image density numbers 0 to 255, representing all of the luminance levels; and last, but not least, the curves palette. This is why certain skills, such as the ones I hope you learn here, will be with you no matter how technology changes in the years to come.

I've been told that I am left-brain dominant. Although I must admit I never feel completely satisfied with my work if I know there are technical blemishes, I'm not completely convinced that the right side of my brain is tied up in the closet. Like a child swinging under the bough of an old oak tree, my mind wanders on occasion, and when it does, there are moments when I can tune out the here and now. I never thought this to be anything other than daydreaming until I began unraveling conceptual or even technical problems during these reflective moments.

There is no doubt that daydreaming is, for the most part, unproductive, and most would consider the logic conceived during these moments to be nothing other than "pie in the sky." When it comes to my photography, though, striving for pie in the sky is what can lead me down a path never before explored and therefore can be considered creative thinking.

It is creative thinking grounded with a good mix of common sense and wisdom that I believe makes the best daydreams. Now, when I consider future photographic styles, methods, and projects, I leave myself as much time as possible to take my values and ideas into consideration. I strive to capture indescribable emotions and experiences that come to me when exploring the wilderness. There is nothing better than acknowledging oneself in one's work.

In the past 30 years, photography has become widely acknowledged and accepted as an art form—the ultimate approval of its potential. Not all photographers are interested in becoming artists, and not all of those interested actually succeed. I say this only to acknowledge the diversity of the term "photography." There are many types of photography, and what I have concentrated on in my life is landscape photography. I can take this one step further by expanding landscape photography into a number of diverse approaches: documentary, journalistic, retro, modern, impressionistic, surreal, and

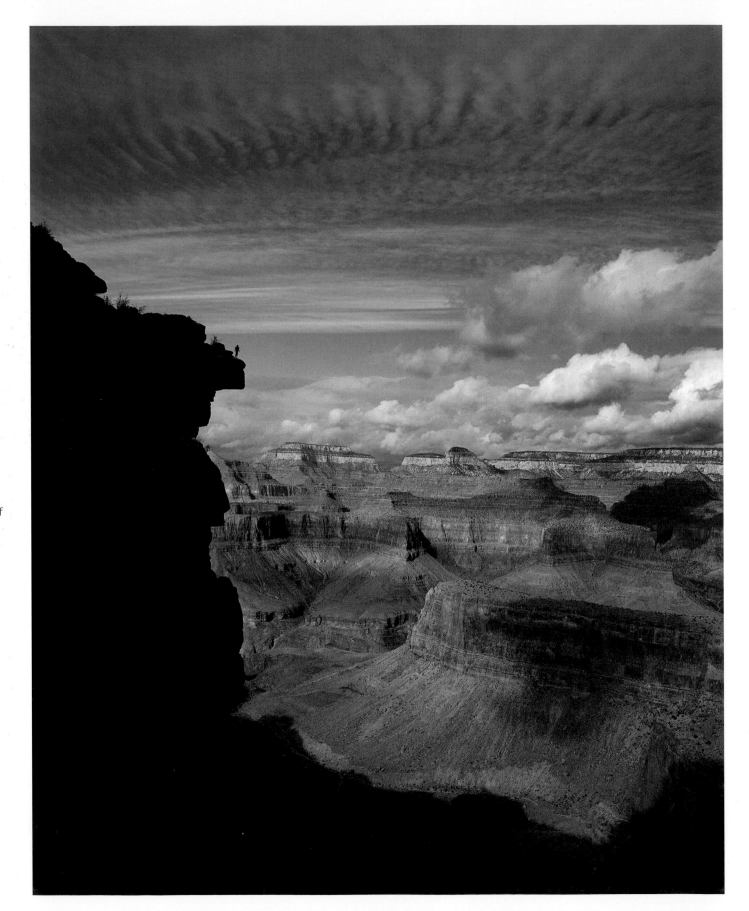

Figure 1-5: Climber Bob Kerry near summit of Zoroaster Temple in the Grand Canyon, Arizona.

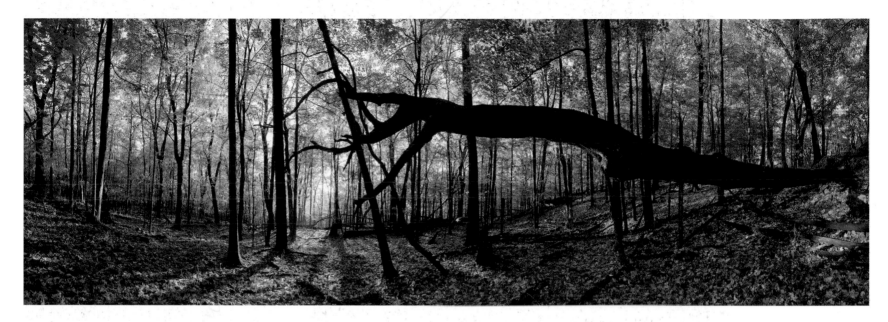

Figure 1-6: Fallen hardwood tree, Shenandoah National Park, Virginia.

so on. The idea that landscape photography can be so much is what interests me. I attempt to produce imagery that becomes many different things under the so-called umbrella of landscape photography.

I was fortunate to have been exposed to photography long before I knew anything about it technically. My first experiences were looking over my parents' shoulders as they pored over boxes of 4×5 transparencies from months of shooting. There was always some screaming when processing errors surfaced, and my father's face would turn red. There would be gasps of shock, followed by laughs of approval. I know for most photographers it's gratifying to peer at the LCD on the back of a digital camera, but I must say, the emotions experienced when first viewing a month's worth of work on a light table are similar only to watching *Gone With the Wind* after a few martinis.

The process of photography is full of unexpected highs and lows. The more you put into it, the more you get out of it—this I learned way before I ever picked up a camera. When I finally began to use a camera, it took many years before I really understood what was happening technically. My one captivating thought was an overwhelming desire to recreate the emotions I was experiencing, not the scene in front of me. The difficulty I had was being patient enough to learn the techniques prior to creating the images I had preconceived. In hindsight, I think that most techniques take years to master, and work created along the way may be accepted by others if done well. But self-gratifying work is not done until all the cylinders are firing and both technique and subjectivity are merged.

Aside from my parents, I had two influential teachers: Ray Canton and Jim Woods. Ray Canton was a journalism advisor at Santa Barbara City College and laid down a set of work habits like no one else I have ever met. If anyone missed a deadline, pens, papers, and even coffee would go flying across the room. I became the chief photographer as well as the editor in chief of *The Channels Newspaper*, an achievement I'm sure never would have been possible without his old-school guidance and values.

Jim Woods, a professional photographer, was one of my teachers at Art Center College of Design. During my first two

◻ My one captivating thought was an overwhelming desire to recreate the emotions I was experiencing, not the scene in front of me.

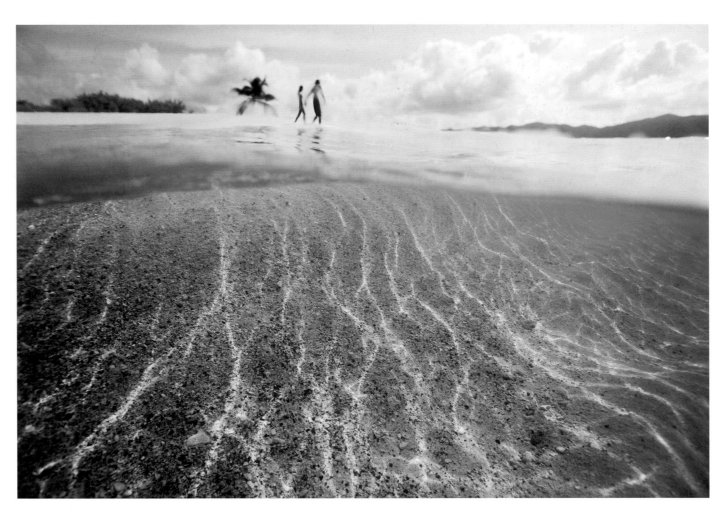

→

Figure 1-7: Couple walking on beach, British Virgin Islands.

years at Art Center, there was not much time for creativity; I was busy mastering darkroom techniques. By the end of the second year, I spent some time in the color lab. Jim showed me the light at the end of the tunnel with the personal work he had completed while simultaneously doing assignments for prestigious clients. He said, "If you photograph what you love, you will love your work." Quite obvious, you might say, but sometimes we get sidetracked and overlook the obvious.

At that time, in 1989, there was no class or even mention of a career in landscape photography. My father and grandfather had made it work, and there were a handful of others. However, the topic was not included in any discussions or curriculum. Some of the career areas for photographers were fashion, architecture, medicine, journalism, or working in a studio for Hallmark. Jim's philosophy gave me the courage to pursue what I loved, landscape photography, in my own way.

Through hiking, climbing, walking, and simply looking, I have learned to seek the hidden stories in the woods—metaphorically speaking, of course. There is much in the natural world that lies below the veil of time. It is still magical to me

how, if all is just so, one frozen slice of time can tell the story of so many years.

If landscape photography consists of no more than found compositions with great lighting, due to the perseverance of the photographer, how can a viewer tell the difference between one photographer's work and another's? I believe an original image is the product of a recipe containing the subject, composition, light, and most importantly, the photographer. There is more to it than just composition and light. I know it's possible to be fulfilled by taking a series of landscape images with no objective other than capturing a very exciting location. I have done this many times. In fact, it becomes very addictive, as I mentioned above. Taking images in a target-rich environment is exciting. The subject is everywhere, and when the light is good, nothing can keep me from taking hundreds if not thousands of exposures. But this type of work, as exciting as it may be, is never quite as fulfilling as learning something new and creating an image that reveals it.

It has been said, "A photographer only records. An artistic photographer reveals!" This statement helps guide me.

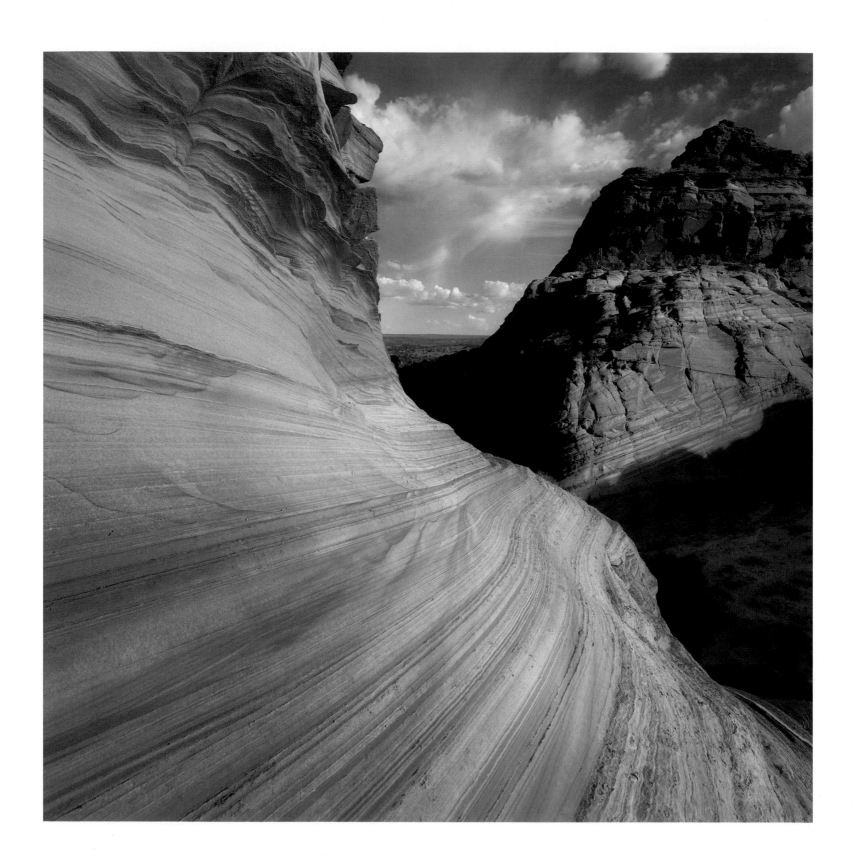

CHAPTER 2
THE SECRET GENE

The bonfire continued to rage as it spread to the driftwood adjacent to the towering sandstone walls. From the banks of the Colorado River to the sandstone cliffs 100 feet away, flames flew high in celebration of my father's twelfth birthday. It was July 2, 1948 and my father was in a place where few people had ever been before. Glenn Canyon Dam did not yet exist. There were no laws against open fires, and besides the driftwood, there was nothing around for hundreds of miles except windblown sandstone. The camp was at the junction of the Colorado River and Aztec Creek, where waters from the 10,000-foot Navajo Mountain drained into the Colorado and brought with it more red dirt. As the ancient summer rains and winter snow-melt made their way down the pine-covered slopes, the waters carved amazing shapes into the red sandstone, but nowhere as impressive as the world's largest natural span of stone called the Rainbow Bridge. This birthday evening, my grandfather, Josef Muench, was revisiting what must have been a favorite place of his, and along with him were my father, David, and my grandmother, Joyce.

My grandfather described in his logbook that it was his seventh time visiting Rainbow Bridge, but this was his first trip by airboat (figure 2-1). Those were different times and just getting to photographic sites like Rainbow Bridge entailed several days of travel packed full of camera cases and potential tragedy. Sometimes these trips ended with next to nothing to show for the arduous effort. To discover a spectacular photographic location can be one of the most fascinating experiences in landscape photography. In order to even consider shooting such a find, you must be ready to spend considerable time studying, walking around, and carefully exploring all angles and options of the location. Simply photographing a place like Rainbow Bridge for the first time is exhilarating enough, but imagine being the very first photographer to publish professional pictures of a previously uncaptured natural phenomenon. I only wish I had the opportunity to ask Josef what his experience was like.

Was it inevitable that this arch would have been photographed in just this way? Who knows! What I do know is that I remember scrambling up the hill wearing my old white Vans skateboarding shoes to seek a possible photograph with my father. He loves arches, so when my sister, Zandria, or I would see one from the car he would pay us a dollar to point it out to him. This time he not only paid

Figure 2-1: Official 1948 logbook of persons entering the Colorado River. (Can you find the Muench family entries here?) The English translation for the Navajo name of the good ship "Tseh Na-Ni-ah-go atin" is, "Trail to the bridge that leads over."

sandstone. As if there were no other images to be taken in the vicinity, he created the composition that he would revisit for years to come, photographing the arch in many various types of light. The image we discovered that hot summer afternoon in Navajo country went on to become one of the most published images of my father's career. The arch has also become one of the most photographed locations in the West. At the time, I had no clue how to take the picture, nor did I even watch my father set up. I had seen the process way too many times to be intrigued by each shot. What I did learn, in hindsight, is how subtle that memorable experience was. There were no jumping orca whales, no rainbows or comets blasting through the sky, only sandstone through sandstone, eroded and shaped through geologic time by weather, windblown sand, and moisture. What to others would appear as only killing time was for my father and grandfather dedicated meandering guided by intuition. To stop the car and walk off the road into the countryside is something you do if you have nowhere to go. However, as I came to realize, keeping your schedule open for meandering is just as difficult as keeping a busy schedule.

What did my father learn from my grandfather? He learned the values, thrills, and benefits of exploration. What did I learn from my father? The exact same lesson! Of all the technical lessons and creative dilemmas in photography this central message has been most influential: *you must allow yourself the time for exploration and discovery.*

Exploration is fueled by the desire to feel life, inspire thought, and discover. It can also be driven by the sudden need to flee. I can only imagine what my grandfather's life was like back in Germany prior to WW II. The stories I have heard depicted it as a very tense time indeed. There may have been many reasons my grandfather left Germany, but none as encouraging as the request made by those who spotted him throwing a tomato at Adolph Hitler. According to family legend, he had thrown a rotten tomato at Hitler during one of

> What to others would appear as only killing time was for my father and grandfather dedicated meandering guided by intuition.

me a dollar but also stopped the truck along the old dirt road leading from Monument Valley Rim to Gouldings Lodge. We got out of the car and began a hot sandy trudge up the hill to the arch, my father carrying his leather camera case and tripod. He used a small rise in the dirt to place a tripod, extend it out all the way to about six feet tall, and employed a medium telephoto lens to capture a view of the distant buttes of Monument Valley through the teardrop shaped window of the

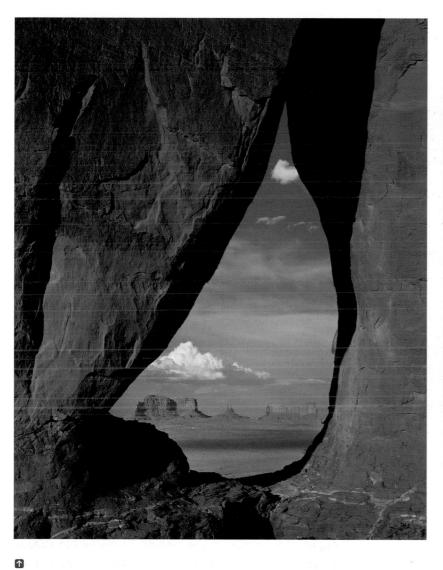

↑

Figure 2-2: Teardrop Arch, Monument Valley Navajo Tribal Park, Arizona.
©David Muench.

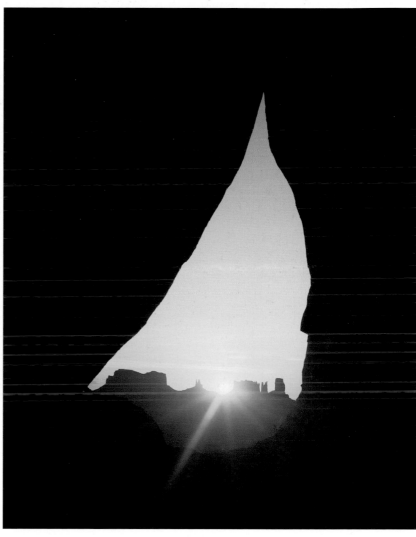

↑

Figure 2-3: Sunrise through Teardrop Arch, Monument Valley Navajo Tribal Park,
Arizona. ©David Muench.

Figure 2-4: Grandfather Josef Muench fishing with son David Muench in Capitol Reef National Park, Utah. ©Josef Muench.

his early speeches in his local community. I was told that the tomato hit a pole adjacent to Hitler and splattered all over his face. (Just imagine how many hits a video like that would get on YouTube today!)

Josef arrived in America in 1926 at Ellis Island and began venturing West, creating a new life for himself. He worked for Ford Motor Company for several years in Detroit where he earned enough money to buy a 1931 Model A Roadster. He spent the following years touring the West before visiting a friend in Santa Barbara. I still have his photo journal filled with pages of images he took with his little box camera during those

travels. My great-great grandmother Rosa Muench was given the camera instead of cash in exchange for her work cleaning houses in Germany. Little did she know that this camera would spark the fire that would influence three future generations of photographers. I was never able to have a private discussion with my grandfather about the stories of these travels or learn why he ended up where he did. I did, however, hear second-hand about the first time he saw the palm trees on Cabrillo Boulevard in Santa Barbara and declared that he would stay. I thank him every time I drive the three miles from my house to the beach in this same town. With a camera in hand, a largely

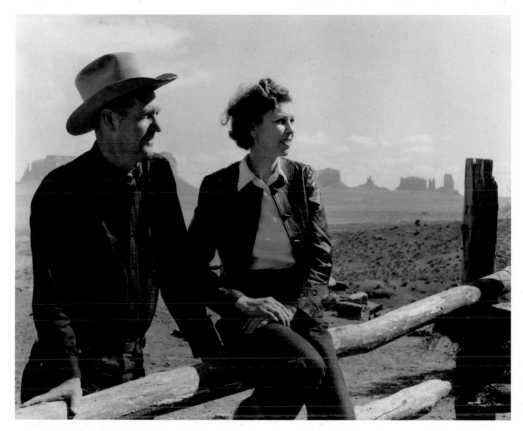

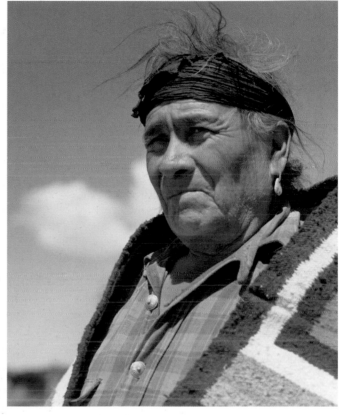

unexplored country at his fingertips, and new magazines eager to publish images of all the previously unseen landscape, he must have felt a rush of adrenaline as he pursued his passion. I do know that he loved what he did and shared that with my father. He must have felt that the locations he traveled to and the country he explored simply needed to be captured and shared.

Sometime during his travels, Josef ventured into Monument Valley where he became dear friends with the couple who had settled in the area, Mike and Harriet "Harry" Goulding. It seems that the influence the area had on Josef was quite profound, and he was drawn back to the Valley time and time again. He became so familiar with the local Navajo tribe that he was given an Indian name, "Mr. Full Belly." I'm sure whatever

trait he had that secured this name also helped develop the trust he earned from these native residents, which provided him the opportunity to photograph many of them in their natural environment.

I made it a point to sit down with my father and talk about the past. Because there was a breakdown in communication between my father David and Josef, I never had the opportunity to have this conversation with my grandfather. I was not going to let that chance slip away with my father. It is way too easy for the two of us to get caught up in our present projects and just "talk shop"; I wanted to look back, way back, with him. The timing of the conversation was in the midst of a reflective time for us, as we had been working hard for several weeks poring over what would become a portfolio of David's

Figure 2-5: Harry and Mike Goulding near Gouldings Lodge, Monument Valley Navajo Tribal Park, Arizona. ©Josef Muench.

Figure 2-6: Navajo medicine man, Arizona. ©Josef Muench.

Figure 2-7: Hunts Mesa, Monument Valley Navajo Tribal Park, Arizona.
©David Muench.

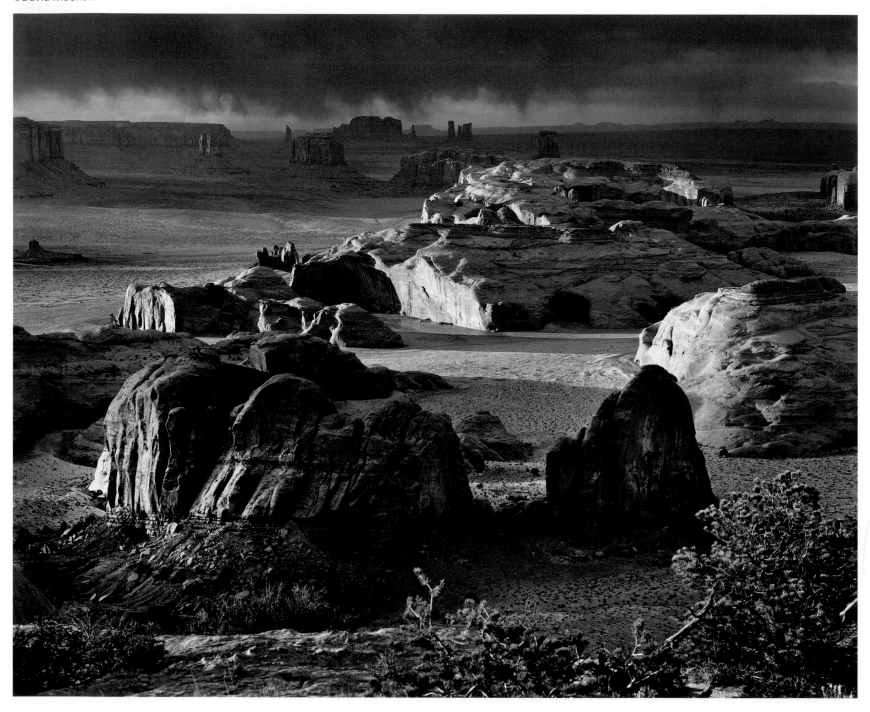

"200 best images." I am thrilled and proud to have printed that collection of images to be archived along side the work of Ansel Adams at the Center for Creative Photography at the University of Arizona. David was placed on a short list of photographers invited at the wish of the late Adams to have their work archived at the University. At last, my father and I sat down to have this long-anticipated conversation in our studio in Goleta, only miles from where my grandfather settled so many years ago and where my father grew up.

I asked David what he learned from his father. There was a period of silence during which he seemed to be flooded with memories that were getting dredged up from somewhere deep within. Finally when he began to verbalize what he had been internalizing, story after story of places he had been as a boy tumbled out; stories I had never heard. He described vague visions of places like Hunts Mesa, Rainbow Bridge, Capitol Reef, and Monument Valley. Then the influential figures began popping into the stories: Morris Knee, Harry Goulding, Art Green, and so on. The places and names, all swirling in his mind with dates, bouncing back and forth, like the story line in the movie *Back to the Future*. I began thinking about how fascinating it would be to have a journal of all those experiences to simply read along as he unfolded these emotion-clouded memories. I asked him what else he learned. Then to my surprise, having only thought of the journal, he said that Josef told him *not* to keep a journal because it steals time! Another long pause and he recalled being told to stay spontaneous. "You should always be ready for the unexpected," Josef would often say.

There are few vistas as grand as the one from Hunts Mesa. The view down onto the scattered stone monoliths of Monument Valley is especially impressive to a young photographer. My father said the first images he took on Hunts Mesa were captured after several rough adventures up the sandy, rocky slopes in an old army jeep with a local named Morris Knee. This image was included in David's recent collection of 200 images (figure 2-7). It was this and his other black-and-white

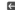

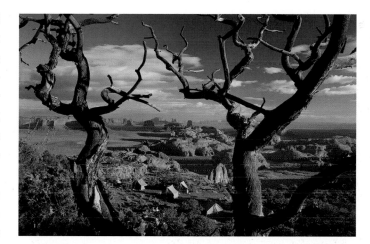

Figure 2-8: Tent camp at the top of Hunts Mesa, Monument Valley Navajo Tribal Park, Arizona, 1994.

Figure 2-9: Road to Hunts Mesa, Monument Valley Navajo Tribal Park, Arizona, 1994.

compositions that filled my thoughts when I first visited Hunts Mesa with a camera, possibly mirroring my father's own youthful experience, except that at the time I was leading a photography workshop. Our guides had been there many times and told us story after story of the epic adventures that had occurred on the journey to the top. Some of those stories included my grandfather and father. I was fortunate the guides knew the way so well because this was new territory for me. Although I was leading others for the first time to photograph this place, I felt as if I knew the location already. Even so, the

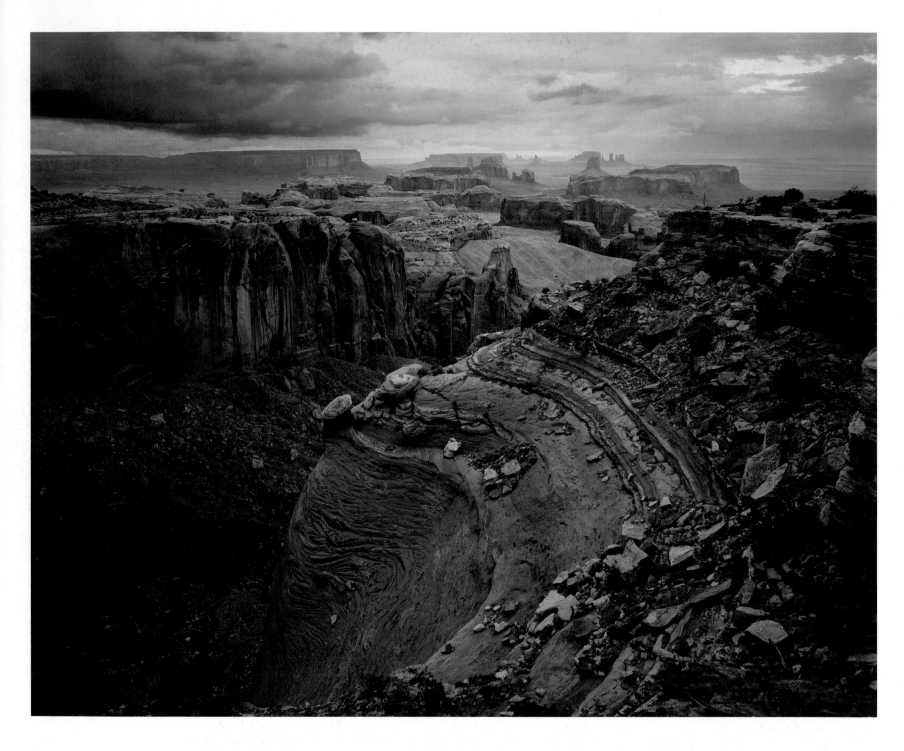

Figure 2-10: Approaching storm from Hunts Mesa Monument Valley Navajo Tribal Park, Arizona.

turn-by-turn anticipation for me was not only thrilling as a first-time experience, but strangely reminiscent of what my father and grandfather had done. I felt as if I were walking into my family's garden.

After several decades the road had not changed. The wind-blown sand still covered the tracks in many areas forcing everyone but the most experienced travelers to turn around. Even so, some trucks got stuck and the rocks punctured some tires.

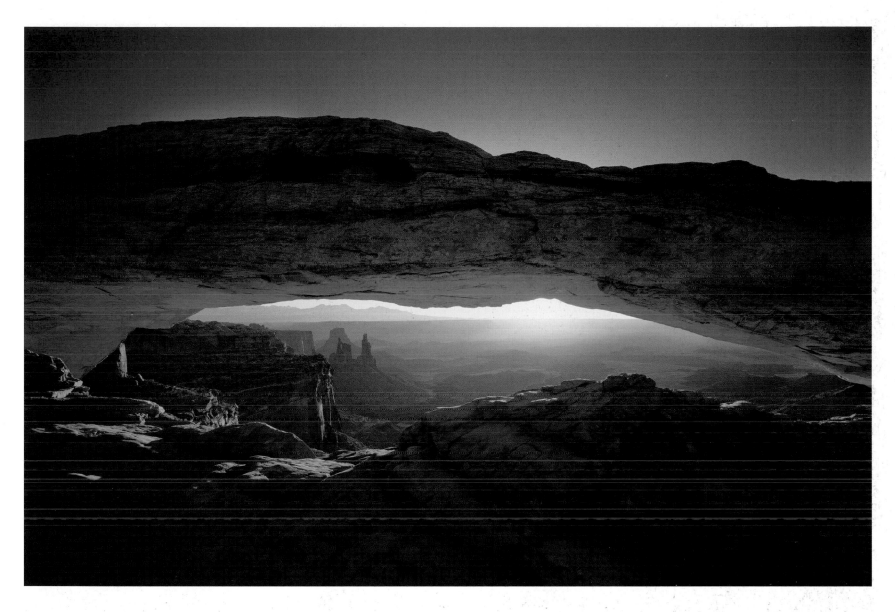

Travelers who succeeded on this path needed to know how to repair all difficulties on the spot. The outfit I was working with was owned by Bill Crawley. Bill and his guides have years of experience in this part of the country. I have visited many locations where I knew my grandfather and father had photographed, but Hunts Mesa was different: I could feel a calling to the place like no other. Consequently, for a very odd reason, which I don't understand to this day, I dug an 8×10 camera out of the closet, whipped the dust off, and bought a new bellows just to use on the trip. I had only used an 8×10 a few other times in my life and found it quite cumbersome. The leather

case was equally as old as the bellows I replaced, and the only modern piece of my setup was a rented Schneider lens which seemed to weigh more than the truck we were loading all the equipment into. What is unmistakably unique and memorable about making pictures with such a beast of a camera are the original chromes that, if properly exposed and processed, become the 'piece de resistance'! At that time a few workshop participants had begun taking one and two megapixel digital cameras into the field, but here I was using a museum piece. Most were actually fascinated with the 8×10 process and were interested in watching me calculate the proper exposure

↑

Figure 2-11: Mesa Arch, Canyonlands National Park, Utah.

values. If I missed the mark, it was like tossing $15 into the wind. With only moments before heavy rain began to fall, I ran out to an obscure overlook and exposed two sheets of film.

I hope that road stays the same so that others can experience the thrill of discovery for years to come.

Mesa Arch is another location that David and I discussed. "The first time I found it, there was no trail," my dad said. I asked him if he had seen a photo that led him to the place. He said that he would often find postcards and snapshots in restaurants or on gas station walls that would lead him to great locations, but this time David didn't have any recollection of something leading him there. I asked him if he had found "the shot" the instant he located the place. "It was fairly obvious," he said with a grin. Now, it's obvious to everyone. Not only is there a trail but there is a line of photographers traveling its length as early as 4 a.m. most mornings.

I also asked him how he felt about being the first photographer to have his photos of these magnificent places published. "I feel very privileged," he said. "After all, nothing is permanent, so I am even more fortunate to have been able to see and photograph these landmarks when I did. Another location that I believe I found photographically was Toroweap Point. I'll never forget getting a long lecture from my dad about my first expedition to Toroweap. On my way there I had also visited Las Vegas for the first time and had taken many images of the lights and buildings at dusk, which I thought were great. When Josef found out I had driven all the way out to a place as dramatic as Toroweap and had only taken four shots compared to the many I had taken in Vegas, he let me have it!"

With many more images to take for his upcoming book, but with broken ribs preventing him from hiking, my father asked for my help. He had acquired permits for camping at the Havasupai Falls tent campground in Northern Arizona. He wanted to spend several nights there in the hopes of capturing Havasu Falls for a book project called *Eternal Desert* to be published by Arizona Highways Publishing. It was 1988, and I was still attending Art Center College of Design; moreover, I was newly engaged. I thought this would be a perfect time to determine both if I could create the needed images and also if my fiancée, Stefanie, would enjoy this type of adventure so integral to my art and career. Also joining me was my mother, Bonnie, and my sister, Zandria. Just going out to dinner with your fiancée, mother, and sister is a test in itself, but going on a camping trip was altogether crazy. As I look back on it now, after 21 years of marriage, the experience was as effective as premarital counseling!

We began our trek early in the morning to avoid the late afternoon heat as much as possible. Most of the route to the waterfall is downhill, but ten miles is ten miles is ten miles, and when the thermometer hit 100 degrees with two miles left to go, it felt more like 20. I had my Zone 6, 4×5 camera with the brand new Velvia film. The guidance my father had given me was to try to get a high view down on the falls and shoot it in the shade of the evening or morning to avoid harsh shadows. We spent two nights in the tent camp just below the falls and were delighted to discover how beautiful the place truly was. It was an oasis unlike any other location I had seen, and it still remains in my memory as one of the reasons Arizona is a lucky state. It would have been very easy to sit down in the grass next to the big old cottonwood tree and just watch the water fall down the travertine cliff and swirl around in the large pool that was keeping my feet cool in the 100 degree heat. However, I was there to take pictures. Inspired to discover something new, I worked my way up a steep limestone cliff band in the hopes of walking back down the canyon on an entirely different plateau about 200 feet above the trail. Thinking the plateau would most likely diminish into a steep cliff and leave me short of ever getting the view straight down onto the falls, I kept walking. The farther I walked; the more hope ran through my veins.

The air was warm but tolerable, as the sun had now set behind the very steep canyon wall to the west. The grasses

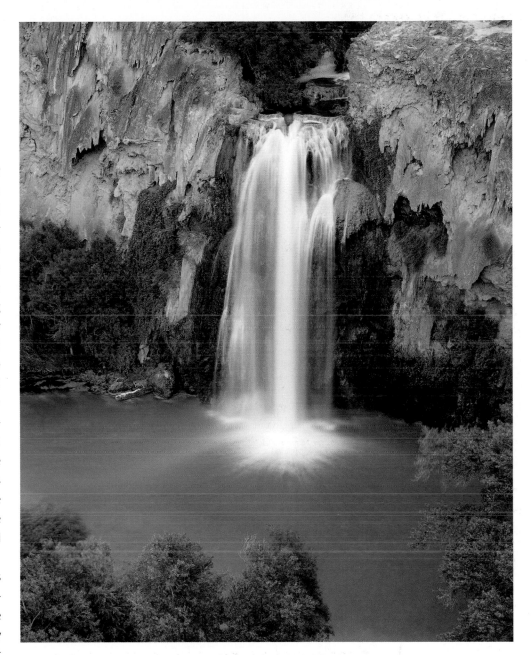

➜

Figure 2-12: Havasu Falls, Grand Canyon National Park, Arizona.

were fairly tall and shrubs blocked my view down canyon. After some time, I began hearing the sound of the falls. The shrubs finally gave way to a clearing and I soon realized that I had found a view down on the falls. The incline became steeper as I approached what was certainly a cliff below some more grasses and shrubs. But Havasu Falls was suddenly below me and I was in the location that my father had described. With no path to follow, and no footprints in the sand, I recall feeling as if I was the very first person to have ever stood there. I know it was not possible, as the Havasupai Indians had lived and hunted in this canyon for hundreds of years and others were probably there before them. However, the sensation was all the same. To have fulfilled this vision was exhilarating. Even though it was my dad's mission, I could still enjoy the satisfaction and exhilaration of discovering something personal and owning the moment. For some reason I felt possessive of the place as well. Not as if I owned the land, but just the rights to photograph it. This emotion must have been similar to the feelings of those who thought they were the first to settle the area. Photographic visions are often internal struggles fueled by vanity that also demand recognition for the find itself.

On the other hand, what I remind myself of over and over is that it is not the find that is important, but rather the experience. The experience is personal and the time spent in those moments become the memories that help shape my story that I will tell others. Owning the location or land is irrelevant in that equation. This image ended up in the *Eternal Desert* book, and then became a poster (figure 2-12). It has since been published in numerous calendars, cards, and magazines. The Havasu adventure was a learning experience that taught me no matter how little we know of a place, visions do come and we must not be afraid to follow them. Even better than successfully finding the picture of Havasu Falls, I survived a backpacking trip with my mother, sister, and future wife. There are simply moments in life when all the stars align!

My parents were never told to love the country they visited as children, nor were my sister and I. It is something that just happened.

La Crosse, Wisconsin, is a long way from the Grand Canyon. Along the banks of the Mississippi River is where my mother Bonnie began exploring the world around her. In the hopes of discovering more hidden secrets of my past, including any interesting genetic characteristics, I interviewed my mother as well. Over the years she had told me most of her history, but we had never talked about how she became so fond of

◻ No matter how little we know of a place, visions do come and we must not be afraid to follow them.

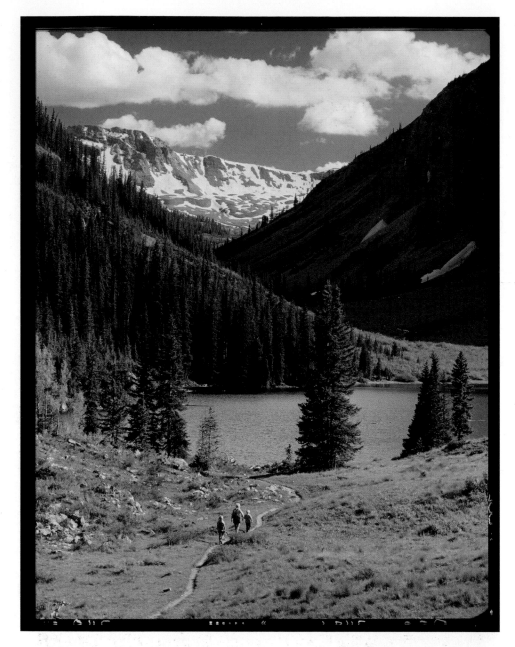

←

Figure 2-13: Bonnie, Zandria, and Marc Muench hiking on a trail in Snowmass Wilderness, Colorado, 1973. ©David Muench.

long journey through memories back through all the summers, spring breaks, and occasional winter trips where certain events triggered other special memories. My mother asked me if I remembered the summer we all hiked a total of more than 250 miles over several different backpacking trips. My father was simultaneously working on two different books and I was 12 years old.

Then she went even further back and reminded me of the time we hiked up Uncompahgre Peak in Colorado when I was only 7, making it the first time we hiked over 14,000 feet in elevation. Fearless of the weather and of heights, my sister dangled her toes near the edge of what was most likely a several thousand-foot drop.

The inspiration for my mom to leave Wisconsin behind and pursue a career in graphic arts had been developing over many years. Several influential art teachers in her local junior high and high schools encouraged her. These inspiring teachers coupled with visions of the tall snowcapped mountains, pulled her west. Suddenly she was walking off the train in Los Angeles to study graphic arts at The Art Center College of Design. This is where my parents met and why I ended up going back so many years later. Her education and experience in graphic arts led her to design most of the books my father published with Graphic Arts Center Publishing Company in Portland, Oregon. I recall walking into our kitchen after school and seeing her paper cutouts of all the book layouts taped on the large sliding glass doors. She did this to get a visual of the continuity of the layouts. She taught me about scale and how it creates depth in not only layouts but images as well. I didn't think much of it at the time, being mainly interested in filling my tummy rather than understanding a concept I thought I would never entertain again. However, like many things in one's youth, some of what we hear is filed away until years later when suddenly life, school, or work demands information about something we actually know from these rather informal but important lessons.

the great outdoors. My mother grew up in La Crosse, catching crawdads and swimming in the brown water with the catfish. What I discovered during our talk was that she remembers living in a small town near Tacoma, Washington, for a short time during the war years while her father worked for the military. She would look up at Mount Rainier and dream of exploring it. I asked her why she loved the travels we made when my sister and I were very small. So she too began the

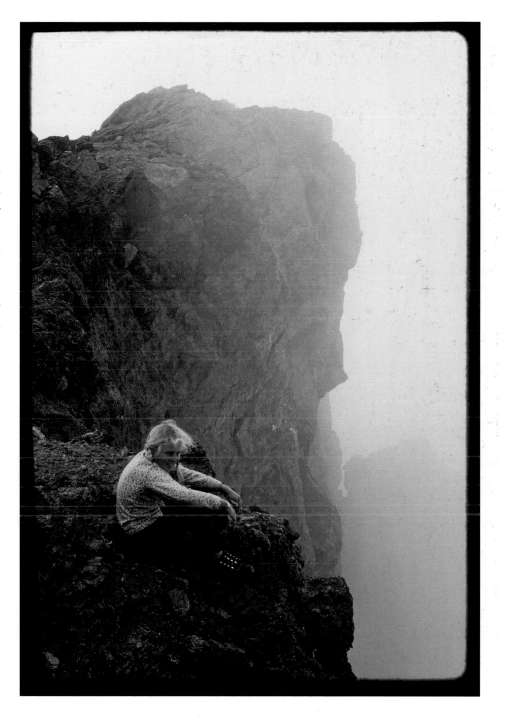

Figure 2-14: Zandria Muench Beraldo sitting on the summit of Uncompahgre Peak, Colorado, 1973. ©David Muench.

Is the secret gene cabin fever? Or maybe the secret is a child's upbringing? Then again it could be one's heritage, which if supported by family, allows one to explore innate curiosity. Whatever the case, I have felt full of this secret gene as I have made my way into some very interesting locations. Every time I go off the beaten path, I am reminded of many people, both in my family and others, who have chosen the road less traveled. I really don't think photography is the only reason I go, but rather the glue that binds all the experiences together. Will I always look around the next bend, hike the extra mile, or visit a location when the light is glorious just to watch? I like to think so!

▢ Every time I go off the beaten path, I am reminded of many people, both in my family and others, who have chosen the road less traveled. I really don't think photography is the only reason I go, but rather it is the glue that binds all the experiences together.

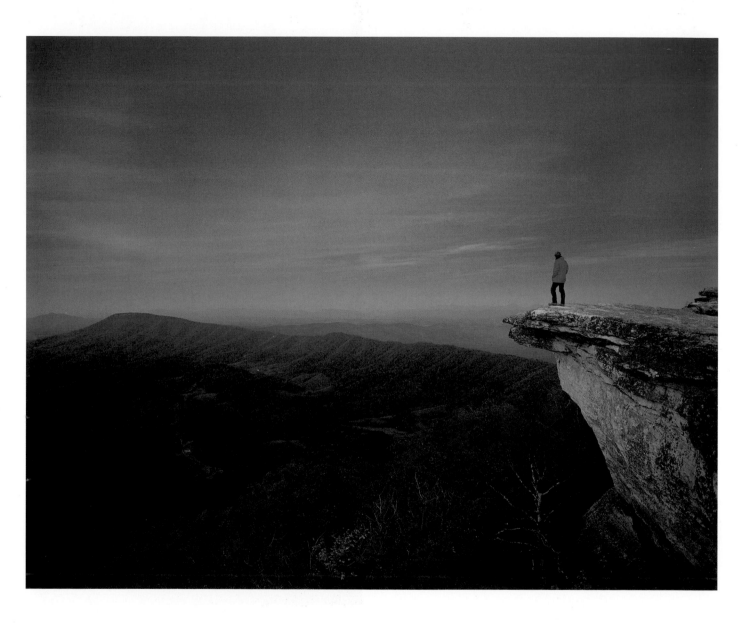

Figure 2-15: David Muench on McAfee Knob, Appalachian Trail, Virginia.

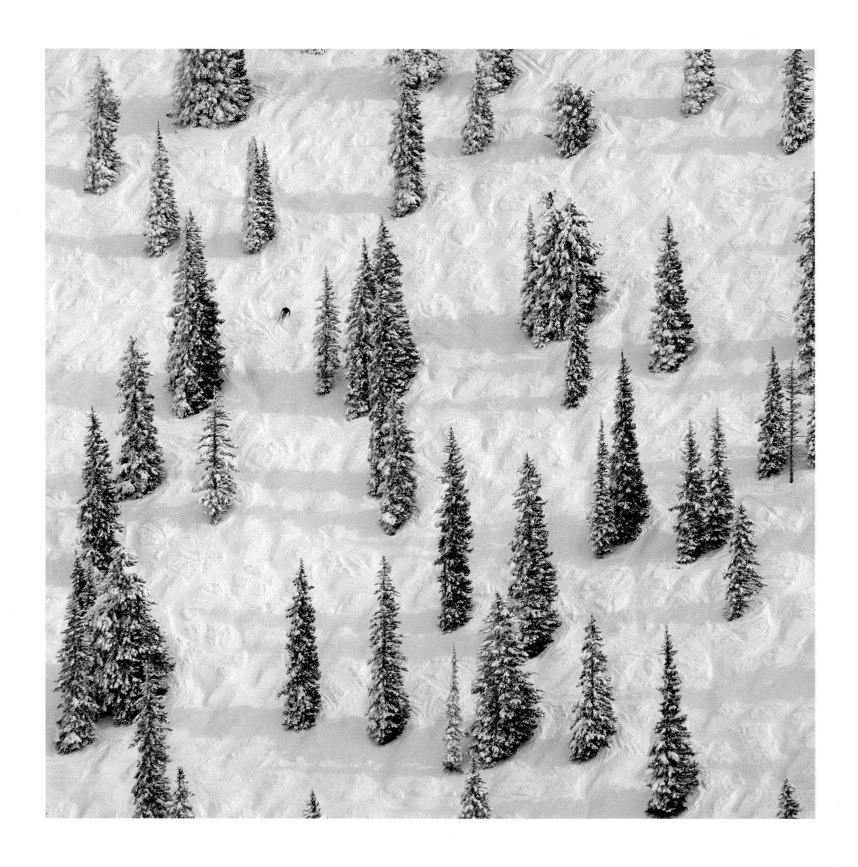

CHAPTER 3
THE DECISIVE PLACEMENT

I was lying in my sleeping bag with my ski boots and down jacket still on, and my head was lower than my feet, which meant no sleep for sure. My pack, filled with my camera and accessories, was sandwiched somewhere between my two friends and me. It was the middle of winter and we were crammed into a two-man tent plopped down on the top of an unnamed peak between Little and Big Cottonwood canyons in the Wasatch Mountains of Utah.

The snow had been falling on and off for a few days but the threat of an avalanche was low and the locals gave us the thumbs up to travel in the backcountry. That was 1991 and there were no online avalanche reports for backcountry skiers, so their blessing to proceed was important to us. The best part of our first night was that we didn't have to worry about any sudden midnight slider ripping us down the mountain. We had hiked up to this summit from Alta Ski Resort, so we were by no means in the boonies. In fact, the lights of Salt Lake City were almost bright enough to read by. The reason for our evening escapade was quite simple: fresh tracks! If we were the first ones to the top of the hill, we would be the first ones to ski down it. With the extra incentive of taking pictures for my father's *Utah* book, I was inspired to capture something more unique than the typical ski resort photo. I think my eyes closed a bit around 3 a.m. when the wind let up just enough for me to hear my friend snore, which for a moment sounded like an avalanche.

After a few more hours had passed, I noticed the faint transition of dawn approaching, so I began unfolding myself from my cocoon. Although I have camped in the snow hundreds of times, the worst part of the experience is getting out of the sleeping bag, even with ski boots already attached. The good news was that I could feel my legs and toes and fingers, and everything was working. My friend Jim was awake so I handed him the flash and barked some orders to him about mashing the button when I called to him.

My camera of choice was a Pentax 6×7 with a 45mm lens, all of which was about the size of my head. This set up was heavy but the end results always yielded impressive transparencies, at least compared to 35mm. My plan was to have Jim set the strobe off during a long exposure, so the tent would be visible in the dark. I fumbled around in the pre-dawn darkness to set up the tripod, causing the little warmth I had in my hands to vanish like water in the desert. It was time to find

my graduated split ND filter to place over the lens, thus making the sky darker and snow bank lighter. I found it just about the time one of the legs in the tripod broke through the thin top crust of snow and sank suddenly, pitching my camera sideways.

Now I was really fumbling around and I had not even found the picture yet! It was fortunate that I still had a hold of the neck of the tripod and the camera was somewhat securely attached: if I had not been holding it, the whole rig would have ended up about 50 feet below the cornice, lodged many feet into the deep powder, surely not to be found for hours. Following the ballroom dance with my equipment, I was standing where I thought there was a desirable composition and I looked up to notice the clouds turning pink. The beautiful color of the clouds spontaneously caused blood to rush throughout my entire body and at that moment I remembered why I loved photography. Suddenly, armed with the inspiration of new hope, I leveled off the camera, peered through the viewfinder and was horrified at the composition. I screamed as the color of the clouds got even better and the light began turning the snow various colors. I turned and ran up the ridge until I found a spot where I thought the composition would be better. Once again I placed the tripod down in the snow but this time I pushed much harder to set it. I peered through the viewfinder only to see I had positioned myself too far up the hill. Now the tent, which I wanted in the image, was lower than the horizon and lost in a dark void.

Once again I scooped up the tripod, camera, and pack and ran a few feet back toward the tent and set up for the shot. I placed the camera and tripod into the snow for proper stability, peered through the viewfinder, leveled everything off, and suddenly there it was: the composition I had been chasing up and down the hill! I pulled out the split ND and proceeded to drop it in the snow, took my gloves off in a panic, wiped the frozen crystals off the filter, and shoved it in what appeared to be the correct placement. I took a test shot and let out a sigh

of relief. Now all I needed to do was get my friends' attention. If all went as planned, one of my friends would set off the strobe from within the tent and the other would stand next to it. Thankfully my campmates were up and milling about, filled with equal excitement for the arriving sun. I managed to get one exposure with the strobe firing inside the tent and my friend Viju standing in the perfect spot next to it.

If I only knew then what I know now: compose with my head and make time for the warm-up!

The Warm-Up

Nowadays I will not set up until I am fully satisfied with my shooting position, meaning within an inch or two of the vertical and lateral position of where I have determined I want the camera. It is too easy to begin setting up the equipment prior to knowing exactly where the camera will go. Once I am confident there is a picture and that I need a tripod, then I take the time to position my head just where all the elements in the composition line up. Once I locate the position, I survey the ground where the tripod legs could potentially go. Finally, I begin my mental gymnastics. If I am clever, I am able to extend each leg to the intended length so when I set it down, the top of the tripod head is very close to where I want it. If I attempt to set up the tripod and camera before finding my shot, then I end up wrestling with my equipment while I locate the best position. This process becomes even more treacherous in rocky or steep terrain.

What I didn't know on that snowy ridge was just how much I had become addicted to composing through a viewfinder. I believe it is difficult to make the transformation of the image and composition from its three-dimensional state while peering through our eyeballs to the two-dimensional state as seen through a viewfinder. Therefore, we become reliant to peering through the viewfinder to formalize a composition.

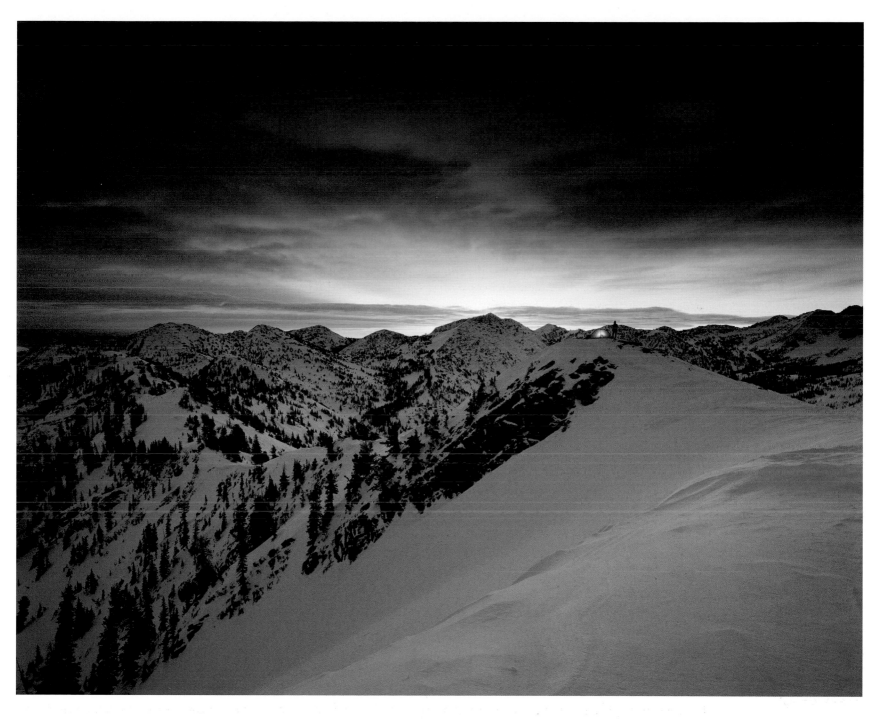

However, with experience, it is not difficult to create the visual composition in your mind's eye prior to setting everything up. To make this experience a bit more enjoyable, watch for the alignment of subjects and especially tangencies with one eye closed. Had I done this on the snowy ridge that morning, I may have prevented the multiple set ups and thus had more time to expose the image. I didn't need a viewfinder or even a modern digital camera with a live view display to show me that the tent wasn't lined up properly with the horizon. A recommended exercise in composing with your head is to make a cardboard

Figure 3-1: Snow camp on Flagstaff Peak, Wasatch Mountains, Utah.

◻ For you, jogging in place, having a cup of hot coffee, or even meditating might help as a warm-up to your camera and creativity. Find out what works and just make the time.

cutout of the correct aspect ratio of your camera (2 : 3 = 35mm, or whatever format you use). To compose the shot, hold the cutout in front of your eyes, close one eye, and then move the cardboard around until the composition looks pleasing. After some experience you will match the correct distance from your eyes with a particular focal length lens. For example, arms fully extended = 200mm, 10 inches away = 50mm, and so on. At some point you will be able to leave the cardboard behind and visualize the composition without props or viewfinders. In addition to saving time, there is yet another significant benefit to utilizing this method: the less time you spend wrestling with your camera, the less gear you will lose—or at least that is my story. I have seen cameras fall over, filters fall off, and lenses get scratched during this wrestling match with the camera-tripod combo.

Warming up to the camera is something I have acquired a habit of doing while in the field. Had I known this back on that snowy ridge above Alta, I may have discovered the shot much sooner. Not only is it better to have the extra time to get ready, but it is even more important to take the time to get my creative thinking in full swing. It is not enough to simply arrive at the location prior to the light being perfect: it is more important to have the time to reach a capable and creative state of mind. I call this process "warming up to the camera". Especially when it's cold and windy, and I am tired, there is nothing worse than missing a shot because I was too lazy to warm up and was not thinking at my peak performance. Although the military method of "hurry up and wait" might apply to landscape photography, it is only half correct. I always try to hurry up so I can perform a pre-shoot. This warm-up time prior to the best light is vital for me to work through some procedures. This only takes me enough time to make 10 to 15 different images, sometimes using different lenses. Consider it yoga with the camera! What I have discovered is that by having just a few extra moments to make images *prior* to the best light, my blood begins to flow and the neurons in my brain begin to

fire. Personally, the task of taking pictures to warm up, even in substandard light, is important. For you, jogging in place, having a cup of hot coffee, or even meditating might help as a warm-up to your camera and creativity. Find out what works and just make the time for it.

The Divine Angle

There have been a few moments while skiing, surfing, or climbing when a few seconds have expanded into days in my memory. Everything was in sync: my arms, my legs, my body were all moving together involuntarily. My thoughts were focused—not forced or strained—but effortlessly in tune with myself and my environment. These unique memories share something in common: they all seem as if time slowed down. What was only seconds felt like minutes!

Consider for a moment what is so intriguing about the West. Is it the clear air, deep canyons, large mountains, or long rivers rambling their way to the Pacific? I believe one of the greatest aspects of the West is the enormous and seemingly limitless space that goes on until the horizon is no longer visible. Consider also what you hear when you see the horizon disappear into nothing: usually not a sound! The sound of space is nothing. When I am photographing other people I want the image to convey not only the vast space but the silence of the moment as well. I arrived at the point where I felt it important to remove myself from the scene just enough to peer down from a distance. If my experience of the action was intimate and the memory vast then I should somehow be considering both while making the images.

Being 100 % involved in the location and activity is just as critical as finding the dramatic and beautiful place itself. It is ironic how elusive these occurrences are but how indelible my memories of them have become. This makes for an interesting challenge photographically. My approach is to

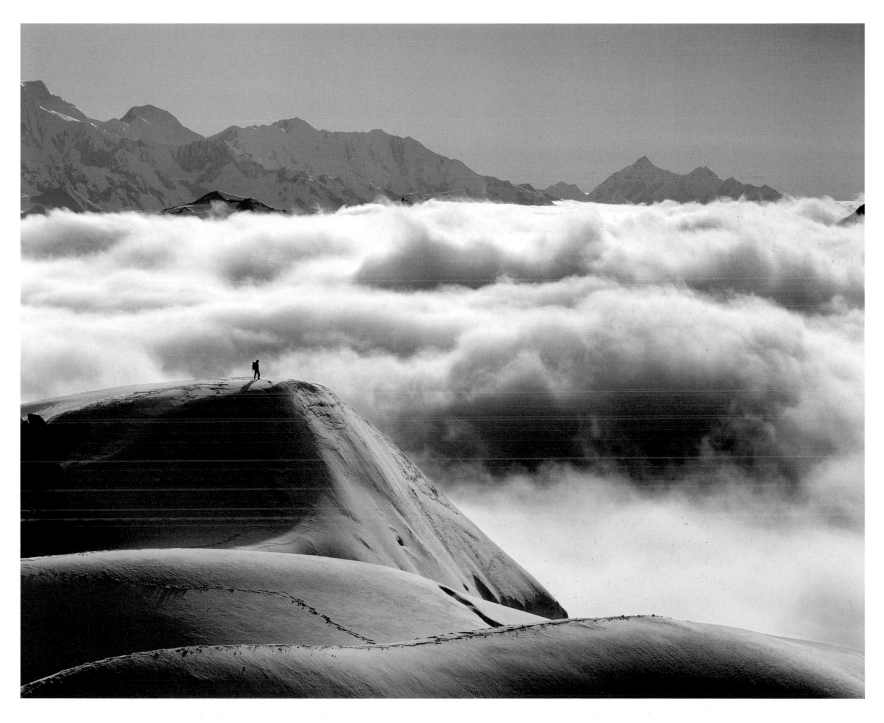

identify the possible location and, through discussions with the athletes or models, determine where they feel inspired to go within the locale. Another even more elusive approach is to be involved with the sport before taking pictures of someone else's performance. I have found that my focus and vision of photographing the scene is enhanced by my visceral memories of my own participation in the sport, which helps guide me into a position which allows the subject unbridled access to the surroundings. Thus, there needs to be a dance between the subject, my position, and the overwhelming space.

Figure 3-2: Climber on unnamed peak in Wrangell St. Elias National Park, Alaska.

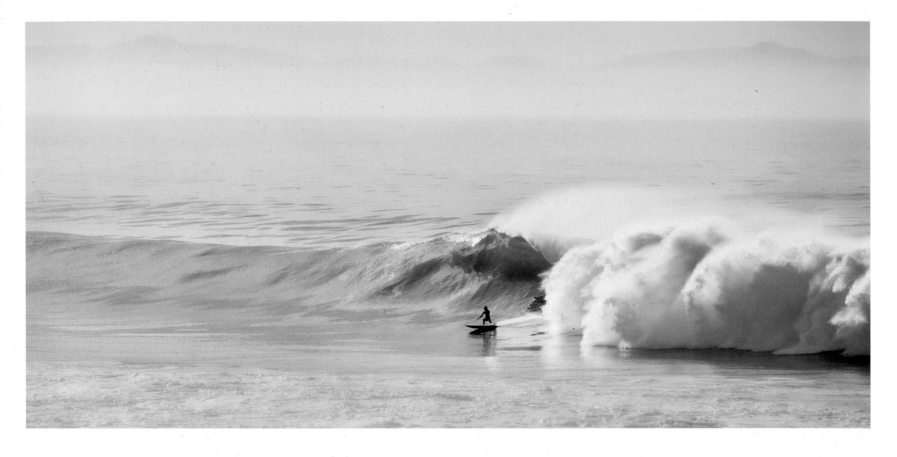

Figure 3-3: Surfer at Coal Oil Point, California.

Catching the Perfect Wave

I did catch a perfect wave once. I don't remember how I stood up on the board or how I felt during the drop in, which are two of the more difficult actions in surfing. I just recall my right hand against the vertical section of the barrel and gliding across the water, which felt quite firm at the speed I must have been moving. The sound of my board chattering was interesting because it should have made a rougher ride. Instead it was smooth, like doing 50 mph over a washboard road in a Lincoln Town Car. My only view was the 20 feet right in front of me. I do not recall the background, which should have been some palm trees on the bluff next to the University of California, Santa Barbara (UCSB) buildings and the green mountains spotted with a few rock outcroppings beyond them. I only recall the very steep face of the wave, which appeared to form perfectly in front of me for what seemed like five very long minutes although I know it was only seconds.

Since then, I have walked the bluffs above that spot many times in hopes of capturing the sensation with my camera. It wasn't until the perfect swell arrived in 2005 that I was able to relive this perfect surfing moment through my camera. The wind stopped, allowing the mist to hover above the water and causing the sound of the large surf to echo all the way to my studio in Goleta. Now when I look at this picture (figure 3-3), I can smell the sea and hear the thundering surf.

Inspired Moments

Photographing people doing what they love in ideal conditions is the focus of my sports work. Placing them in the conditions at the right distance, angle, and time becomes a challenging ballet of point of view, camera equipment, and state of mind. So far, my best images are of those inspired moments where my personal experience gave life to the more abstract concepts I felt needed to be incorporated within the image.

Downhill snow skiing and ski mountaineering motivated me to pick up a camera in the first place. I remember the moment, skiing with a friend in a blizzard at Brian Head Ski Resort in Utah during a high school ski trip. We had been sleeping in the back of his Jeep for two days over President's Day weekend when we decided to drive all the way to Colorado. My friend Jim Perlin had convinced me that the mechanical wizardry he'd performed on his car would get us there without delay. He had rebuilt the carburetor and changed the head gasket and timing belt all by himself. He reminded me that he was taking auto shop and that, after all, the car had successfully made it to Brian Head. However, when we decided to make the additional drive to Colorado during our five-day road trip, my first thought was not whether the car would break down or if we would actually make it, but rather how cool it would be to get a picture of skiing in Colorado. We did make it to Colorado and skied Telluride for one day. With several days of heavy snow forecast for that area and sun predicted the next few days in Mammoth, we turned around and drove all night closer to our homes to Mammoth Mountain. We were high school students with way too much energy and not nearly enough wisdom. The only part of the all-night drive I recall was stopping in Caliente, Nevada, for a cup of coffee and getting it in a one gallon container!

Over the following years I became addicted to photographing skiing. It didn't matter if I was in a resort, a ski area, or slogging up a slope in the backcountry, I just needed to find someone to publish more of my images. My first choice at the time was *Ski* or *Skiing Magazine,* but they had many veteran ski photographers from which to choose. And, I argued with myself, why would they want me to photograph skiers within my landscapes? So I figured I would try another approach: convince a landscape photography magazine to publish my skiing photos. It just so happened that *Arizona Highways* liked the idea of a story on skiing in the San Francisco Peaks, a ski area in Arizona that was definitely not a resort. I must admit that Aspen or Vail were far more intriguing to most skiers and ski photographers, but, as it turns out, I was thrilled to consider shooting skiing in a rather obscure but very spectacular location.

The San Francisco Peaks rise to 12,000 feet above the sea of sandstone called the Colorado Plateau. From the summit of Mount Humphreys, you can see most of the Grand Canyon, the buttes surrounding Lake Powell, and, on a clear day, the colorful cliffs of Bryce Canyon. If you spin to the south, you can peer down into the Superstition Mountains above Phoenix. The problem with my proposal did not even occur to me until several weeks after the euphoria of coming up with this concept wore off and I realized there was not enough snow to complete the story, let alone ski. The ski area was considering closing down after only minor early snow, which was rapidly melting during a rather warm February.

Fate was kind that year, however, and the good news was that The Snowbowl, as it was called, was on the same storm track as Santa Barbara. There were several storms lined up in the Pacific, ready to drop inches of rain on me. By the end of the week, Santa Barbara had received five inches of rain and another five were expected in the next two days. I made calls to a few of my contacts at the ski area and the news was perfect: they had three feet of new snow and it was still dumping. When I photographed in Alta, Utah, and Mammoth, California, I learned that if you really want to get around on a ski mountain, it is always best to work with the ski patrol. They know

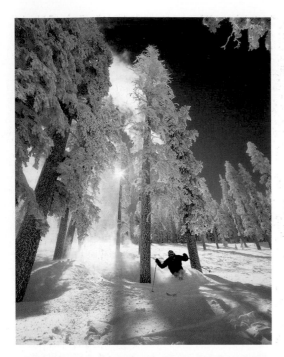

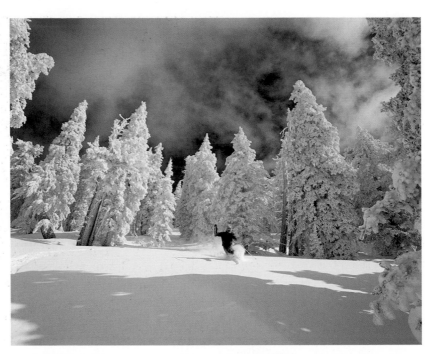

⬅️⬅️⬇️⬇️

Figure 3-4: Skier at Snowbowl ski area, Arizona.

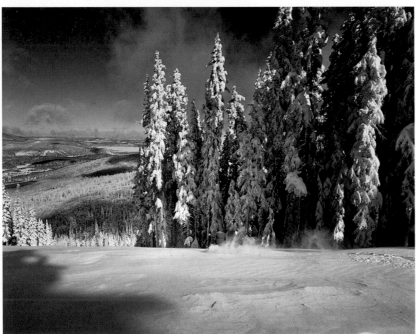

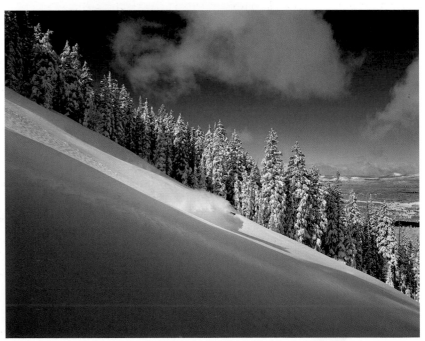

every inch of the area and can even dig you out if need be. With a good report from the head of the ski patrol, I packed everything up and began the ten-hour drive to Flagstaff.

About an hour outside of Kingman, it began snowing. It was cloudy, dark, and snowing hard, reducing the visibility to about one hundred feet. Driving on an interstate in a blizzard at night behind tractor-trailers is very exciting. It was my adrenaline that kept me awake more than my drinking a gallon of coffee. The next morning I met with the ski patrolman and took a tour of the mountain. It felt good to get out on the slopes and

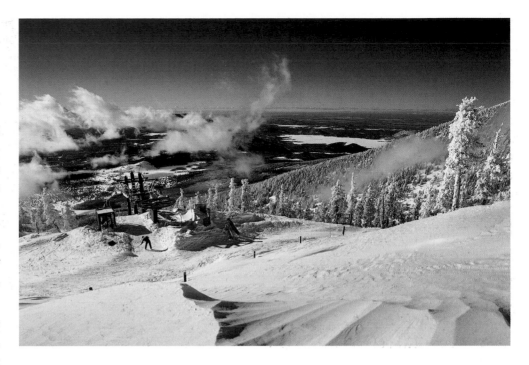

ski with my pack on. I was still taking ski shots with a Pentax 6×7 medium format camera, the weight of which gave me additional inertia while skiing and while falling, providing the extra force to drive my face deep into the snow if misfortune prevailed. It always takes a day to get my ski legs on.

The next morning was divine and spoiled my skiing for years to follow as I luxuriated in the fresh powder on everything; waves of snow covering all the ski runs and patches of blue sky allowing the morning sun to pop out between swiftly passing brilliant clouds.

I remember panicking because so many pictures were waiting to be had but the chair lift seemed agonizingly slow. My plan was for several ski patrol members to change out of their uniforms and ski with me, but the eight feet of new snow kept them busy with additional work to get the mountain open. So, I was on my own to find skiers to photograph. What occurred that morning was definitely not planned and kept me from taking contrived ski images in which I would direct skiers where and when to ski through a found composition. Instead, I hung out at the top of the chair lift and asked certain skiers if I could follow them down the mountain. I had learned to identify proficient skiers by not only the certain confidence with which they disembarked from the chair but also by what equipment they possessed—their bindings and skis being high performance but well worn, and their clothing usually functional with efficient weatherproof design rather than fancy fur around the edge of their jacket hood. Dropping the name of the magazine usually draws some interest, but there have been times when the potential skier-subjects have completely blown me off, wanting nothing to do with me or having their picture in a magazine. Because of the extraordinary conditions that day, I had little trouble finding the excellent skiers I sought. I was successful early and found some good subjects. I was working hard to keep up with two guys who were definitely thrilled to be skiing and did not have a clue about how I needed to get below them to take their picture.

After about a third of the way down the run, with a rather winded shout, I finally got their attention and asked them to stop so I could get below them and shoot while they descended down their intended route. I was careful about asking them where they planned on skiing, then skied down without tracking up the vicinity to a position where I could compose their expected descent. I did this all day long, recruiting as many different skiers as I could. It was a small mountain and before long, people were yelling at me to come take runs with them. It was one of the best days of skiing ever!

To round out the story for the magazine, I had convinced the editor of *Arizona Highways* that the ski story would have a twist, as I had planned to include the mountain operations as well as the skiing. This meant I needed images of the "snow farmers," otherwise known as the groomers, and the lift operators. With two days of skiing, and a few beers between me and the patrolmen, I figured it was time to ask them for a favor. I wanted to spend the night in the patrol shack at the top of the highest chair. They didn't think of this as a favor, but actually thought I was a bit loony!

The radio in the shack crackled on and off well into the early morning hours. I had been instructed to keep it on in the event of an emergency. Between the guys driving the

Figure 3-5: Top of Agassiz chair lift, Snowbowl ski area, Arizona.

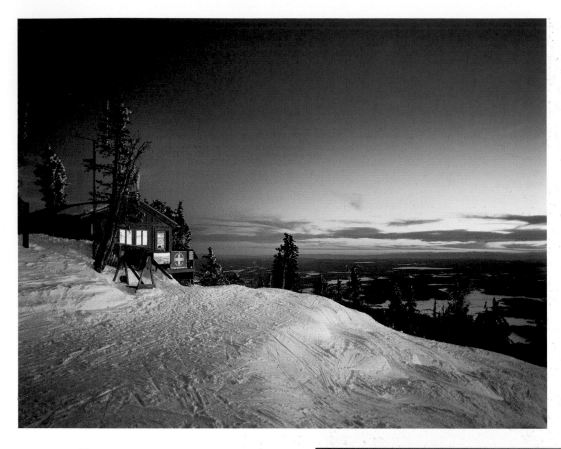

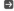

Figure 3-6: Patrol hut, Snowbowl ski area, Arizona.

Figure 3-7: Shadow of Mt. Agassiz at dawn, Kachina Peaks Wilderness, Arizona.

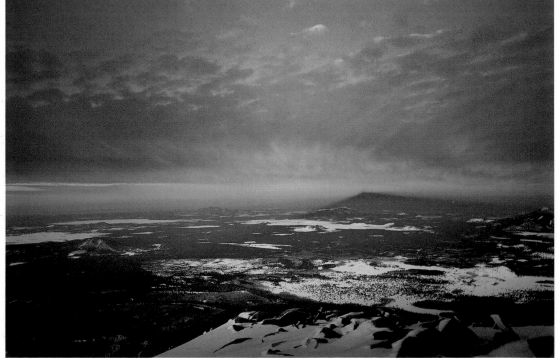

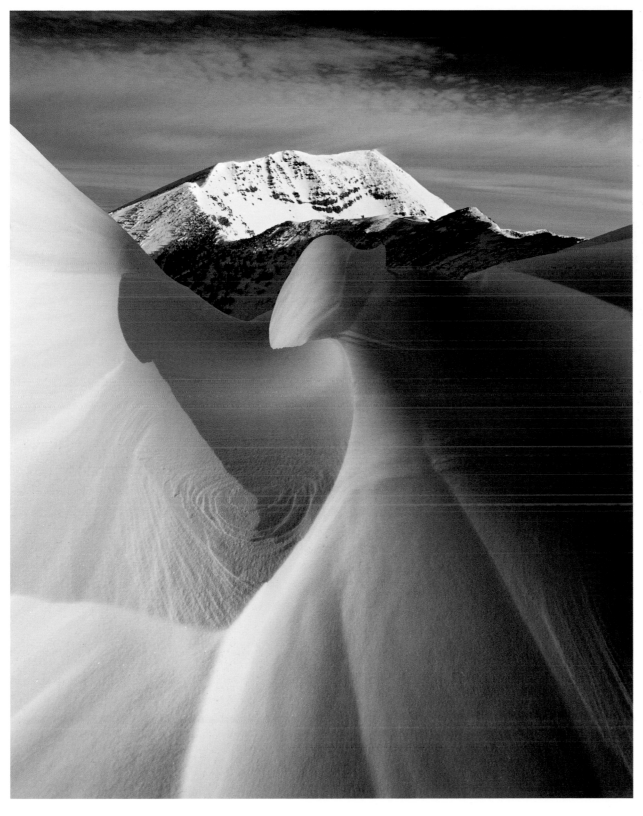

Figure 3-8: Mt. Humphreys, Kachina Peaks Wilderness, Arizona.

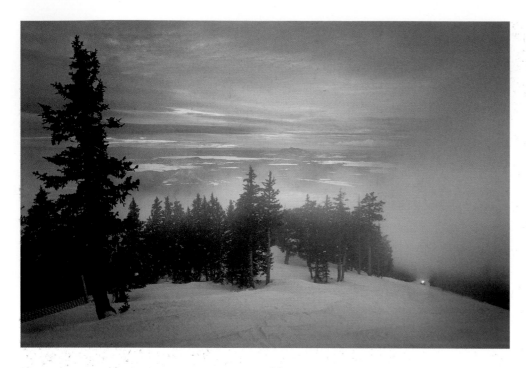

Figure 3-9: Fog-shrouded ski trail, Snowbowl ski area, Arizona.

grooming machines and talking about conditions and some maintenance chatter, there was nothing too interesting except what seemed like the patrolmen using their radios to tell jokes while walking home from the bar. I never brought it up again but one joke was about California skiers not being as good as Arizona ones!

The next morning was clear and the winds, which had blown most of the night, had carved snowdrifts on the top of the ridge. I spent several hours before the chairlifts started, running up and down the ridge photographing in the changing early light. I have learned that even though I am addicted to photographing skiing, I am not able to fully enjoy the experience without giving myself plenty of time to define my perception of a location through landscape photography, even if it means listening to bad ski jokes!

Since staying in the patrol shack that night, the experience of being close to my work has stuck with me. There may be more comfortable places to spend the night but few locations with comfort are ever close enough to the action. I never would have dreamed of a shot where the snow cat would be emerging from the foggy depths of the valley below to begin a nightly routine of snow grooming (figure 3-9). These moments captured mainly because of the unusual weather are almost

impossible to imagine and must be experienced. The more I have endeavored to experience such moments, the more I have realized the photographic potential in most situations. Within a two hundred yard radius, I was able to capture fascinating, unique images during these off hours, illustrating the uncluttered mood, drama, space, and silence of the top of Agassiz chair lift.

Experiencing those five days at the Arizona Snowbowl convinced me that I could fully engage myself in life through the goal of telling a story with my photography. It helped me solidify my developing ideas about decisive placement and the divine angle at a time when the development of personal style was critical. After skiing, hiking, meeting wonderfully interesting people, and witnessing beautiful landscapes, the highlight of the trip was lingering like the final drop in a long rollercoaster. With the lift operations still closed, there were only a few people on the mountain—several snow cat drivers beginning their nightly routes, and the director of patrol, B.J. Boyle, who had been generously helping me all week. It was late in the afternoon and we were both tired from the long hours of canvassing the mountain. However, the conditions were so unusual that neither of us was going to simply go back down without skiing something special. It had been about two days since any fresh snow had fallen so most of the runs were all chopped up from tracks, making it a potentially bumpy ride, but B.J. had something else in mind. He made a quick call to find out if any of the groomers had paved a path through the cut up snow or laid down the corduroy, which is what skiers call fresh groomed snow. I heard his radio crackle with directions to a run that I now knew fairly well. Once identified, we jumped on our skis and down we went over a single lane of groomed snow, which literally lead us off into the sunset!

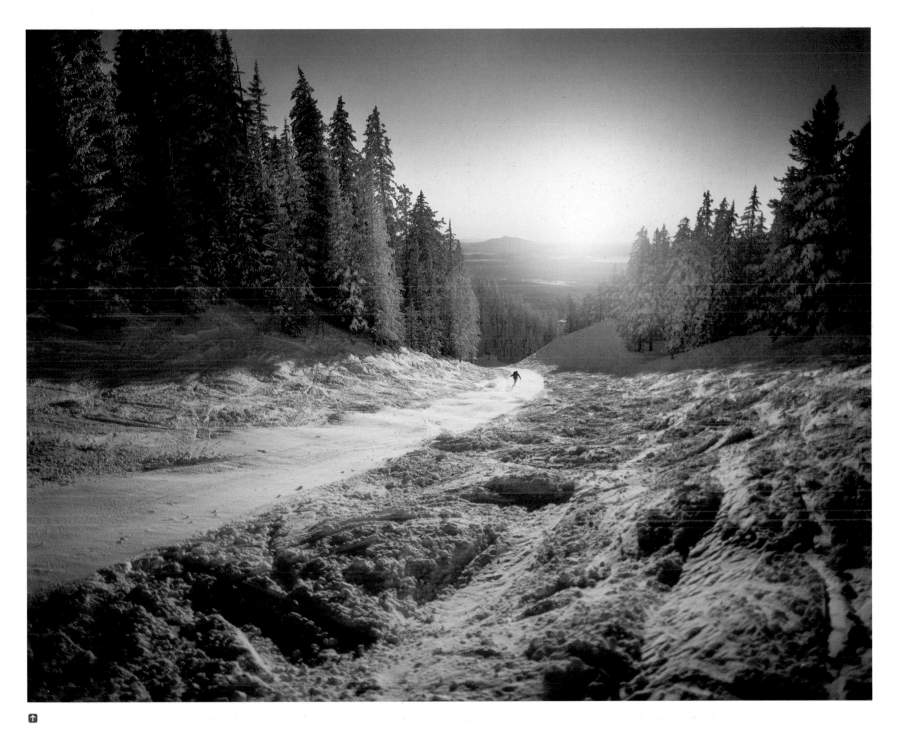

Figure 3-10: Sunset over ski run, Snowbowl ski area, Arizona.

As Good as It Gets!

It is true—once you ski fresh untracked powder, there is no going back. There's the initial push to shift my weight forward to get the skis moving, and then the pull from gravity, which usually takes my breath away, as if it were the very first time. Finally, the first smooth glide of my skis on the powder and I am off on another ride through the heavens. Once again, if everything is just right, time seems to slow down and seconds stretch into minutes. My weight shifts from side to side helping the ski tips plunge in and out of the snow, as it goes by faster and faster and begins to spray up into my face, sprinkling my cheeks with the icy cool sensation of winter. "This is skiing," I say to myself as I dive farther and farther into the spacious, inviting whiteness.

Figure 3-11: Skier in deep powder, Alta ski area, Utah.

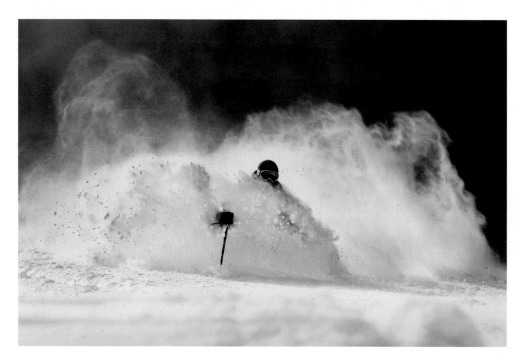

Heli Skiing in the Rockies

The Bugaboo Spires are the crown of a range contained within the expansive Rocky Mountains. It was a sunny afternoon in the middle of winter and I was sitting on the deck of one of nine lodges nestled high in the Selkirk Range. Seated next to me on a bench in the late afternoon sun was Mark Ginsburg, the President of Canadian Mountain Holidays (CMH). I recall Mark explaining his earlier days of skiing in this region, including all the "steep stuff" as he called it. These were areas that are now labeled as "Extreme Skiing." Mark was visiting Bugaboo Lodge to meet with me and several other photographers from various publications to discuss how we could best accomplish our work while simultaneously accompanying the paying group he would be taking up the mountain. I was photographing for my first book, *Ski the Rockies,* and explained to him my vision of capturing a view looking down on several skiers as they descended a large unskied glacier. To my surprise, he proceeded to ask me when I thought it would be best to use the helicopter for the shot. It was hard to breathe. In what seemed like two seconds later, I was in a Long Bell Jet Ranger flying up to the Vowell Glacier in the morning sun, accompanied by four of the greatest skiers in Canada (the lodge chef, two dishwashers, and one guide).

My mission for the book was to photograph all aspects of the skiing world from New Mexico to Canada, visiting as many ski areas, resorts, lodges, and mountains as possible. I had no political motive other than to expose the beauty and enrichment of a truly inspiring sport enjoyed by many who loved the steep snow as much as I did. There are many places that receive great snow; some are fortunate to receive it more often than others. I was in search of those places as well as the ones that contained the perfect amount of groomed runs, trees, and off-piste (backcountry skiing) to fulfill the "feng shui" in any alpinist.

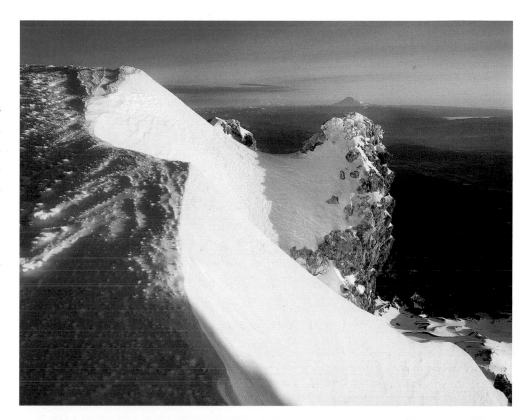

Figure 3-12: Sunrise on summit of Mt. Hood, Oregon.

When the skies cleared that morning and the necessary participants, equipment, and inspiration assembled at the Bugaboo Lodge, I knew a special moment awaited me. Because I was considered a journalist and allowed to take the week-long trip as professional compensation, I couldn't have expected anything better. The only potential issue was that I had been grouped together with two journalists (who stayed quiet most of the time) and a photographer from a Japanese ski magazine. The writers weren't interested in the private tour that morning, but the photographer was. At first it seemed unfortunate that he couldn't speak English nor I Japanese, but to my unexpected advantage this meant he couldn't direct the helicopter pilot during our shoot. I know this sounds selfish, but as it turned out we were after completely different images; he wanted tighter images of the skiers, and what I had in mind was a bit farther away with a wide angle lens peering down on a perfectly untracked glacier at least the size of Central Park in New York City. This is what Mark Ginsburg and I had talked about the previous day.

Nevertheless, both the Japanese photographer and I got what we wanted and we became good friends by means of sign language. I am forever envious of his working relationship with the writer/assistant who accompanied him. After eating a glorious lunch way up on the slopes of a snow-covered mountain, everyone wanted a group shot. He instantly offered to take the picture and motioned to his assistant to come over. Before anyone could blink his assistant was on his knees to allow him to get on his shoulders for a higher view. Just like a Sumo wrestler, the assistant grinned and grunted until reaching a standing position with the photographer on his shoulders. The stunned group suddenly broke out in laughter. I'm quite sure his images were just as glorious as the view beyond. My biggest regret is that I didn't have my camera to get a picture of the two of them. The image I took of the lodge chef, guide, and two dishwashers became a double-page spread in my book and later appeared on the cover of the CMH 25th anniversary book.

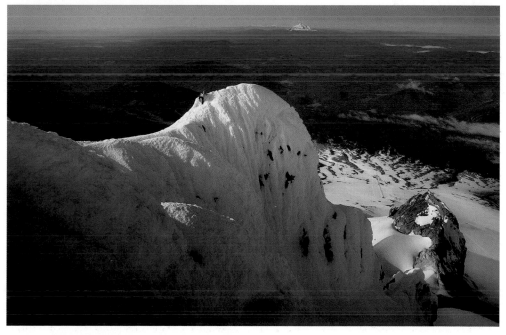

Figure 3-13: Climber near summit of Mt. Hood, Oregon.

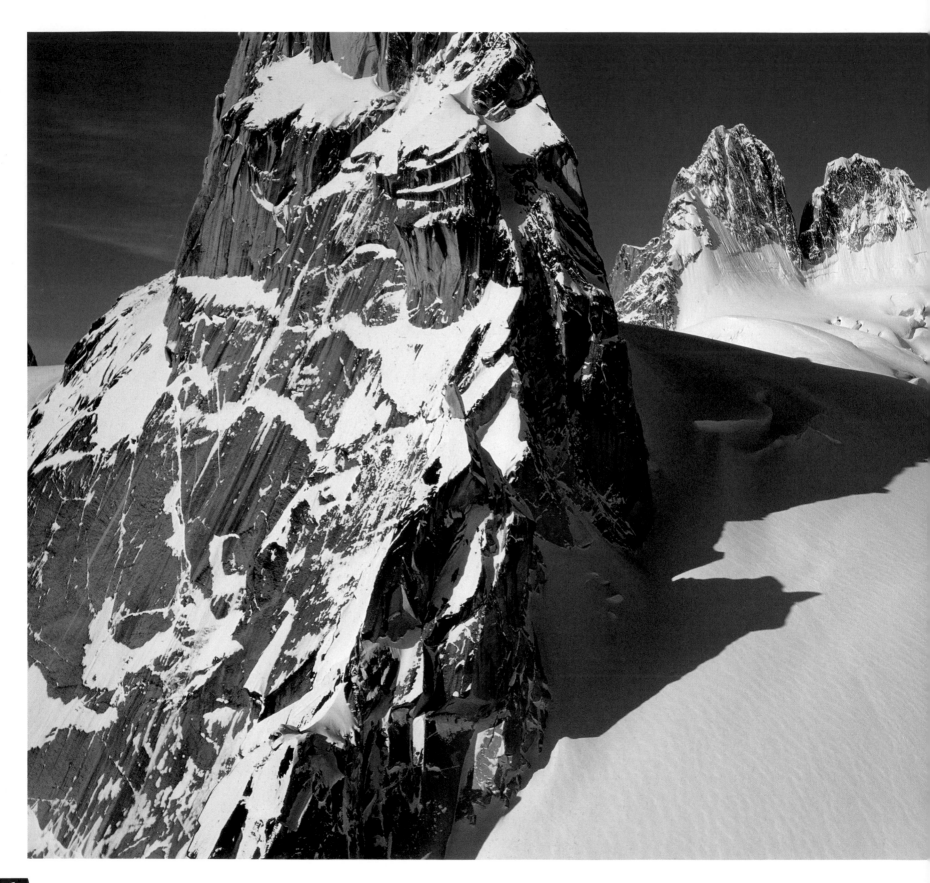

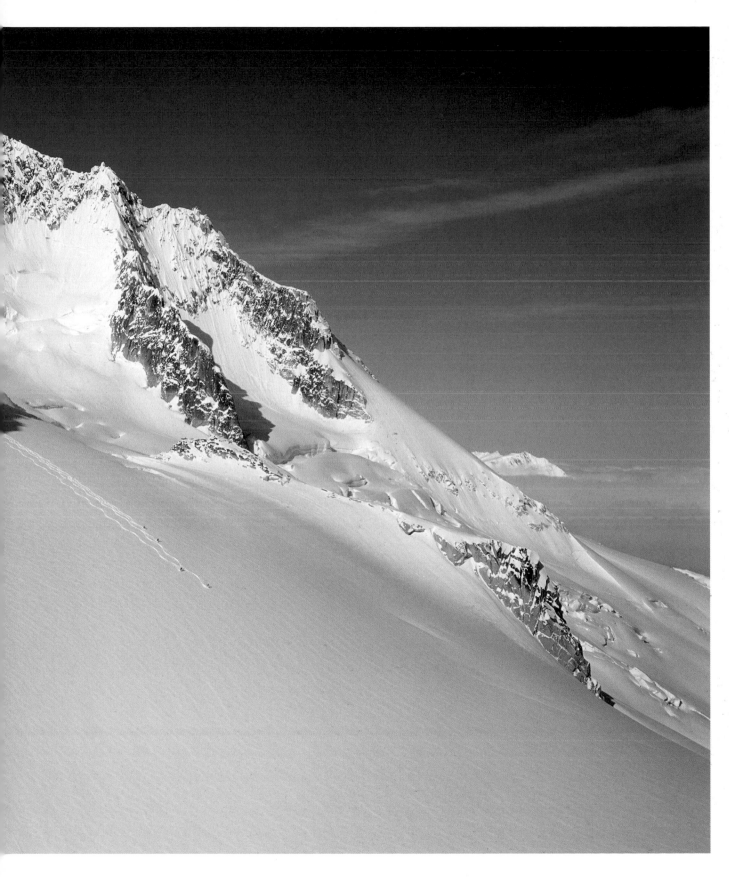

Figure 3-14: Skiers on Vowell Glacier, Bugaboo Provincial Park, BC, Canada.

Risks and Rewards

It was a good day in the mountains. My friends and I had climbed Mount Hood, starting out in the dark and ending up in the warm parking lot, standing around in climbing boots that were soaked from the descent through slushy snow. A journalist from a Portland, Oregon, news station interviewed us about the early season warm conditions on the climb. We told him we did notice a few extra rocks breaking loose due to the change in the temperature early in the morning but considered that to be normal daily activity, at least for the springtime—after all, it was late April. However, someone had tipped off the station that the warm conditions would be a good story since many climbers had planned on ascending the mountain that weekend. Our experience told us to be down off the mountain before it came unglued in the warming conditions. It was now noon and, sure enough, several large parties were still descending the steeper part of the mountain called the Pearly Gates. Due to their late start and slow pace, they now faced a dangerous predicament, one that gave the local news station something to talk about.

The reality of any outdoor activity is that we often put ourselves in harm's way. The purpose is not always for attention or glory but something deeper and often more personal. What you end up discovering in the process is the way in which you deal with stress, pressure, and in some cases, dire conditions. The line between calculated risk and stupidity can sometimes become thin, giving many who never partake in such activities the wrong impression about why we climb, ski, or do anything life threatening. The only reason I bring this up in a photography book is that I fell into my understanding of risk through the back door. I was on the move undertaking risky hikes, climbs, and adventures, not because I wanted the adrenaline rush but because I was passionately in search of photographic compositions. When I discovered that unusual perspectives were worth the physical and organizational efforts, I became more adventuresome and, therefore, involved in more risky activities. I learned that at some point you have to realize your own threshold of ability and risk. Fortunately for me, I did just that before losing my life.

Creating images of dynamic sports in wild and stunning locations is a challenge. There are two approaches I have considered every time I am in these situations. First, the images can be *orchestrated,* and second, the images can be *captured.* To capture the real event with little or no intrusion can offer more genuine imagery. However, this takes more time and doesn't always yield the intended results. For example, if I am on a commercial shoot, I must first accomplish what the intended job requires. One benefit about working commercially in outdoor environments like this is that most of the time I am given ultimate creative freedom, allowing me to pursue both approaches. This unusual confidence from a paying client can be attributed to the fact that, normally, art directors have never been on the end of a rope hanging off the side of anything close to what would be considered a cliff. During ski shoots I have worked with art directors that wanted nothing to do with descending double black diamond slopes or climbing up under a fifteen-foot cornice to get the dramatic angle. When a paying client is not hovering over my shoulder, there have been times when I have spent hours waiting for certain events to happen naturally, or, in some cases, I scrambled for a camera to capture what was spontaneously happening right in front of me. There have been other times when, because of the intentions of the paying client, I had to orchestrate a climbing, skiing, or hiking scene.

When possible, I prefer to work with friends who don't mind me running around taking pictures. I have found that an unspoken trust develops after years of working together in unusually dangerous and trying situations. At some point, you reach a plateau in the relationship when you can rely on your partner's choices and abilities. For example, while on the summit of Mount Hood accompanied by my good friend Brean

Duncan, we had a summit moment. This is a time when all is still, no wind blows, no words are spoken, no one else is around and, most of all, our exhausted bodies get a moment to relax after a strenuous ascent. Brean then decided to head out on an icy ridge to catch a view straight down the Pearly Gates. This was his personal adventure in a spectacular environment that was critical for him to fully experience the location. Most people who haven't experienced a mountaintop won't understand why Brean chose to risk it all just to walk out this short distance where one slip could buy him the farm. With the extreme price to pay for any mistake, the slightest deviation from complete focus could cost dearly. It is this total concentration that forces the senses into overdrive. This is when you feel the most, see the most, and are truly not distracted from the situation and location, and it is this connection I strive to capture in my images during any adventure.

Climbing, skiing, surfing, and even hiking have all given me the opportunity to discover my personal thresholds of risk and ability. Moreover, what these activities have done for me has become critical in my photographic development. I have learned the difference between observation and participation. My critical discovery for my work has been found in understanding what, why, and when to capture a still image to best convey the greatest detail and emotion. I am convinced there is no better way to take unique and captivating pictures than to participate in the activity of your subject.

My father was reluctant to climb any mountain covered in ice. As proficient a hiker and scrambler as he is, he never did take to ice. But there are times when unusual things occur while climbing mountains. Such occurrences have shaped my life in many positive ways, including the way I create imagery. It is for this reason that I wanted to share this experience with my father—not only the act of climbing but the locations as well. With a little training and some extra equipment pulled from my closet, he was willing to give it a go. Many years following my first climb up Mount Hood, I was able to bring my father through the Pearly Gates. No pun intended!

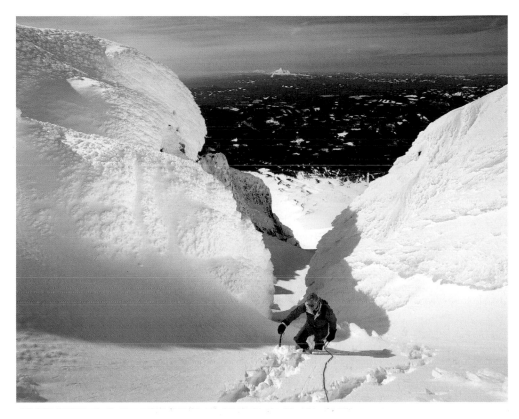

Figure 3-15: David Muench ascending through the "Pearly Gates" near the summit of Mt. Hood, Oregon.

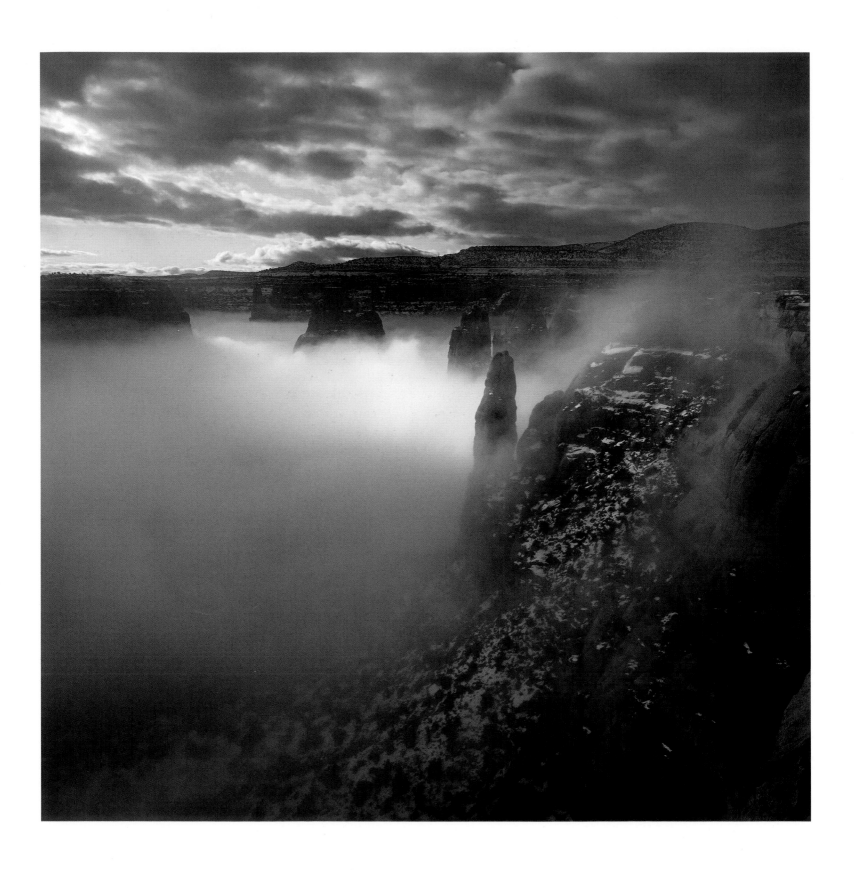

CHAPTER 4
CHASING THE LIGHT

Truly amazing light does not need to be manufactured, but simply caught! When it's good, it can be really good, with rays shooting out from bands of clouds like light sabers and hues of the color wheel that are completely out of any printable gamut reflecting on trees, rocks and mountains, adding additional texture and complexity to an already beautiful scene. In landscape photography, I call unusual moments like this "light shows." I am convinced these light shows occur more often than we think, so the question becomes: are we motivated enough to find them?

My compelling obsession to find great light started the minute I first caught sight of it. Everything else after that seemed dull, until it happened again. Now convinced that this great light experience could happen repeatedly, the chase was on. I must tell you that I make a clear distinction between catching great light and getting lucky. For catching great light, I place a feather in my virtual cap.

If I have done anything in the process of predicting the alignment of a great subject with great light, I have done it because of what I have learned through years of experiencing and observing weather. The Weather Channel has helped but not nearly as much as traveling with my parents, followed by years of my own traveling and photographing. Many people might think that the observation of weather is akin to watching paint dry, so I am a bit embarrassed to admit to having this habit. My experience now leads me to believe it has helped guide me in many situations where others have felt helpless and have given up even attempting to make a decision when everything seemed out of their control.

Why is this important? If you place a person who has reached a threshold of technical skills in the middle of a decent location with great light, he is bound to get a great shot. This is inevitable because he has just enough technical skills and can identify great light. With this in mind, a big percentage of the pursuit of landscape photography is being able to predict when the potential is highest for great light and how best to place yourself smack dab in the middle of it. This can simplify landscape photography down to three very basic ingredients: sufficient technical skills, visiting well-known dramatic locations, and identifying great light. This, however, is what I would call second base. One of the final ingredients beyond the first three mentioned here is *time*. With time, you can pursue your personal story. Like everything in life, it takes time to make something truly exceptional.

□ I am convinced these light shows occur more often than we think, so the question becomes: are we motivated enough to find them?

□ One of the final ingredients is time. With time, you can pursue your personal story. Like everything in life, it takes time to make something truly exceptional.

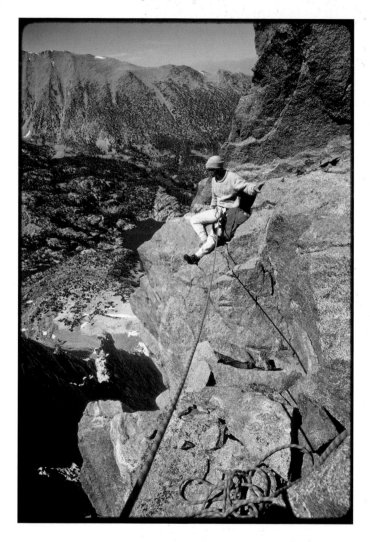

Figure 4-1: Climber, Bill Hurst on Temple Craig in the Sierra Nevada, California.

called "Venusian Blind" on the east face of Temple Craig. The climb is a moderately-rated 5.7 in difficulty but goes on for 12 to 15 pitches, ending up at nearly 13,000 feet after threading needle-like spires on a narrow and lofty ridge. Nothing I learned in high school prepared me for that challenge!

Normally I can associate certain memories with the food I ate during the experience. That particular evening, however, I was so exhausted that I don't remember what I ate, only how good it tasted. Doug suddenly let out a cry that can be understood only by someone familiar with the "call of the wild". We all jumped up and turned toward the sounds of Doug's voice to see what was happening. The sun had set way below the towering peaks to the west and now magical light was bouncing off the high thin clouds, which in turn were reflecting the evening glow down onto the gray Sierra granite, turning everything pink. I spilled my dinner as I ran for my camera. Standing as still as I could on a nearby field of boulders, and wobbling on tired legs, I made my very first picture of alpine glow. The convenient appearance of the moon was a bonus, and yes, I would consider that luck!

Catching the Light

When I was asked to contribute to a book celebrating the dawn of a new century, titled *Daybreak 2000*, I decided the chase was on. With most of the world caught up in computer paranoia, I figured there was no better place to be than up in the air. I chartered a small plane out of Camarillo Airport and planned to fly 20 miles south to Channel Islands National Park. My hope was to capture the sun rising over Anacapa Island. I knew its long thin shape would make for a potentially interesting foreground for the sunrise. Before dawn shown in the sky, I went through all the steps of setting up the plane for my camera gear, including strapping the window up to the bottom of the wing and loading extra film before getting a decent sight of

Getting Lucky

I was way up in the Sierra Nevada with high school friend Bill Hurst on our first multi-day mountain climbing trip together. We were learning from a well-known veteran climber named Doug Robinson, who was guiding/mentoring us. Unlike our classmates who were sitting on a beach in Hawaii, we had just descended from a multi-pitch climb up what is

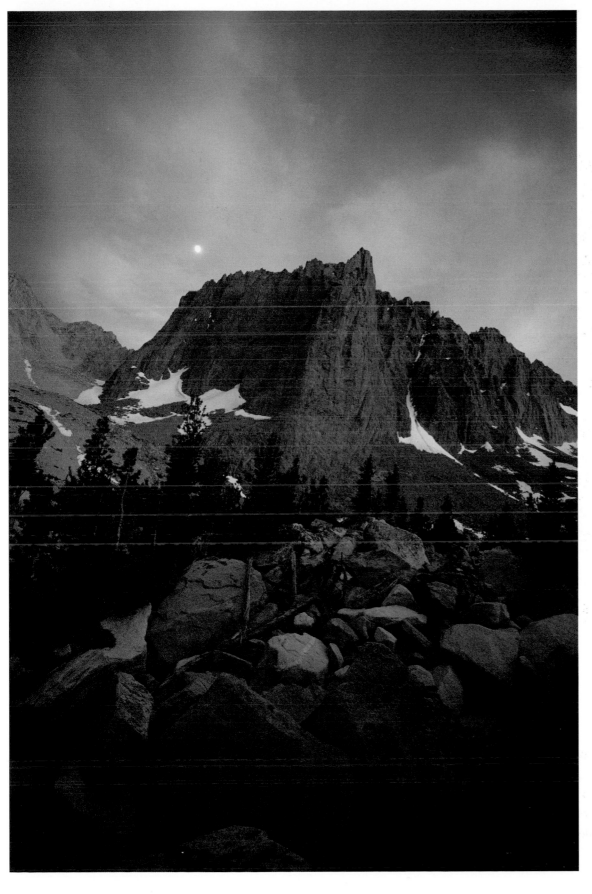

←

Figure 4-2: Temple Craig in alpine glow, Sierra Nevada, California.

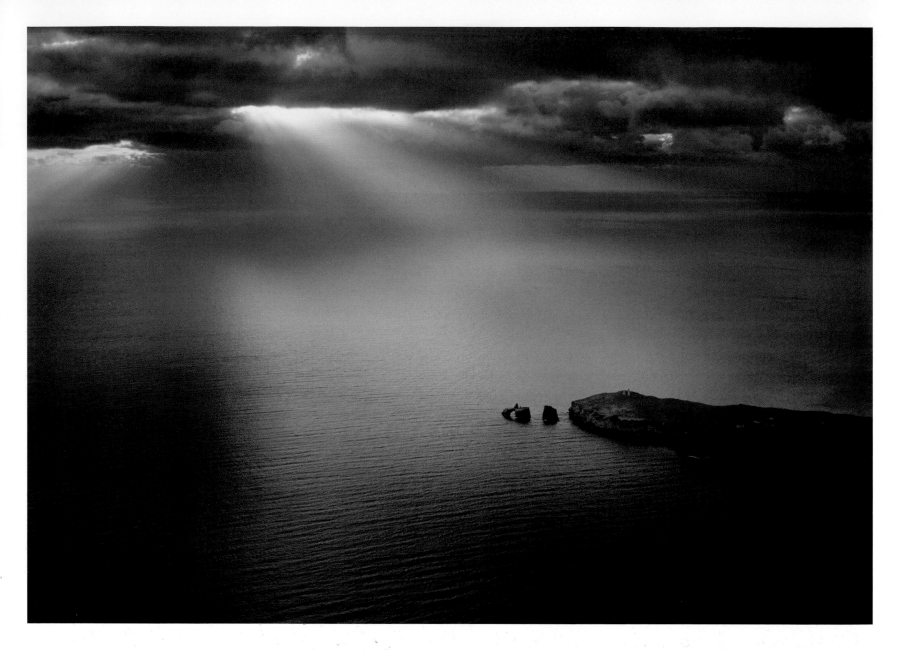

↑

Figure 4-3: East end of Anacapa Island, Channel Islands National Park, California.

the sky. When a touch of light crept through we could see a large marine layer of clouds covering all of the heavens like some computer virus. No problem! The chase was still on, although my spirits were a bit dampened. Nevertheless, we flew straight out over the channel, and by the time we reached the south side of the island the wind direction changed and a few holes in the gloom appeared. The remaining hour was a blur of looping, dipping, and climbing to get the plane into the right position where the island lined up with the sun's rays and where we would not smash into the very slopes I was trying to photograph. This definitely was a chase!

I am quite sure great light occurs all over the planet every day, but no one is there to witness it all. Therefore, the odds are quite good that if you spend enough time in the pursuit of great light, you will be "lucky" again and again.

The two images of this cypress swamp were taken four days apart. Figure 4-4 was taken in the evening on my first visit to the location. Figure 4-5 was taken following a storm when the moisture on the ground was condensing in the cooler air and creating the backlit rays of light. Had it not been for the storm or the extra time I had on assignment to wait through the storm, I wouldn't have witnessed the great light that

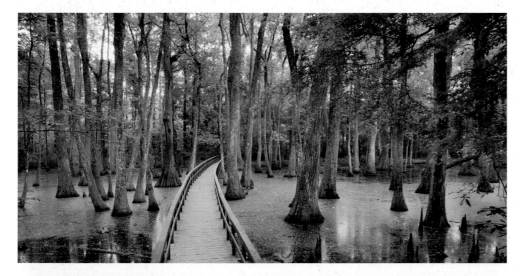

Figure 4-4: Cypress swamp,
Natchez Trace Parkway, Mississippi.

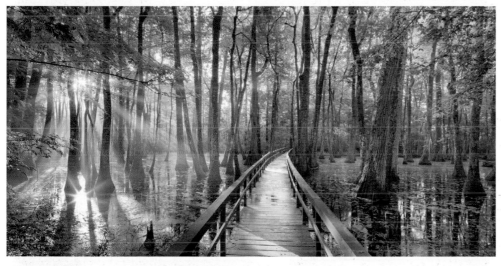

Figure 4-5: Cypress swamp,
Natchez Trace Parkway, Mississippi.

Figure 4-6: It takes time to create
luck.

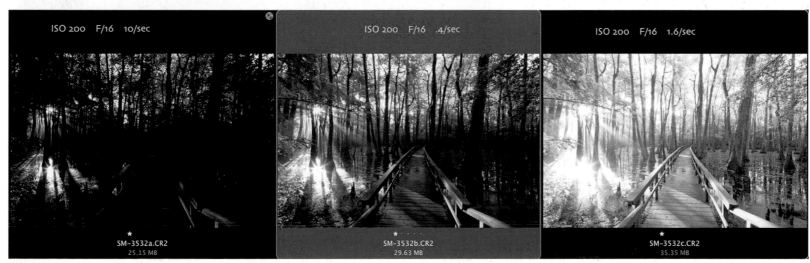

morning. Since I was assigned to photograph a much larger area than the cypress swamp, I had been traveling 100 miles south during the storm, forcing me to make the call late one night to drive back north where, if everything went as hoped, the clouds would blow east, allowing the sun to shine through the trees and allowing condensation to occur. It was a shot in the dark, but possible! Clearing storms, especially in the morning, can create some of the very best light. The light in figure 4-4 was low in contrast and the scene brightness ratio could be captured in one exposure. Figure 4-5, however, contained significantly more contrast and needed to be captured with three bracketed exposures. To process the HDR image, I used a method that I share in Lesson #7 later in this book.

Great light is elusive and storms don't always clear, so in the hopes of feeling slightly more powerful than the local weather person, I have found ways to make good light better through post-processing techniques. Some call this *enhancing,* some call it *Photoshopping,* but I call it *photography!* I learned to enhance my images for two different reasons. First, as a professional photographer, I needed to learn how to capture and print great light, with the humble hopes of doing it justice. Some might call this documentary or reality photography. Second, I needed to learn techniques that allowed me to please my clients, which sometimes meant recreating reality or magically turning good light into great light. The really beneficial part of this was that I also gained knowledge that became imperative for accomplishing my personal work.

It doesn't take long to learn how to add contrast, color, and saturation to images in the effort to recreate something that you once witnessed. There is, however, a visual difference in images created by the person who actually witnessed the great light and was guided by his unique vision, versus someone who has not experienced how that great light affected everything in the scene. If you have only seen great light a few times, chances are your eyes were peering through the viewfinder. This experience is not as indelible in my mind as having

□ There is a visual difference in images created by the person who actually witnessed the great light and was guided by his unique vision, versus someone who has not experienced how that great light affected everything in the scene.

actually watched the phenomenal show of great light as it alters the scene from beginning to end. How do we tell the difference? I believe the end result must be believable. Whether the photographer's reproduction of the great light becomes a facsimile of reality or not is determined by the image's believability. My mission in reproducing great light, or enhancing good light to be better, is to not let my post-processing get in the way of the picture, whether I'm emulating reality or conveying a personal preference. I want my real experience to inspire my post-processing with the goal that it becomes believable and, therefore, untraceable.

With that in mind, I get up early and stay out late in the hopes of capturing as close to the greatest light possible, making my post-processing simpler, not only because the light was naturally there, but more importantly because I gained crucial firsthand experience. This careful observation helps me to study the differences in color in bracketed files of a scene with a large scene brightness ratio. Optimal colors and contrast show up in different areas of the scene within each of the files. If I recognize what areas I liked the most and match closest to what I recall, then I can use that information when I manually blend the files together in post-production. My desire to always photograph in the most dramatic light has become an addiction. As simple as it is now to turn good light into great light through post-processing, I have learned ever so slowly over many years that there is no substitute for the real thing. This has made my chase even more fervent.

Change

I have come to the conclusion that in much of North America, and especially in and around the various mountain ranges, it is rare that the weather remains the same for more than two or three days. By the third day, weather patterns change enough to bring about exciting light. In some cases, rain will persist for

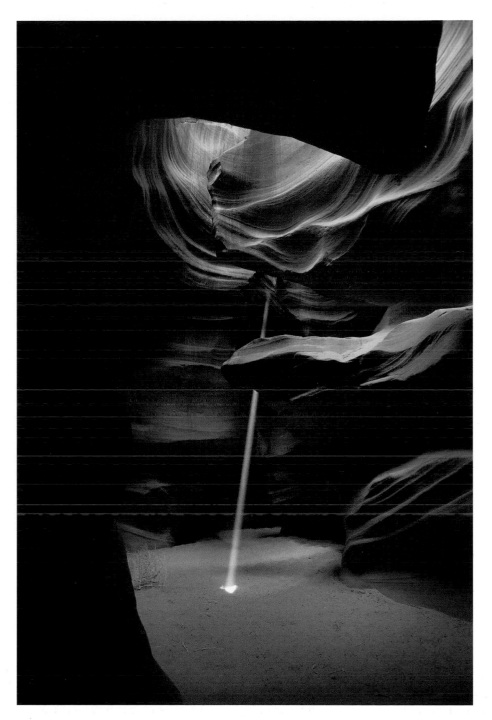

many days, but the chance of a break, as short-lived as it may be, is higher than most think. I have seen storms break for only minutes, giving way to spectacular light that would not have occurred otherwise. There are other significant elements that lead to a great light show. Wet leaves, fresh snow, fog, and rainbows are a few phenomena that require certain weather to exist. These weather-driven conditions become a significant factor in determining the potential of what type of landscape image you are looking for.

Of all the photographic locations in the Southwest requiring particular weather conditions, the most popular has become Antelope Canyon. The first time I visited, the road was narrow and unpaved. My dad was looking for a slot canyon he had read about in a guidebook. The narrow canyon is like a scene out of the movie *Raiders of the Lost Ark*. The sand falling on your head as you walk in the dark reminds you of the scene when spiders cover Harrison Ford's back in the dark cave. (Are there spiders in some of that sand?) In spite of this, the location has become one of the most famous icons of western landscape photography. It is now called Upper and Lower Antelope Canyon. The best time to visit the canyon is in the spring or fall, when the skies are clear and the wind is blowing. Because the best shots require the sun to bounce down into the canyon from directly overhead, the middle of the day is preferred. Chances are good there won't be large thunderstorms and the wind will blow during the spring or fall, making it both safe to enter the narrow canyon and providing the best odds of seeing the falling sand reflect the sun's rays. Today there is a large parking lot and the only way to enter the upper canyon is with a tour operator. And when the sand doesn't blow into the canyon to create the beautiful rays of light, guides will simply toss up a handful when all the photographers are ready.

Do you have the luxury of time? Although I should in this profession, I find the issue for me is more about patience than time. So, the question becomes this: do you have the patience to give yourself time? I have stated that the subject is the picture and the light makes it. As true as I believe this is, when it comes to landscapes and unpredictable, uncontrollable light, what really helps is to discover variations on a concept or subject. If the light is poor and appears as though it won't change soon enough, then a different approach may be in order.

Figure 4-7: Upper Antelope Canyon, Arizona.

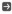

Figure 4-8: Bison, Theodore Roosevelt National Park, North Dakota.

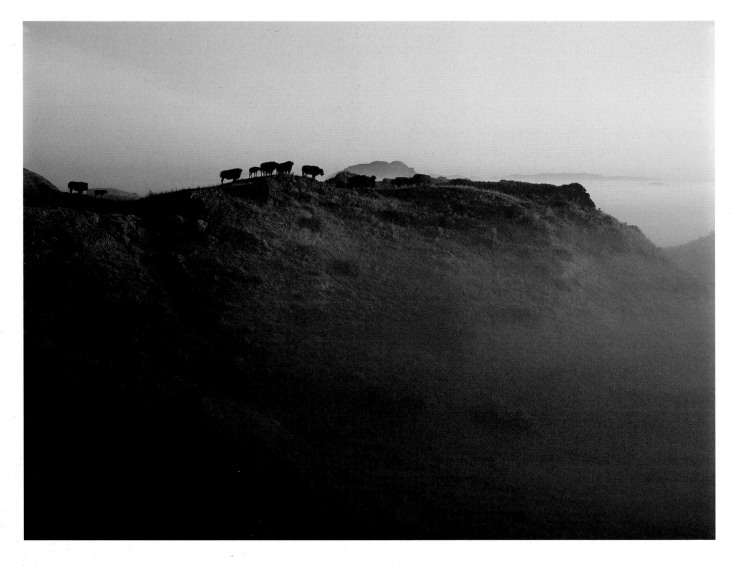

I was trying to illustrate the vast wide-open spaces in North Dakota for its department of tourism that was marketing the "Wild Wild West" as a theme to Norwegian visitors who still believed they could be cowboys. Blue skies were preferred and what was a slight change of pace on this shoot was that at first the art director instructed me to shoot during the middle of the day only. They thought the bright days and blue sky would make the concept better. What they forgot was just how dramatic the early and late light could be. In addition to shooting at midday, I woke up early and stayed out late as I worked to capture that special light. Two additional images they ended up using were from an early morning session. one was where bison literally stormed up a hill adjacent to where I was shooting a landscape and placed themselves on the crest, as if being paid by the state to model for me. The other image was taken just after the sun dropped below the horizon and everyone was packing up from the shoot. I learned that not only is patience with the light a virtue, but patience with your clients is especially advantageous.

Speaking of patience and having learned to be patient with my clients, I have also appreciated my clients who have shown great patience with me. While shooting a campaign for Copper Mountain ski area in Colorado, I spent five days waiting for five minutes of sun to appear. We ended up capturing very unusual brilliant moments of skiing euphoria at the expense of a very nervous client.

The owners of the mountain wanted to have images of their undeveloped terrain taken in sunny "bluebird" conditions. It was March by the time I was hired and there was little time left in the season. I was reluctant at the time, knowing April normally brings spring conditions and, while there may be bluebird conditions, the snow would be hard and possibly icy. However, several local ski patrolmen I spoke with talked about the occasional big April snow. They had seen it snow up to two feet of fresh powder late in the season and the best part was that there were few people around to enjoy it. It just so happened in April the jet stream dropped and two feet of snow began falling the day we arrived and continued right on through the entire week until the day after our shoot was over. During one stressful meeting to decide if we should call off the shoot, I mentioned how incredible it was that we had good snow and that we should take a risk to capture something unusual. Understanding the money they were spending, I did offer to return at another time for half my normal reshoot fee if we were ultimately unsuccessful.

Now, with my profits on the line, I began watching The Weather Channel like a hawk. The problem with predicting weather in such a specific location with very specific dynamics is that there is no way to simultaneously predict certain photographic conditions, such as 30 seconds of sun striking the eastern slope of one mountain following a snow squall in the late afternoon. The only way to do this is by sitting it out with patience and good ski boots. Years prior, while working at Alta Ski Resort in Utah I became friends with ski instructor Dave Crans. Among other things, Dave taught me to spend good money on high quality ski boots. I have thanked him over and over every year since while standing around in the cold, deep snow waiting for light.

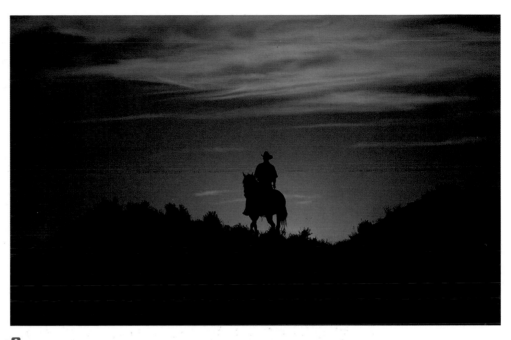

Figure 4-9: Horseback rider near Medora, North Dakota.

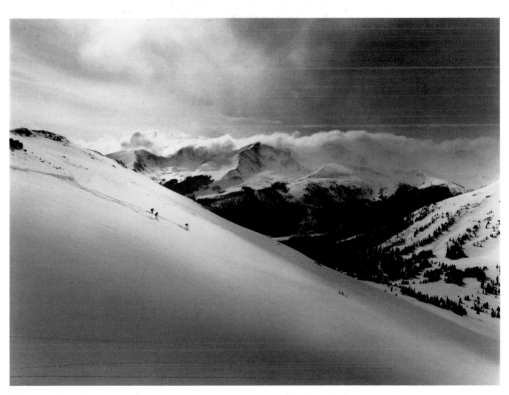

Figure 4-10: Skiers descending back bowl at Copper Mountain ski area, Colorado.

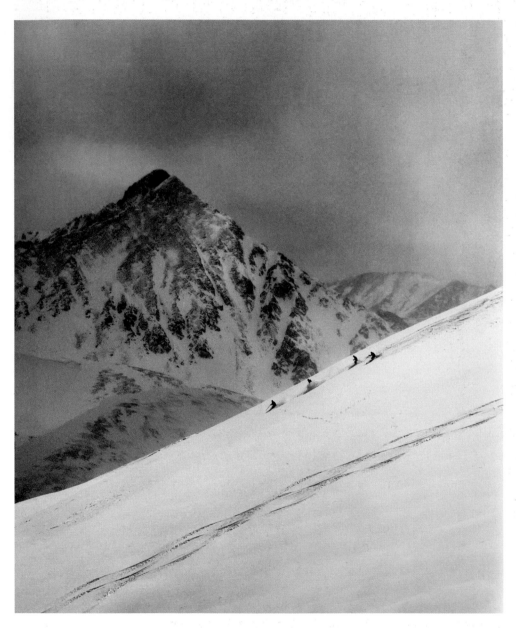

Figure 4-11: Skiers descending back bowl at Copper Mountain ski area, Colorado.

Chasing the Light

Lightning was cracking off in the distance, wind was pushing my truck close to the tractor trailer next to me, Pink Floyd was playing on the stereo, and I was driving home from a week-long shoot in Colorado. I had been photographing for a Graphic Arts Center coffee table book on the state of Colorado, up in the Elk Range between Aspen and Crested Butte. I had my usual third cup of strong coffee to help pass the time.

My favorite story of chasing the light occurred on that afternoon. The big storm that was miles away was now dropping nickel-sized hail on my windshield. Then it finally dawned on me, as if one of the ice balls knocked me in the side of the head and jogged my geographical memory. Since I was driving west on Interstate 70 toward Grand Junction, Colorado and the storms were moving east, if I could head south toward the Sneffels Range and potentially put myself in a photographic spot at about the time the storm passed, I might be able to photograph the sunset. It was definitely a stretch, but after all, what's the worst that could happen? I guess hail could crush my windshield and turn my coffee cold! The Sneffels Range is one of the most ideal locations in the world. Fourteen-thousand-foot snow-capped mountains tower over rolling aspen-covered hills, speckled with stands of Colorado blue spruce and other pines splintered by streams filled with giggling trout. Farmers and a few very fortunate homeowners now own most of this country. Full of envy but thrilled to be visiting, I began my chase to the light show. Of course, I knew it might not even occur, but with nothing but potentially cold coffee and a bit of extra gas to lose, it was worth the adrenaline rush. By the time I reached Ridgecrest, there was a bit of a glow emerging on the horizon just below the clearing storm. I knew if I could just get through the last of the many long and frustrating stoplights, I might just get there in time to see it happen! The drive up from Ridgecrest to one of the most photographed locations in the west is only several miles, but when the sun began to

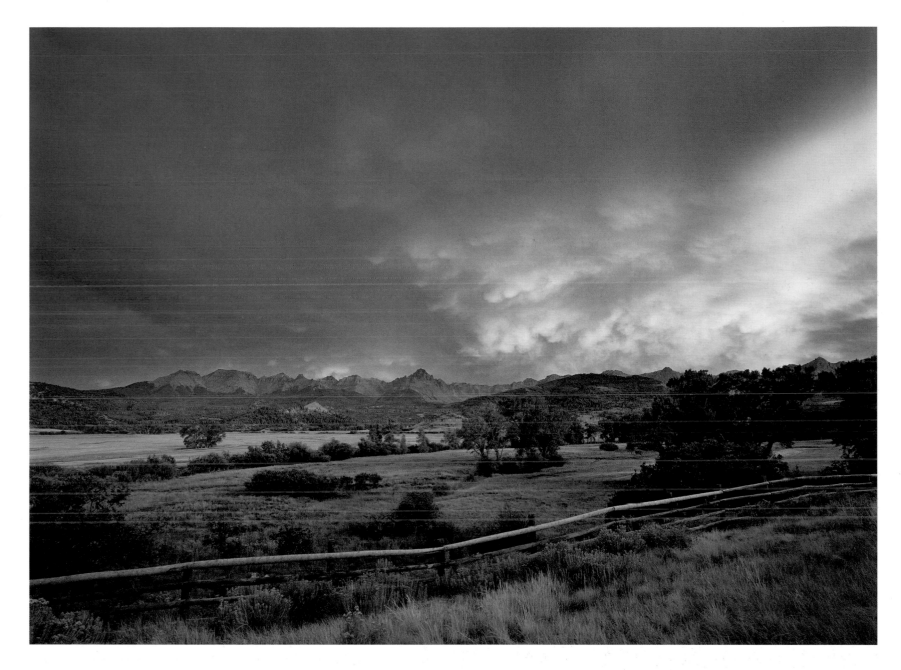

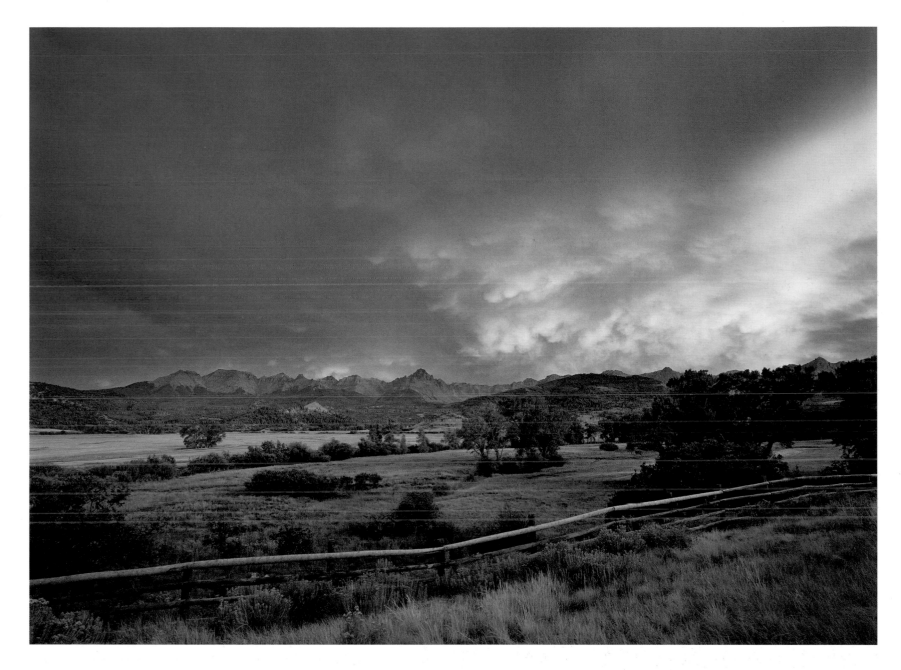
Figure 4-12: Sneffels Range, Colorado.

break and strike the high peaks, those few miles seemed to last longer than the motion picture *Gandhi*! By the time I arrived on the side of the road, I had already fumbled my camera case into position right behind the driver's seat so I could instantly grab my camera. The time suddenly slowed down. These moments become a blur in hindsight and I really don't recall running across the highway to set up the tripod. This was an example of a time of intense concentration when nothing else

in the world was on my mind. As the light left the mountains, it began striking the clouds above, reflecting the evening's colored glow back down onto the farmlands scattered with large cottonwood trees. The sound of the shutter is so sweet at those moments!

If I had only taken a lighter bracketed exposure for the shadows, I could have manually blended the two images together in Photoshop using the method in Lesson #7. As it is, I

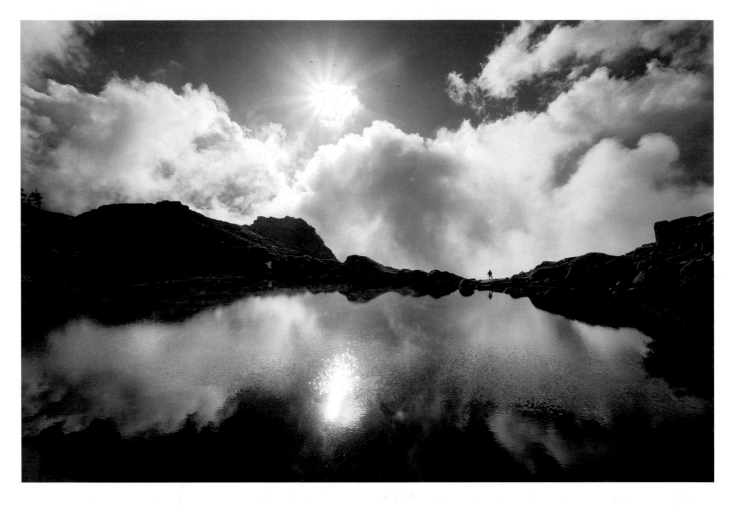

Figure 4-13: Hiker on unnamed lake near The Tablelands, Sierra Nevada, California.

used a series of quick masks to lighten up the farmlands below the mountains and darken the stormy sky above: a method that I share in Lesson #5.

Equipment used:

- Suburban truck and three cups of coffee
- Large dynamic rainstorm
- Contax 6×4.5 medium format film camera
- 35mm wide angle Schneider lens
- Slick tripod
- Fuji Velvia film ISO 100
- Polarizing filter

Shooting Directly into the Sun

Sometimes I turn about face and catch the light by surprise!

Shooting directly into the sun is one of the first rules they teach you not to do in Photo 101, so this was one of the first rules I broke. For most of my career I have been buying lenses that could create great stars and flare the least in order to satisfy this obsession. There are two reasons I love to shoot into the sun. First, the sun star represents several very important aspects of my life: energy, warmth, and light. The second and more practical reason I often shoot directly into the sun is to satisfy my fascination with the effects of back lighting. For starters, silhouettes of subjects can offer much intrigue. As you look a little further away from the direct line between the sun and lens, the light edges many partially transparent subjects and forms dynamic rim lighting. Then, as if that were

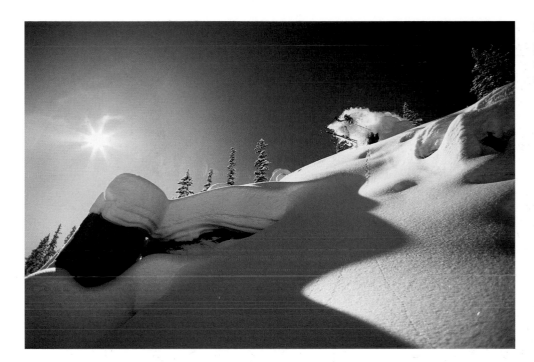

Figure 4-14: Skier in Rock Island area of Snowmass ski area, Colorado.

not enough to yank my camera into the solar vacuum, there are often interesting shadows that can be used as compositional elements.

The reason for the rule in the first place is the scene-to-brightness ratio has always been too high for film or sensor to handle. The other reason is that most lenses flare terribly. To suit my purposes, I require certain circumstances with particular equipment and camera settings. First and foremost, the correct lens must be on the camera: the wider angle the better. Not all wide-angle lenses are created equal, so some testing is required to choose the lens for the desired star effect. Nowadays there is a greater variety of stars due to the plethora of wide-angle lenses available, both fixed focal length and zooms. The new Nikon lenses give so many rays I have not yet found the time to count them all! I have made many good stars with lenses from all formats of cameras, but since going digital I prefer the following lenses:

- Canon 17–40mm zoom
- Canon 17mm TSE
- Canon 24mm TSE
- Canon 24mm 1.4
- Nikor 16mm fisheye

Here are the criteria I have found work best when shooting into the sun:

- The smaller the aperture, the larger the rays. I recommend F16 or greater.
- Take all filters off the front of the lens, as they create additional flares.
- Angle your composition to avoid most flares, especially with zoom lenses.
- The fewer the elements in a lens, the fewer the flares. I recommend a fixed focal length for this reason.
- Partially obscuring the sun behind an object can reduce flares.

I take pictures directly into the sun for various reasons. On occasion, I simply want the sun star to fill a cloudless sky. But the main reason for my obsession of shooting into the sun is for the incredible rim light. I also like to use the shadows cast by certain subjects as a graphical element. I began shooting directly into the sun while photographing skiing. Combining the sun with the shadows and backlighting made for greater dynamic light in what was usually the middle of the day. Much of the time I was in a very bright environment where light was

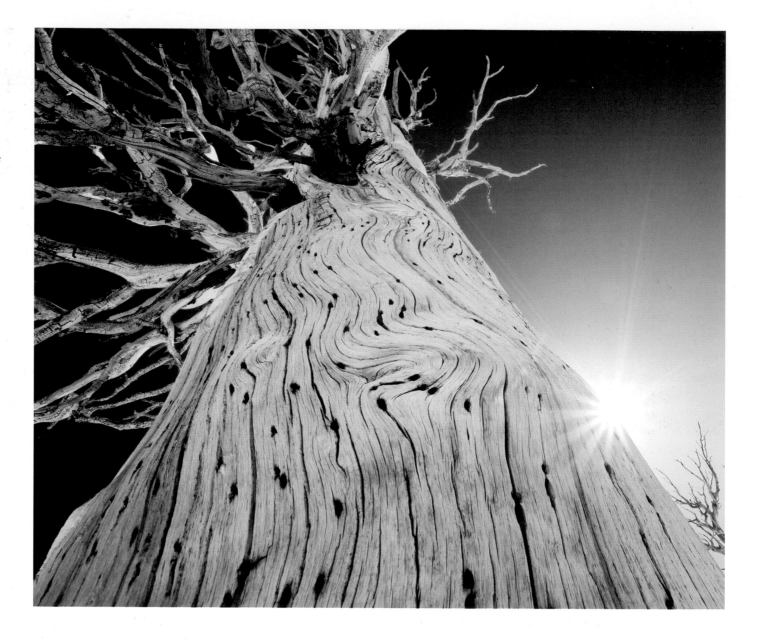

Figure 4-15: Foxtail pine tree, Sierra Nevada, California.

bouncing all around. In these snow scenes, I was less concerned about the large scene-to-brightness ratio because of the amount of bright light everywhere.

Sun stars have improved over the years thanks to better lens design. Wherever light passes through glass, there will be flares. I have learned that by partially blocking the sun, flares can be reduced. I often use this method in my landscapes. However, I must warn you that it is easy to cause permanent damage to your vision while peering through the viewfinder and watching the sun to click the button just when it is partially blocked. I recommend composing these scenes through the camera display while using live view. Many cameras today offer live view for shooting video but, as in this scenario, can be quite helpful for shooting stills.

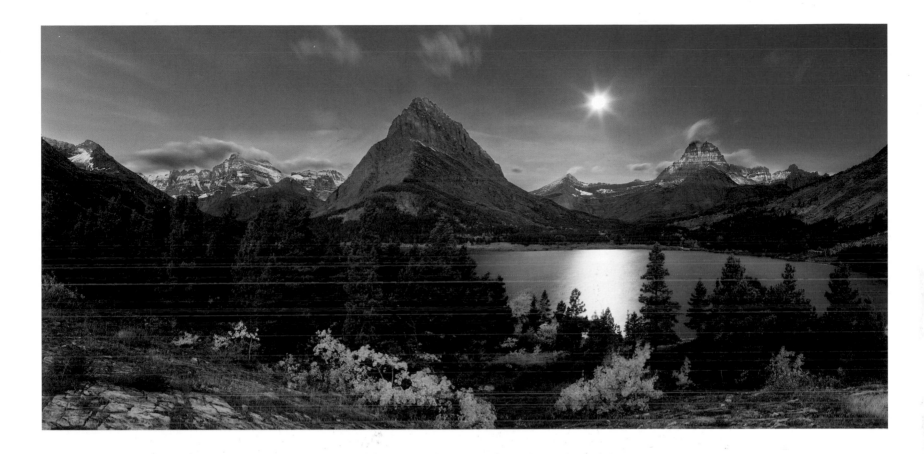

Revealing the Light

Consider a single candle in an otherwise dark room. The scene is instantly more dramatic than the same room fully lit with flourscent tubes. Directional light, which occurs during the early and late time of day, can also be concentrated. This is similar to using a snoot over a studio light when a photographer wants to light up only one particular region of the scene. Since I have not yet found a snoot large enough to use on the sun, I must settle on the whim of cloud formations. As unpredictable as they are, there are moments when clouds perform quite well. One example of revealing light is when the light pokes through clouds in just the right place spotlighting the subject, as if the director had shouted through the bullhorn when and where to shine the spotlight.

The amount of surrounding or supporting light you leave in the scene depends on how much other information you want the viewer to see. If you leave detail in the shadows, it would be similar to lighting up different areas of the room, making the single candle lose its unique qualities. Therefore, everything with light on it in an image should be considered important to the image. The lit areas can reveal information or simply complete a form. And shadow areas can be used to push the viewer's eyes to the lit areas while simultaneously creating dynamic forms.

The Waterpocket Fold in Capitol Reef National Park is a geological landform called a monocline. It is shaped by the earth rising and water eroding. The water's erosive effect is quite visible on the porous sandstone, giving the place its name, but nowhere quite as well defined as the pool in figure 4-18. This pool is about ten feet in diameter and lies in one of the more remote sections of the park. After stumbling around looking for arches, I took off up a very steep section of the incline and found myself peering down on a small but very interesting pool. As I approached, the pool became even more intriguing, to the point where I was attaching my tripod to my pack so I

Figure 4-16: Full moon over Swiftcurrent Lake, Glacier National Park, Montana. A star will form around any direct light source, including the full moon!

could use both hands to carefully climb down into the small canyon.

When I finally reached the pool, it was as if I had landed in an already composed picture. The exclusion of the light from just about everything but the distant cliff focused my eyes on the image immediately. I have never discovered the composition of an image so instantly. Like my hand was being held, I looked down to a small flat platform where I could rest my 4×5 camera so it was just at the water's edge. This allowed me to capture a perfect reflection. As if that were not perfect enough, the flat section of stone happened to be in the very opposite shore as the drainage. The sandstone framing the distant cliff was symmetrical as well. I remember making several exposures really quickly as if somehow the entire scene was going to disappear before I could take a picture of it. I finally settled down and began watching the light change. As the sun dropped lower and lower over the course of the afternoon, the light became more selective. As the shadows grew, so did their form. As the sunlight disappeared, it revealed the symmetry of the sculpted canyon surrounding the pool.

Whether you are catching, revealing, or chasing the light, it is a wonderful journey every photographer must take. Discovering the light that reveals what you want to say becomes one of many personal artistic tools available to all who embark on this journey. Captivating the viewer's eyes is what dynamic light can accomplish. It is not until we have seen what this light can do that we understand what is possible. The more you look the more light will happen!

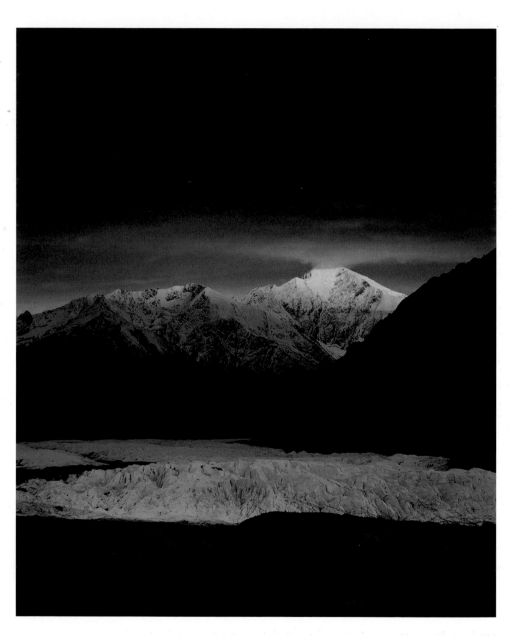

Figure 4-17: Last light on Chugach Range, Alaska.

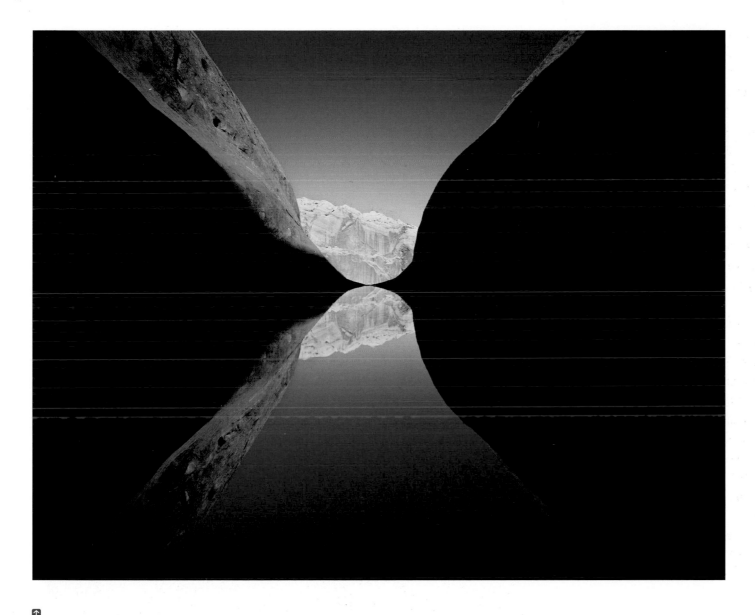

Figure 4-18: Reflecting pool, Waterpocket Fold, Capitol Reef National Park, Utah.

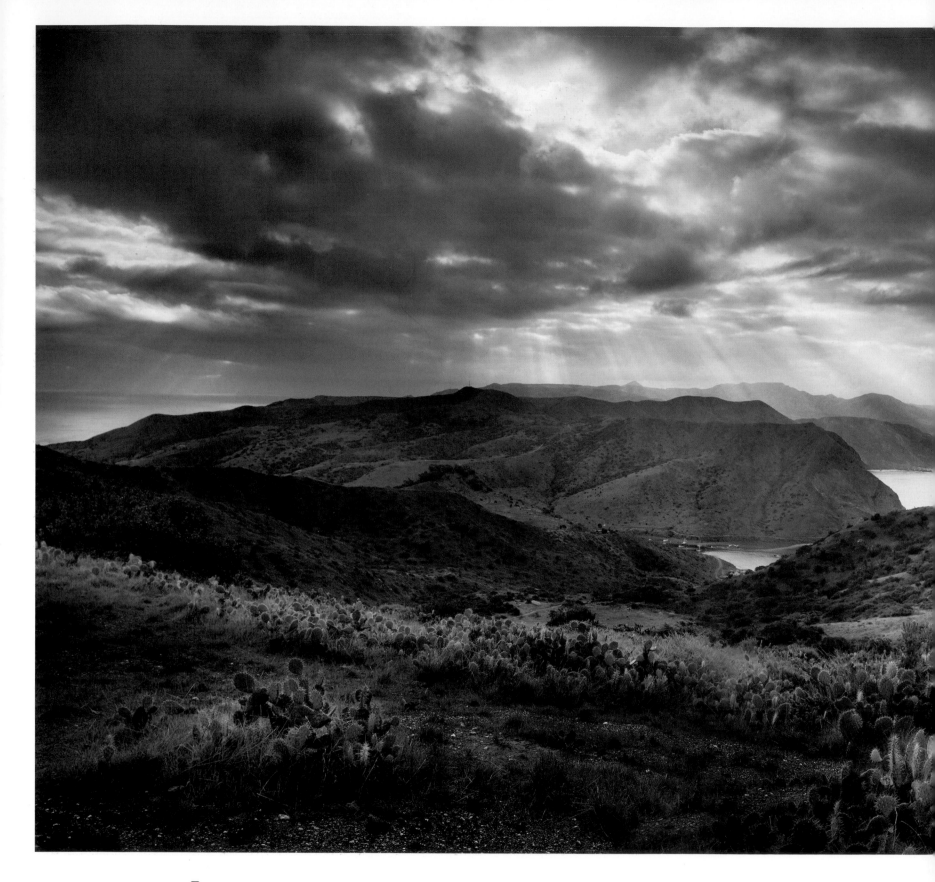

Figure 4-19: The Isthmus, Catalina Island, California.

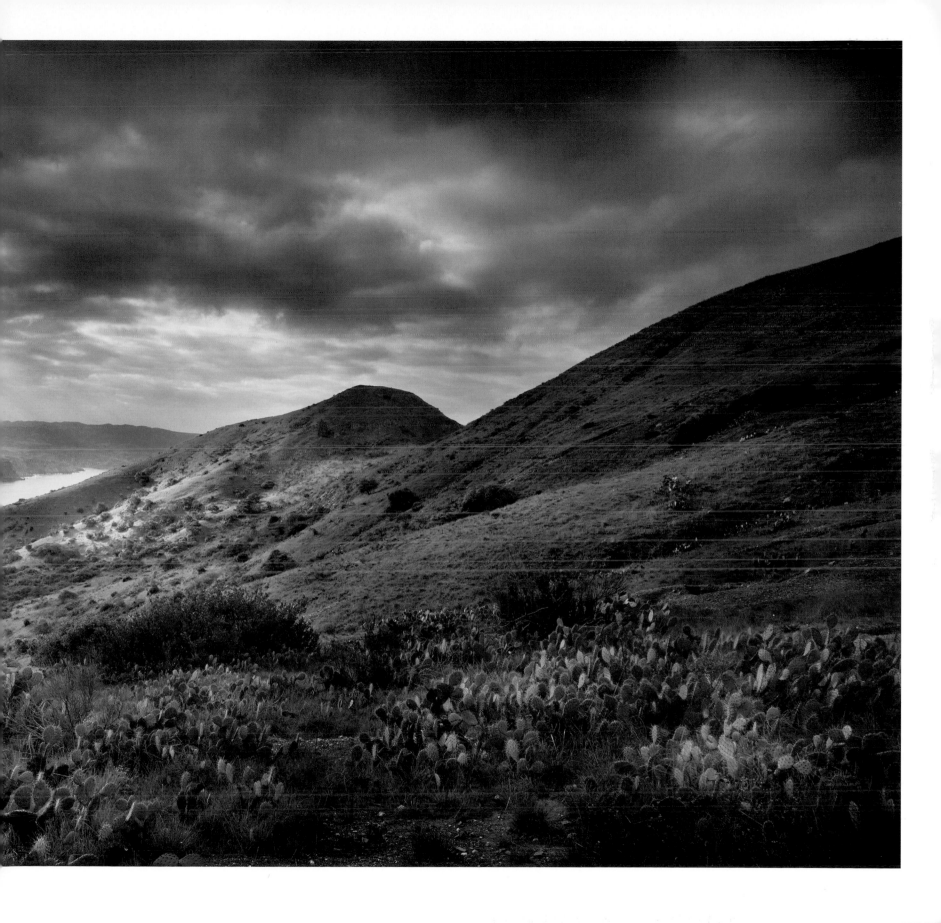

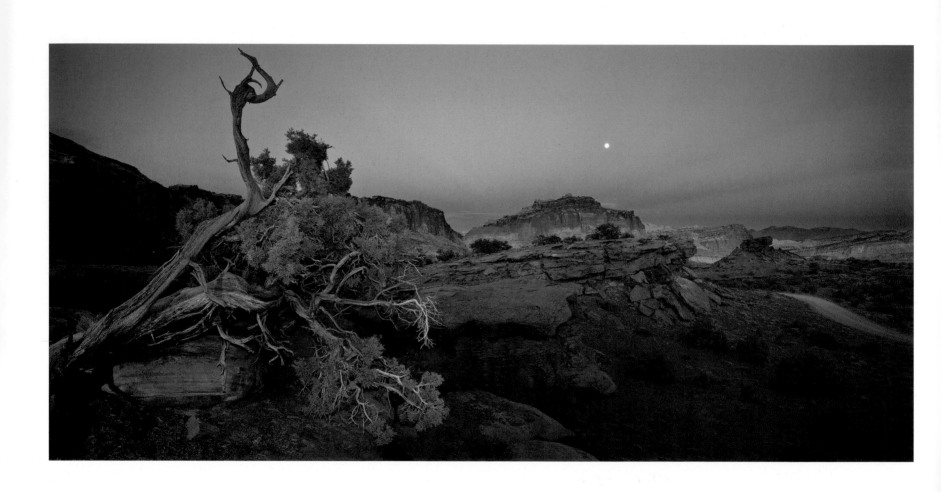

CHAPTER 5
EVOLVING METHODS

This part of the book is an exploration into the ways I have been blending the creative and technical aspects of photography. Like a perpetual river flowing to the sea that changes velocity, volume, and occasionally direction, so do these methods. I carry them with me everywhere I go, keeping them just within reach, ready to be yanked out of my virtual tool belt at a moment's notice. I am pleased with where my intrigue has lead me, and hope I never become complacent in the search. Not leaving room for improvement, no matter how much I have invested in something, would be like the ostrich pulling his head out of the hole to only glance in one direction. This chapter is about looking in all directions. In this chapter, the post-processing of images is not illustrated step by step because it is not the focus. The only exception is the explanation of the rough steps for manually stitching image tiles. I have not used any secret post-processing, however. Therefore all postprocessing done on these images is explained throughout the Lessons later in the book. These evolving methods are only intended to make you aware of some of the potential everyone has while exploring the country with a digital camera and their personal postprocessing visions.

I am continually exploring the following topics and will introduce to you as we move through this chapter:

◉ Panoramic Imagery
◉ Tilt / Shift Lenses
◉ Still Time Lapses
◉ Shooting Into the Sun

▫ **Like a perpetual river flowing to the sea that changes velocity, volume, and occasionally, direction, so do these methods.**

Panoramic Imagery

The old adage, "If it ain't broke don't fix it," applies only to great coffee, bones, and toilets. On the other hand, when it comes to photography, I often try to break the rules as I attempt to discover potential issues, boundaries, and most importantly, new territory. I mentioned earlier that I have divided my study of photography into two categories: technical and creative. However, the trick is to apply what I

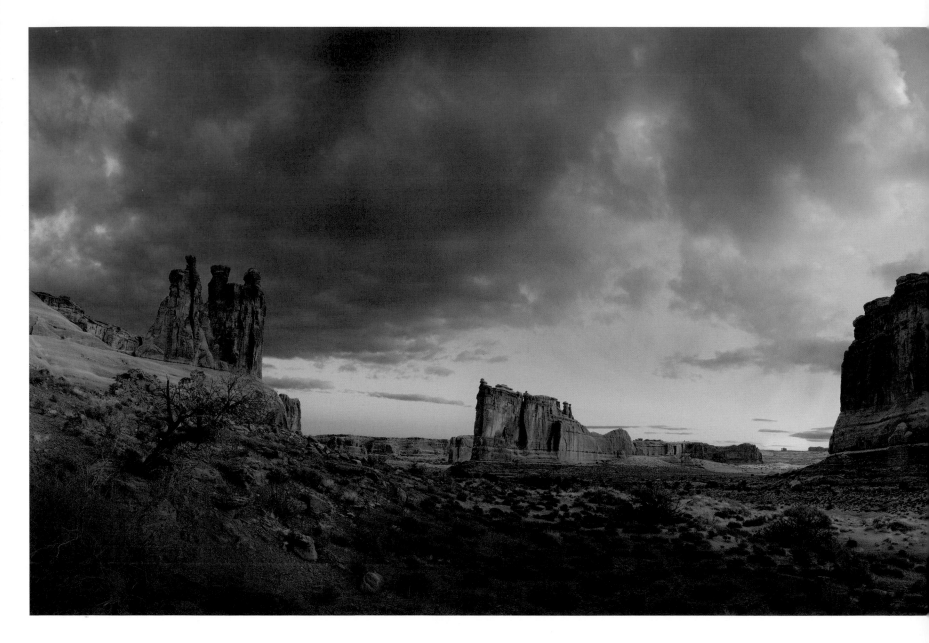

Figure 5-1: The Three Gossips, Park Avenue, Arches National Park, Utah.

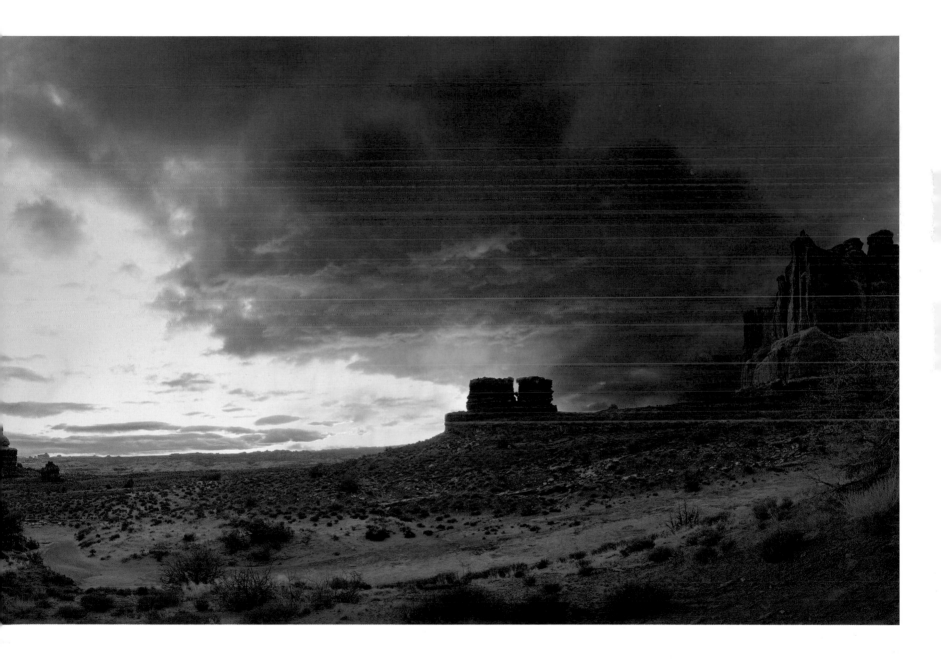

have learned in both realms when working with a single image or a series of images that have a unified style, message, or purpose. Additionally, as a professional photographer, I must keep my mind on what is working in the publishing business to make the money that will pay the bills. Ultimately, the reason I began this career in the first place is to use my creative mind and to explore new territory (both literally and figuratively). I wish to do exactly that for all my remaining days.

In consideration of all the aspects of photography to explore, I will begin with the most basic, its foundation—the shape of the image. The ideal aspect ratio of an image is, and always will be, up for debate. The commercial market for landscape images has traditionally been governed by a demand for the standards, such as 35mm, which is 3:2, and 4×5, which is amazingly 4:5. The 3:2 aspect ratio can be traced back to Oskar Barnack, development manager at Leica in the early 1900s. Oskar was originally inspired to reduce the size of the negative, and therefore eliminate the bulky cameras that were required to expose the large plates. Later, when working for Leica, he was given the chance to reinvent the wheel, or camera if you will. Given the potential to revolutionize photography with a small hand-held camera, he was compelled to carefully select a new aspect ratio. Some feel he chose the 3:2 aspect ratio because it was much closer to the Golden Rectangle than any other format.[1] Basically the golden rectangle is believed to be one of the most visually pleasing geometric forms and therefore a good choice when considering a new aspect ratio for a new camera. That was almost 100 years ago!

I figured it's time to break some rules. Well, I am not the first one, nor by any means the only one considering new aspect ratios, although I have been compelled to mix things

> **There must be a better reason for the pano than how swell it fits above the couch.**

up a bit when it comes to standards and so-called panoramic photography. I have been attracted to panoramic images ever since I held two pieces of paper over one of my father's 4×5 chromes on a light table. I didn't tell him how much better it looked cropped to a pano, but I did find it quite intriguing to apply to some images. Could my intrigue have simply been due to the fact that the view was different? The dilemma continues to live on, and I have been compelled to discover reasons that justify the panoramic aspect ratio. I knew there must be a better reason for the pano than how swell a print fits above the couch.

I have also discovered that simply making panos just for the fun of turning many images into one, gets old quickly. What intrigues me the most about the pano aspect ratio is the viewers' path of discovery. Like normal 4:5 or 2:3 ratios, which carry a viewer's interest in order of subject and light, the pano offers its own type of journey, forcing the viewer's eye to travel through the scene more slowly, and is therefore closer to the experience of viewing the scene in reality. Large prints with crisp detail better facilitate this viewing experience. Implementing the principles of panoramic photography, including making the required extra equipment efficient, can be challenging. In order to accomplish my intentions, I sought out locations with a lot of intriguing detail in a dynamic landscape that was larger than the general field of view. I wanted to use a lens that offered great depth of field, sharp detail, and most importantly, the ability to shift. I decided to choose the Canon prime, 24mm Tilt/Shift lens.

Many cameras offer panoramic options within the operating features, but these simply crop into the full frame, eliminating resolution rather than increasing it. Sony just released a point-and-shoot camera that allows you to hold down the shutter while you twirl about. This camera takes all the image files in some kind of movie mode that shoots enough frames per second to accurately stitch a pano together. The other option is to take as many images as possible, depressing the

1 The Golden Rectangle is defined as a rectangle that can be divided into a square and a smaller rectangle which has the same aspect ratio of the original rectangle. The ratio of the longer side of each rectangle to the shorter side is known as the Golden Ratio. Mathematically, this works out to the 3:2 aspect ratio of 35mm film.

shutter yourself, and then stitch them together using postprocessing software. This has become the most popular method but in many cases changes much of the detail based on the auto-stitching capabilities of the software.

However, it is still fun and simple to hand-hold a camera and shoot multiple images while panning the scene in front of you. If all the subject matter is more than 20 or 30 feet from you, most everything lines up nicely between all the image files, if the shots overlap enough. The problem with having the subject closer to the lens is that it actually changes dimensions as it is recorded from one side of the lens to the other. The issue with stitching images together comes down to scale. If something in the corner of your lens appears larger in one exposure than in the next, the auto stitching program will make the decision for you as to just how large that object will be in the final pano. Because I believe certain elements in my images actually make a difference compositionally, I want to control the sizes and placement myself. This means I have to take more care in the shooting and later stitching of the pano. To capture the scene in the most accurate way, I spin the camera around what is called the lens nodal point. (The equipment and procedure are explained in the following text.) Then to control the stitching, I manually stitch the image files together, allowing me to choose my preferred size for all the subjects.

Because there is no way to create a pano or stitch in the camera, there is no preview available to check composition. When I am working with panos or even stitches I am visualizing what the elements will become once assembled. There are a few tricks to help if you are new to this. First, I would like to recommend some technical strategies that have worked for me, such as camera settings and special equipment used.

Common camera setting for both panos and two-image stitches are as follows:
- Manual metering mode
- Manual focus

Figure 5-2: My setup for taking panoramic images.

- Auto white balance
- Live view, if your camera has it
- Lowest possible ISO for noiseless detail

Preferred equipment for shooting panoramic images:
- Really Right Stuff, Pano Elements Package
- Really Right Stuff, BH-45 or BH-55 ball head
- Really Right Stuff, L-Bracket, specific for each camera
- Tripod
- Tilt shift lens

As I state, these are preferred settings but are not required!

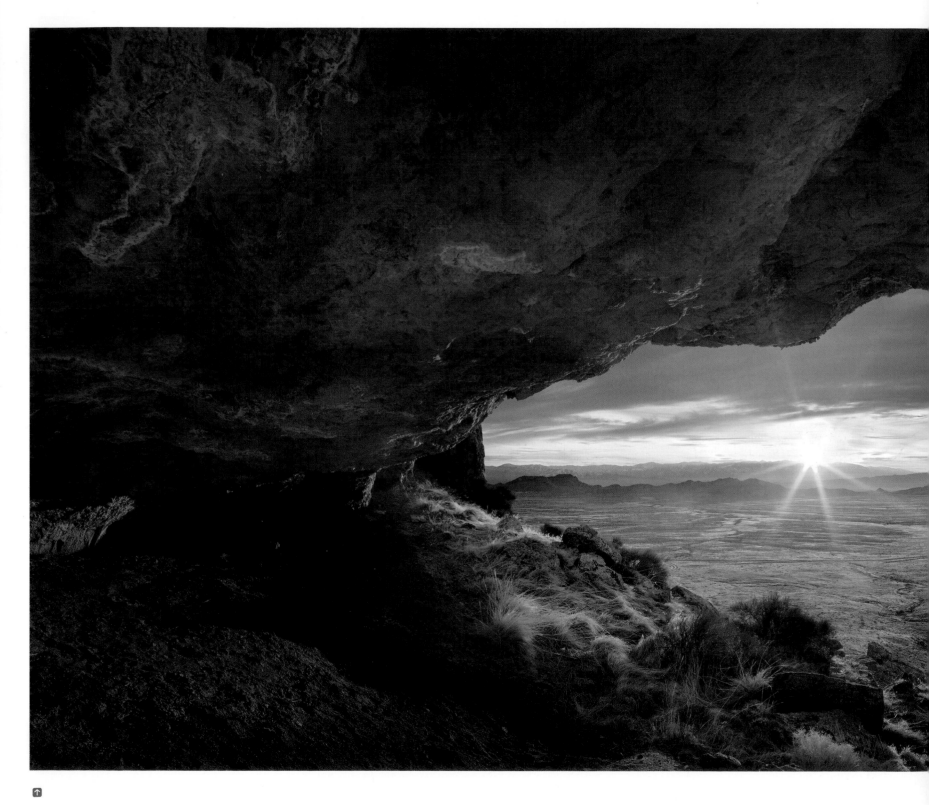

Figure 5-3: Limestone cave, Great Basin National Park, Nevada.

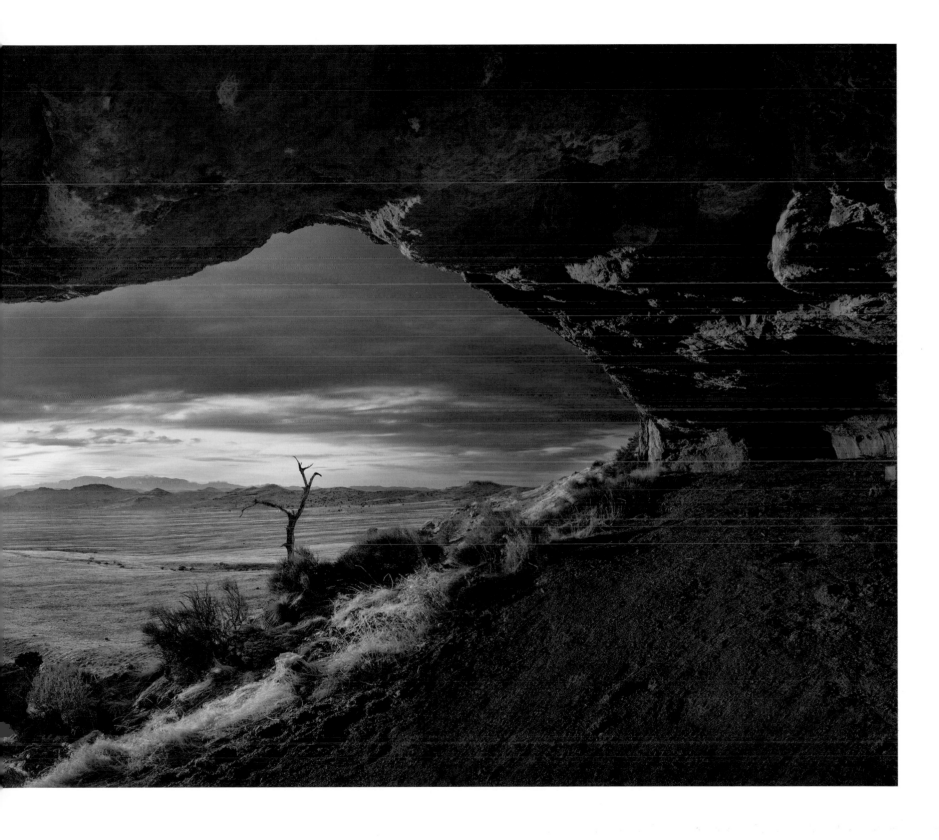

Seven-Stitch Pano in the Desert

If anyone watched me find the composition in this cave (figure 5-3) it would have looked as though I had lost my wallet. I walked and crawled around the location until several of the main elements lined up. I wanted the horizon to be lower than the corners of the cave. Only after I found the elevation I needed could I consider the next element. The dead tree could not be in the center of the composition, nor could the sun. I could not get too close to either edge of the cave or it would appear significantly larger than the opposite side. I ended up just left of center about two thirds of the way into the cave. Once my pacing was over and I felt pleased with my position, I marked the dirt with a large "X". After retrieving my camera gear from the edge of the cave I set everything up.

I mounted the camera in portrait position. With my left hand on the ball head and my right on the camera, I leveled the camera by using the bubble on the nodal slide. Once leveled, I tightened down the ball head and loosened the panning clamp. This allows the camera to rotate independently of the ball head to keep everything level while pivoting. I swung the camera around while viewing through the viewfinder with the intention of getting a visual on what was included in the composition. Once I realized there was too much dirt in the foreground, I knew that a shift was critical to include more of the beautiful ceiling of the cave and exclude the trampled dirt below, so I shifted the 24mm lens up. This capability is what makes this lens so very valuable when shooting panos. With no way to change the composition without moving off of level, all panos made without a tilt/shift lens must be taken with the horizon dead center. I made about three practice shots to calculate the very best exposure and determine where to start and end the pano. Because I didn't take multiple bracketed exposures for this scene back in those days, I needed to adjust everything to the sun's rays as they would become critical in the final image. When calculating an exposure for any pano, whether I use HDR techniques or not, it is best to treat the entire scene as one exposure. In this case, I made my exposure based on the frame including the sun (3rd from the right in figure 5-4).

Making the exposure directly into the sun takes a bit of practice, however. I discuss this in "Lesson #1: Making the Exposure." Because the brightest point in the sun will never be contained entirely in a single exposure along with the deep shadows of anything, let alone the inside of a silhouette cave, I was forced to leave the very center of the sun overexposed. What I was more anxious about were the rays just surrounding the sun itself. In this case, the exposure was F.16 at 1/25 sec, ISO 100. I used F-16, which on a 24mm lens creates a very large depth of field and created the desired effect on the sun's rays at the same time. I didn't use any filters because I was shooting directly into the sun.

Regarding light, there was a slim chance the sun would break below the layer of clouds for a brief moment before plunging down into the distant mountains for a long sleep. After getting the shot all lined up, I had some time to spare, so I walked around to explore my suspicion that it might be greener on the other side. I have never really lost that suspicion, just tamed it with quick explorations when time permits. This additional exploration helps do two things for me while shooting. First of all, I find it amazing how time flies in places like this. There is nobody around for literally 10 or maybe 100 miles in the Nevada desert (and that one person, maybe, is most likely the only person driving on the highway for another 50 miles in either direction). So, it's not as if I am stressed from other people or photographers clamoring around me. The time just goes by because my mind is cycling through all the potential events, compositions, and subjects presenting themselves as I examine the location more thoroughly. If I don't entertain other possibilities, I become too anxious, making it even more difficult to focus when I need to. In this cave in the middle of this limestone rift, smack dab in the center of the basin

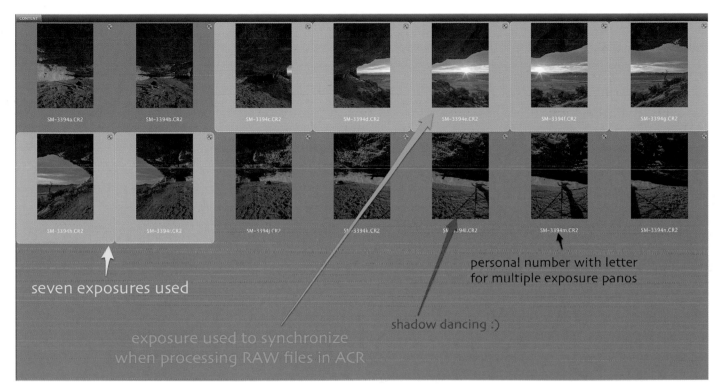

seven exposures used

exposure used to synchronize
when processing RAW files in ACR

shadow dancing :)

personal number with letter
for multiple exposure panos

Figure 5-4: Shooting a pano directly into the sun from inside a cave.

and range country of Nevada, I was ready for the light when it finally made its way through the thin layer of winter cirrus clouds. The extra time to work through my pre-shoot allowed me to relax, listen to the vast silence, and focus on creating the final image. I made about three pans left to right while the sun was out, but the middle one you see here turned out to be the best while the sun was brightest. I even had time to pose my shadow, just in case somebody ever wanted a picture of shadow dancing in a cave!

Equipment used:
- Canon 1Ds Mark II Camera
- Canon 24mm T/S Lens
- Really Right Stuff BH-55 ball head, pano package, with L-bracket mounted on camera
- Slick Pro883 tripod

Seven-Stitch Pano – Hawaii

It was 98 degrees and the sun on the Big Island of Hawaii was searing my white flesh. I was not complaining though, because after all, it would be my first real tan of the year and it was already July. I had my vision that morning while talking with my wife and kids about the day's plans: we had none. I figured it would be a good time to grab the camera and mini travel tripod and head for the rugged lava shoreline out in front of our rented condo. I was not on assignment, nor was I even thinking about shooting for any project other than my own hopeful imagination. I wanted to stack three filters, including a polarizer, on the front of my 24mm T/S lens and shoot a pano. Now, most photographers will tell you to take that polarizer off when shooting panos. Of course, that was an invitation for me to break the rule! The polarizer filter was the only way I was going to see down into the clear tropical waters below the lava rocks in the middle of the day. I also needed the ND filters to create a long enough exposure to make the intended motion blur.

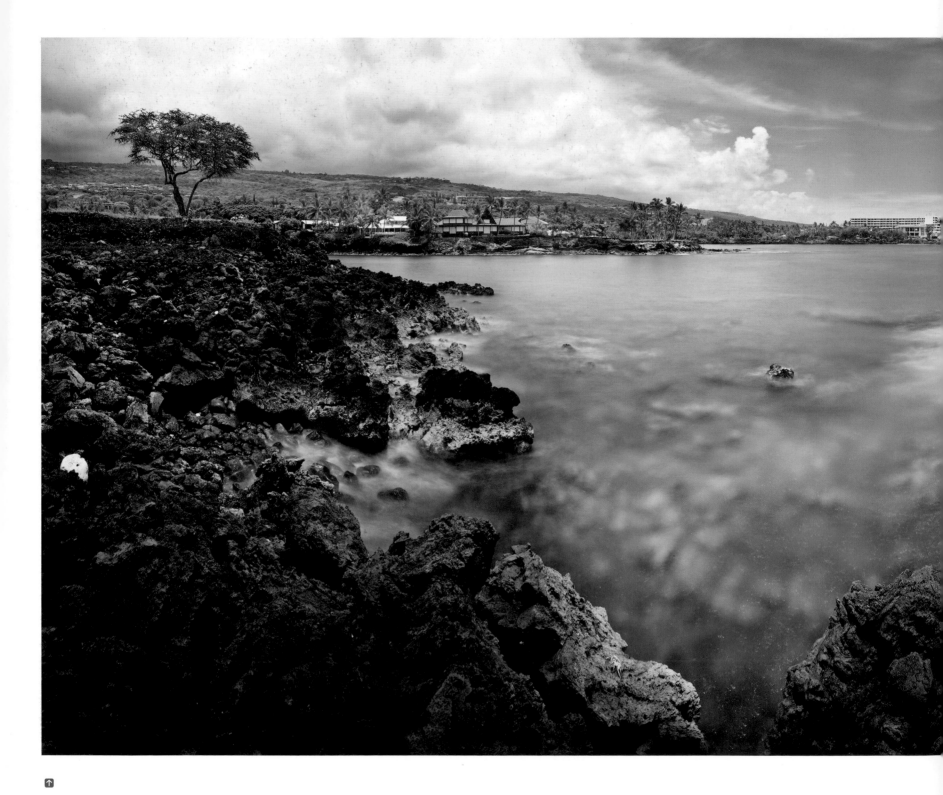

Figure 5-5: Kona Coast, Hawaii.

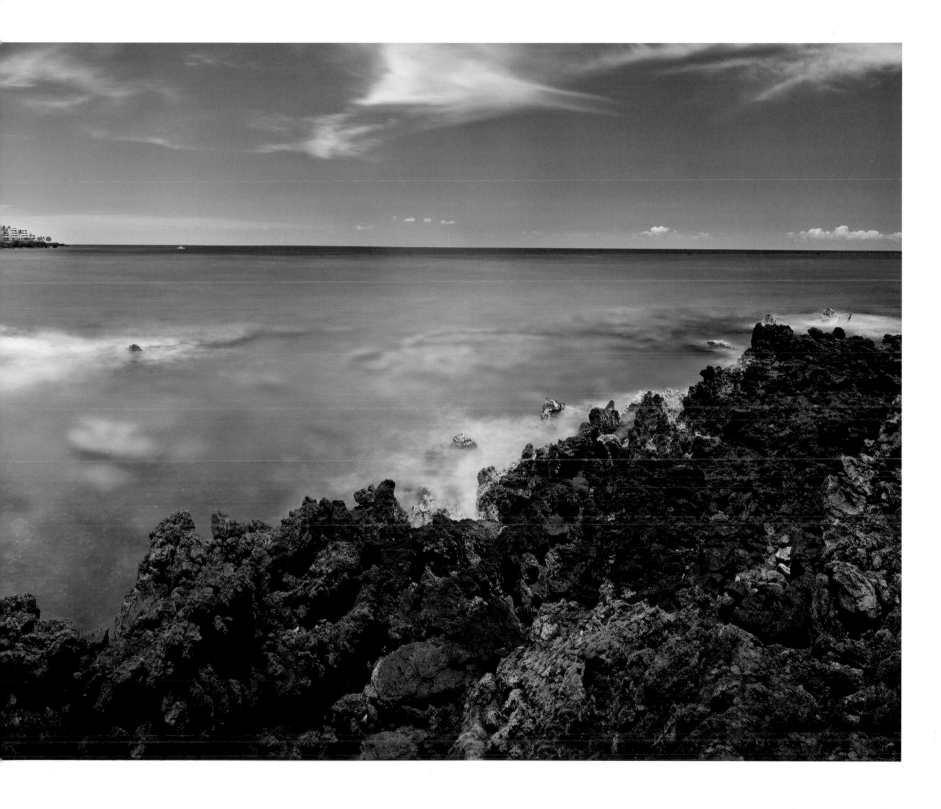

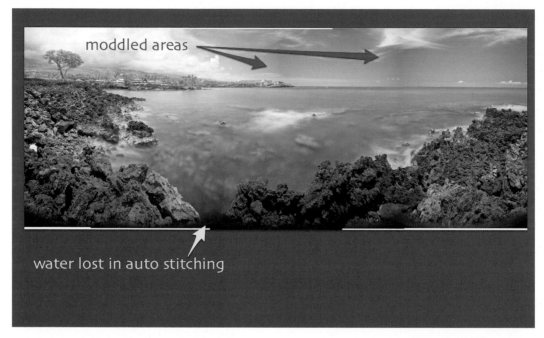

Figure 5-6: Image prior to some Photoshop cleanup.

Figure 5-7: Seven images used for the stitch.

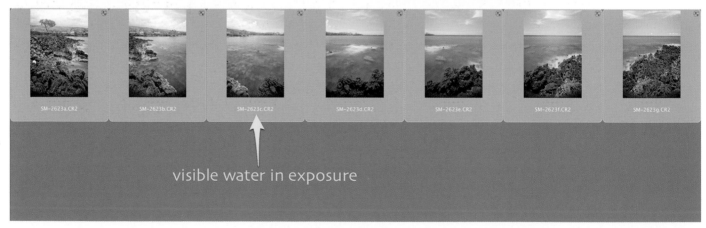

The reason the polarizer becomes an issue when making panos is that it makes a very distinct darker region in the center of any clear blue sky, while using a wide-angle lens. The tonal variations in the sky make it very difficult to stitch, even when using auto-stitching in Photoshop or other software. However, there is a method of manually stitching panos which professional photographer George Lepp taught me many years ago. The method is very time consuming, but does yield next to perfect results if you are patient enough. George was actually one of the pioneers in stitching panos. In fact, he was doing it with multiple sheets of scanned film before the term "stitching" was a trick in most photographers' tool boxes. The

process allows for gradients to be used on masks, when large even-toned regions of images don't match, especially skies.

In reality, that day's shoot proved to be a real time consuming project, which I didn't finish until months later when I was back on the mainland. After utilizing George's method, there were still clumps of darker blue sky in various regions. Using Photoshop, I had to use a large, soft brush at very low opacities to massage the areas together. I would continually zoom the image file in and out, helping me identify where it was splotchy. Finally, after many brush strokes and clicks, the sky appeared even as you now see it. The other challenge was making sure the vignette created by the extra stacked filters did not get in the way of the subject matter along the bottom of the composition. When shooting with any one filter on the 24mm T/S lens, I utilize a step up filter ring to keep the filter from vignetting after making a move such as shifting up or down. What you see in these image files is the vignetting from the three stacked filters. (Note: The new Canon 24mm and 17mm T/S lenses have much larger image circles, allowing for greater movement and less vignetting.)

Equipment used:
- Canon 1Ds Mark II Camera
- Canon 24mm T/S Lens
- B+W step up ring 72mm – 77mm
- Filters: Hoya HMC 77mm NDx8; Hoya HMC 77mm NDX400 and B+W 77mm Slim Circular Polarizer MRC
- Really Right Stuff, BH-25 ball head, pano package, and L-bracket mounted on camera
- Slick Sprint Pro 3-way tripod

To achieve the final version of this image (figure 5-5), I used my regional dynamics technique listed in "Lesson #5: Evolving Methods." I broke the image down into five basic regions and made changes to the contrast with curves layers. The regions were ocean, blue sky, cloudy sky, lava, and mountain.

Basic Steps to Stitching Images

There are many informative tutorials on manual stitching, but just in case, here are the basic steps:

1. Select all images in Bridge.
2. Select Tools > Photoshop > Load Files into Photoshop Layers.
3. Stretch canvas out to length adequate for all images. Use Image > Canvas size.
4. Grab each layer and drag across to appropriate place in pano.
5. Turn off all layers except bottom two, which should be on left of canvas.
6. Change layer opacity of top layer to 50% to view both images, and align at center of overlapping areas with the Move tool.
7. With 50% layer opacity begin painting away top image file with Brush tool only in the center. Change layer opacity to 100% and begin painting more with different size brush strokes where appropriate.
8. To gradate sky, make a selection of the area with the Lasso tool. Now use Gradient tool, left to right or right to left, to change density of area.
9. Continue steps for as many images as in pano.
10. Done!

Tilt / Shift for More

I really don't miss setting up my large format camera, or do I? The truth is, there are times I miss the zone I would enter while setting up the various parts of the view camera prior to composing an image. The procedure could be calming, at least until I finally reached my threshold of patience. There is one other element about a view camera I missed more than I could bear: the movements! This is what separates a large format camera from a medium format or 35mm camera. The large format camera allows the lens and film plane to swing freely, giving the photographer the option to manipulate both the perspective and focus plane.

There is one type of lens, however, that allows me to alter the perspective while shooting with my digital camera. Canon and Nikon make perspective control lenses, which are normal fixed focal length lenses, mounted on a machined bracket that allows the lens to slide up and down or side to side in addition to swinging. These movements are very helpful for changing the perspective while keeping the censor plane vertical. I mentioned how useful the tilt/shift or perspective control lens is while creating panoramas; but wait, there's more! In addition to panoramic photography and normal single exposure images, there are three different ways I have been using my tilt/shift lenses: two-image stitch, horizontal (figures 5-8 and 5-9); square (figure 5-10 and 5-11); and vertical (figure 5-12 and 5-13). It is very simple to create these images. The camera settings are the same that I use for the panoramic images, since I plan on stitching them together in post-processing.

For the horizontal composition (figure 5-8), I compose the frame with the assumption that I will be sliding the lens left and right, calculate the exposure while the lens is dead center, and then slide the lens all the way to the left and take the exposure. Next, I slide the lens all the way to the right and take another exposure. Because I have not moved the camera or changed the exposure, the two frames auto-stitch together

perfectly in Photoshop. Not only does this create another aspect ratio, but it does so by adding resolution rather than deleting it. For the other two aspects, I simply set the camera from landscape to portrait and/or slide the lens up and down rather than side to side. I always make sure that the front element has not slipped into a tilt thereby causing part of the image to lose focus.

Figure 5-8 was taken with the following equipment and position:

- Canon 1Ds Mark III in landscape position
- 17mm TSE lens, two exposures, one shifted left and one shifted right

Figure 5-10 was taken with the equipment in the following position:

- Canon 1Ds Mark II body in landscape position
- Canon 24mm, F3.5 TS-E, two exposures, one shifted up and the other shifted down

Figure 5-12 was taken with the following equipment and position:

- Canon 1Ds Mark III in portrait position
- Canon 24mm, F3.5 TS-E lens, two exposures, one shifted up and one shifted down

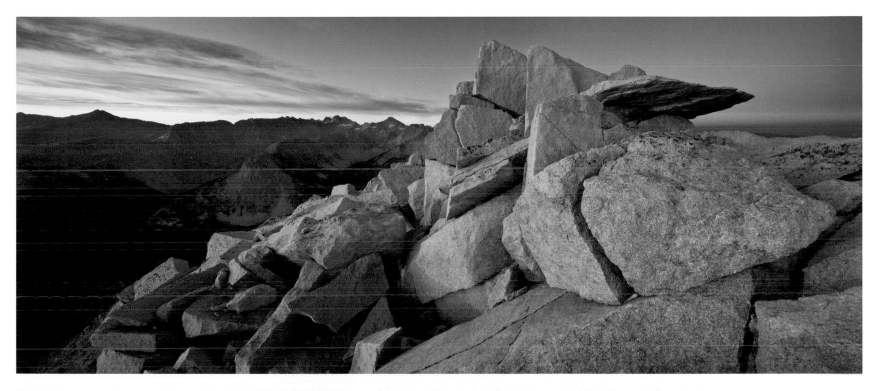

more sun light in this second exposure

↑

Figure 5-8: Summit of Mt. Hopkins, Sierra Nevada, California.

←

Figure 5-9: The two images that were stitched, horizontal.

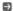

Figure 5-10: North Creek, Zion National Park, Utah. Two image stitch.

Figure 5-11: The two images that were stitched, square.

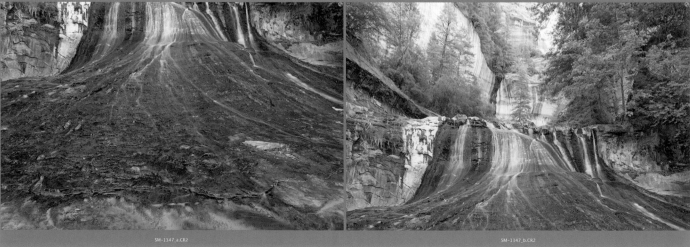

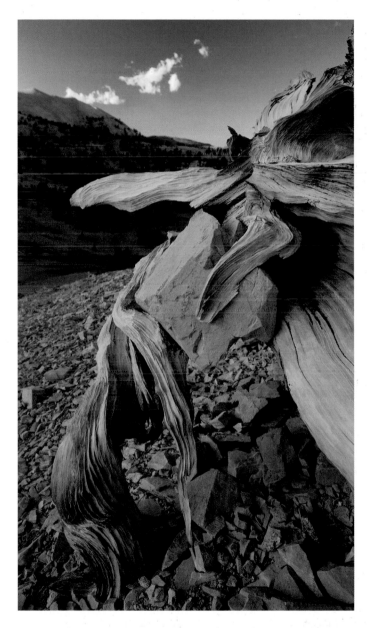

SM–3173a.CR2 SM–3173b.CR2

Figure 5-12: The two images that were stitched, vertical.

Figure 5-13: Bristlecone tree trunk, White Mountains, California.

Still Time Lapses

If I could keep time in a bottle, this is what it would look like. The moment I began editing my video nature footage of similar scenes I captured as stills, I realized something interesting. I suddenly learned how my mind was compositing, not only with anticipation, but in hindsight as well. It seemed that once a scene began rolling, and water, clouds, or another element moved in the scene, my mind began predicting what might happen next. Then once the video was completed, my mind assembled all the best parts together, creating a memory of the footage similar to a composite.

What is commonly done with nature footage is either the speed is increased, or a time lapse is actually shot instead of video or film. Both do essentially the same thing—allowing the viewer to partake in a long event in a much shorter period of time. At first, I thought this was more about our limited attention spans, but as I have spent many more hours editing footage I have come to realize the beauty of this type of image. The time lapse creates something similar to what my memory of the scene in real time was. With this in mind, I began assembling the stills from a time lapse into one single image. I took the best parts of various captures and manually blended them together. The following images are a few examples of my still time lapses.

Figure 5-15 is a three image time lapse taken over the course of 10 minutes. The second and third exposures were taken within several seconds of each other but as bracketed exposures. I did this to blend the shadows of the brighter exposure into the scene. This image was taken with the following equipment and position:

- Canon 1Ds Mark III body
- Canon 17mm F4, TS-E lens
- Front element of the lens was shifted up to get the large sky in view

Figure 5-17 is a four-image time lapse taken over the course of one hour during sunrise. I used a flash to fill in the chaparral bushes in the foreground of the third exposure. I also bracketed exposures adjusted for the regions for that particular image. This image was taken with the following equipment and position:

- Canon 1Ds Mark III body
- Nikor 16mm fisheye F2.8 lens
- Canon to Nikon lens bracket
- Canon 580EX Flash with off camera extension cord

Figure 5-19 is a nine-image time lapse HDR composition taken over one hour. I was most concerned with the high contrast while creating this time lapse. I wanted to show the intriguing haze in the air that I knew would be lost if I made one exposure and set the black point. I decided to combine the top half of the scene with three manually stitched exposures. The bottom half was combined in a similar fashion, but parts of the middle section overlapped the bottom to include more interesting water patterns. The crashing wave exposure took me the most time and patience. The exposure used is one of about 20 splash images, all taken with various exposure times to capture the variety of water movement. I used ND filters and a polarizing filter to increase the exposure time. This image was taken with the following equipment and position:

- Canon 7D body in landscape position
- Canon 50mm F2.5 lens
- Hoya HMC 77mm NDx8 filter
- B+W Polarizing filter

Figure 5-21 is a two-image time lapse taken over the course of 5 minutes. My focus in this composition was the moving clouds and the colored rocks. I needed to change the exposure time to capture both elements of wind and water. The misty water

from the long exposure was not giving me the windy look, and the fast exposure was not giving me the motion of the moving clouds! Combining the images, however, did just the trick. I used an ND filter to obtain the long exposure. This image was created with the following equipment and position:

- Canon 1Ds Mark II body in portrait position
- Canon 24mm F3.5 TS-E lens shifted down
- Hoya HMC 77mm NDx8 filter used for the moving cloud exposure
- B+W Polarizing filter used for the water exposure

SM-3593a.CR2 SM-3593b.CR2 SM-3593c.CR2

Figure 5-14: Three images used for this single time lapse still.

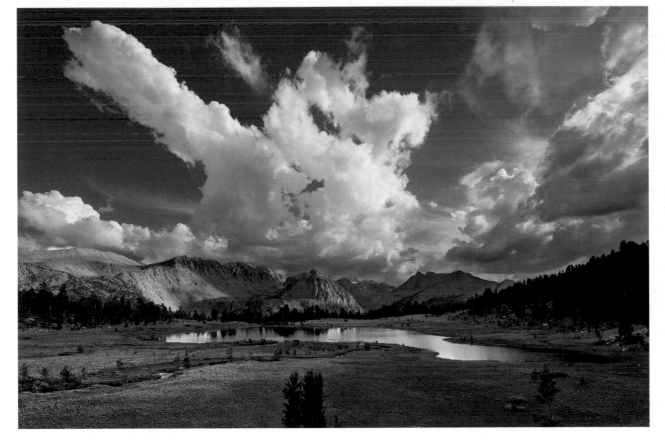

Figure 5-15: Pioneer Basin, John Muir Wilderness, Sierra Nevada, California.

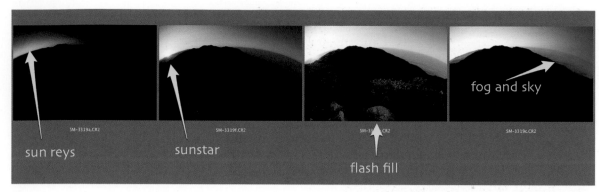

Figure 5-16: The four images used for this 1-hour time lapse image.

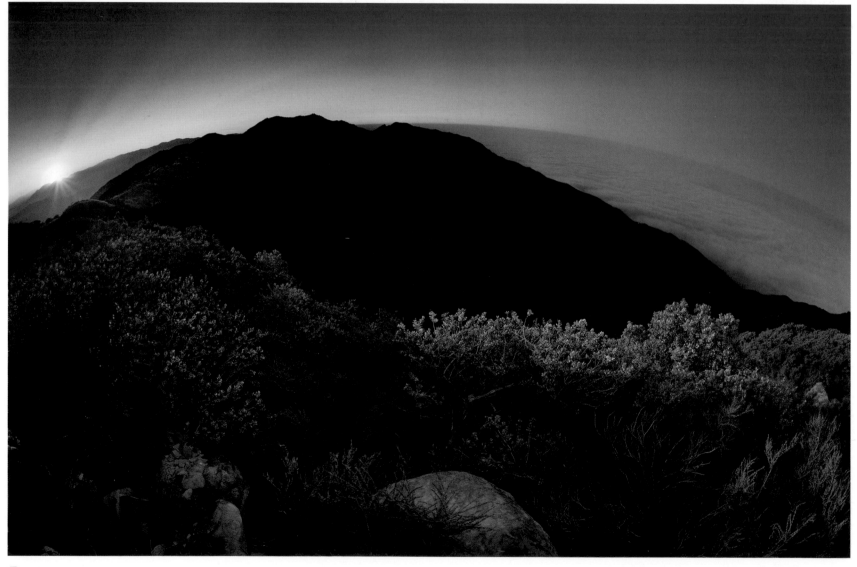

Figure 5-17: Santa Ynez Mountains, California.

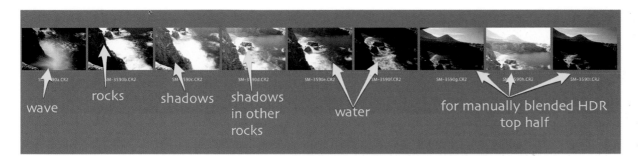

Figure 5-18: The nine images shot during this 1-hour time lapse image.

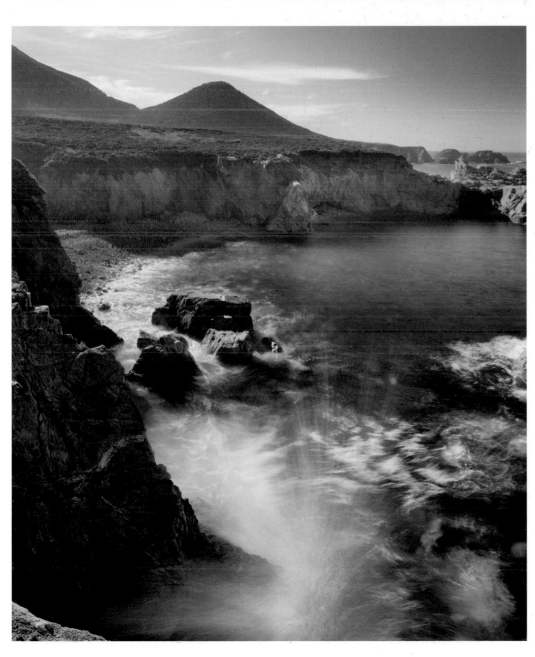

Figure 5-19: Garrapata State Park, Big Sur Coast, California.

↑

Figure 5-20: Two-image, 5-minute time lapse shot.

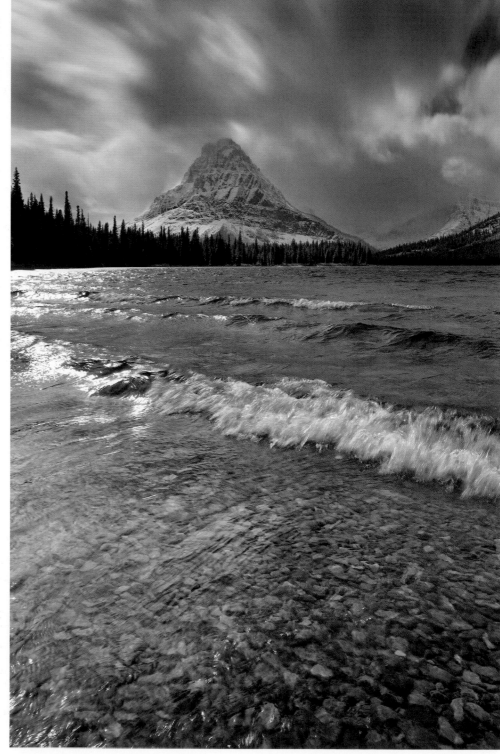

→

Figure 5-21: Two Medicine Lake, Sinopah Mountain, Glacier National Park, Montana.

Shooting Into the Sun

As mentioned earlier, I like shooting into the sun. I discussed some of the reasons in the chapter on chasing the light, but wanted to add this method here, as it is something I didn't begin applying until after working several still time lapses. The trick is simple: Just hold part of your hand, or anything for that matter, in front of the lens to block the sun for one of several exposures. Due to the high dynamic range of the scene, I would shoot an HDR composite anyway. Since auto software would go crazy attempting to do something with my hand, I have composited these images only manually, utilizing the methods in "Lesson 7: Manual HDRI." This works best under the following conditions:

- Use a wide angle lens
- Place the camera on a tripod
- Compose the sun close to the edge of the frame
- Take the time to make several exposures

An interesting variation is to include a moving subject. I have blended such composites and they do work. Just keep in mind that you may or may not get to choose when to use those moving subjects, since you may partially block some with your hand during that exposure. I also make sure to take one additional frame with the very same exposure setting as the one with my hand. I explain why this is important below.

The dynamic range of this scene was not quite the same as most images taken when looking directly into the sun. The clouds knocked down the sun's brightness, creating about six stops of exposure difference rather than seven. I normally take three exposures two stops apart, but with the slightly lower contrast, the third exposure was only one stop brighter than the second. One issue that can be difficult to deal with is replacing the area where my hand is. Because the exposure with my hand was three stops brighter than the sun exposure, I was concerned that important gradation values in the sky next to the sun might be lost. The only reason for taking the second exposure was to adjust for the tones just surrounding the sun.

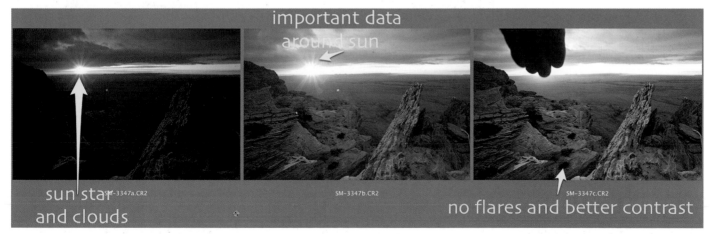

Figure 5-22: Using my hand to block the sun.

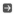

Figure 5-23: Vermillion Cliffs Wilderness, Arizona.

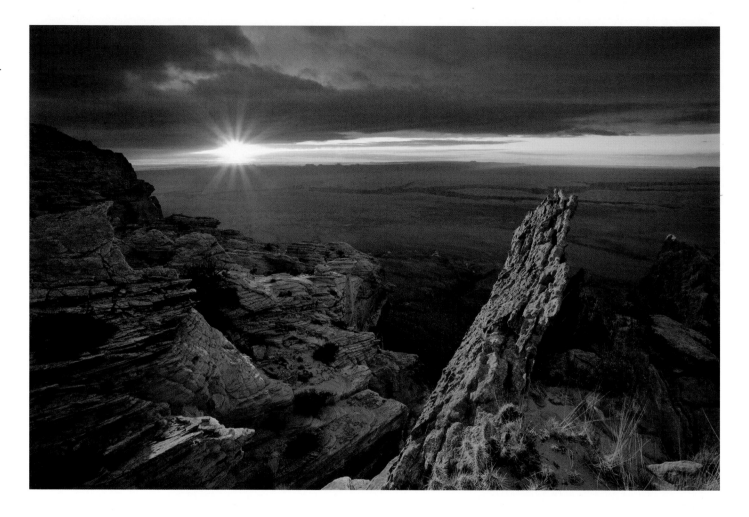

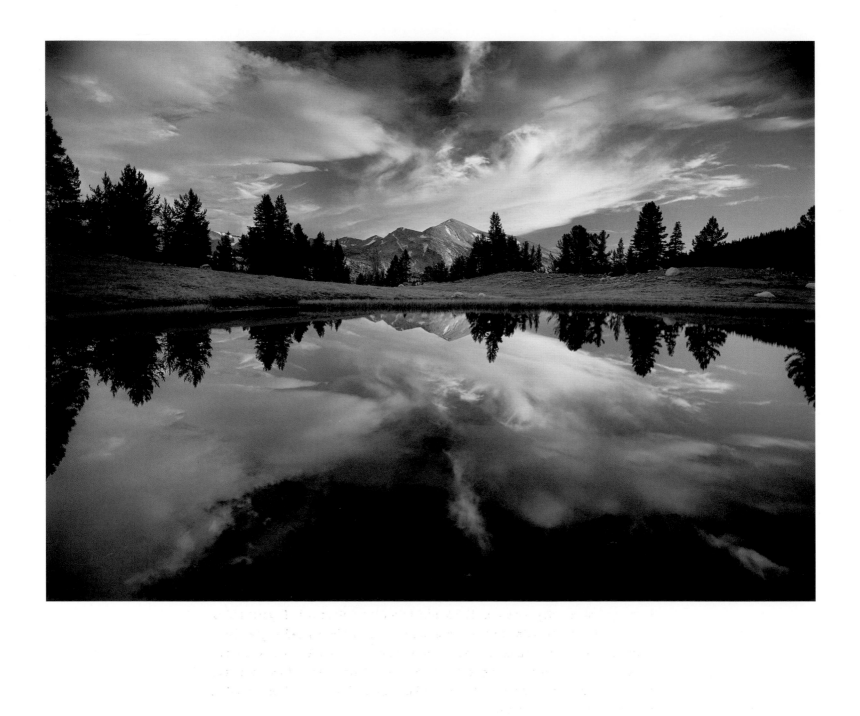

CHAPTER 6
FAVORITE PLACES

With the entire world before me as a possible location to shoot, I still find myself compelled to continue to explore two regions: Santa Barbara County and the Sierra Nevada Mountains. After having traveled to many great locations around the world, I am convinced these two locations offer more than enough varieties of subject, light, and story to keep me occupied photographing for several lifetimes. I will continue to travel to other areas on this planet, especially within North America, but I also know I will carve out time to continue my work in these two special regions. The work in the following two portfolios was created during various projects over the past 30 years. All the images were post-processed using the methods illustrated in the Lessons found in the second half of this book.

Sierra Nevada

Every time someone mentions the name Sierras, my senses fill with the smell of the foxtail pine bark, and the sounds of a few chirps of the canyon wren bird and the dull roar of a freshwater stream pouring directly out of a snowfield up high on the Great Western Divide. My father even convinced Graphic Arts Center Publishing to publish an entire coffee table book on the location, which is the main reason I experienced the *"Range of Light"* early on. Doug Robinson was the first person to tell me (and teach me) that the Sierras are the best place to climb. The second was Galen Rowell, who had been to many of the world's largest and most spectacular mountain ranges. Doug and Galen had partnered together back in the 70s to make the very first one-day accent of Half Dome in Yosemite, along with Royal Robbins, Chuck Pratt, and Yvon Chouinard. This and many other climbing, hiking, and wilderness experiences had convinced them that not only were the Sierras a place to satisfy the best of climbers but they also provided the best weather. I too have spent a significant chunk of my life in the Sierras, creating many adventures that have turned into iconic memories.

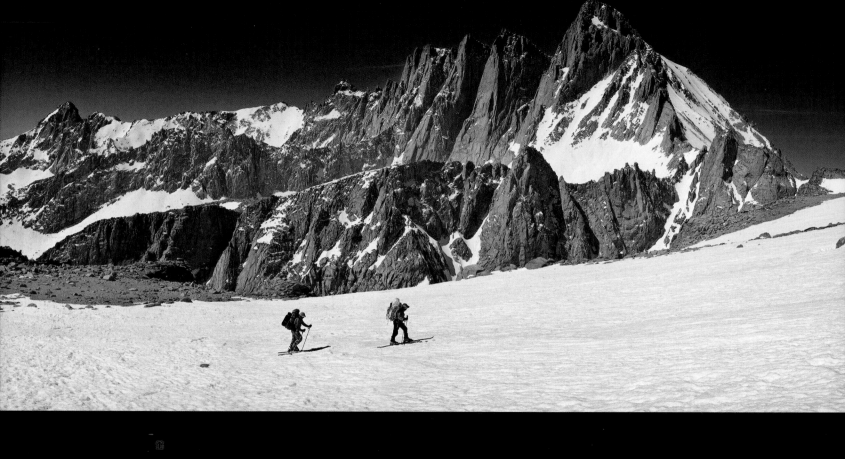

Figure 6-1: Skiers ascending Mt. Russell with Mt. Whitney in the background, Sierra Nevada, California.

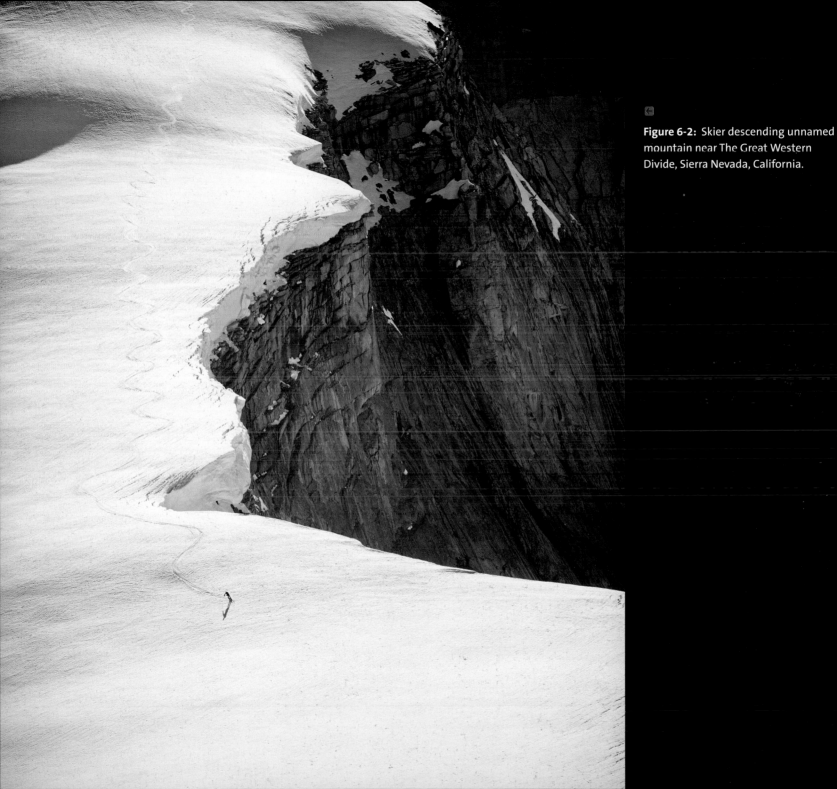

Figure 6-2: Skier descending unnamed mountain near The Great Western Divide, Sierra Nevada, California.

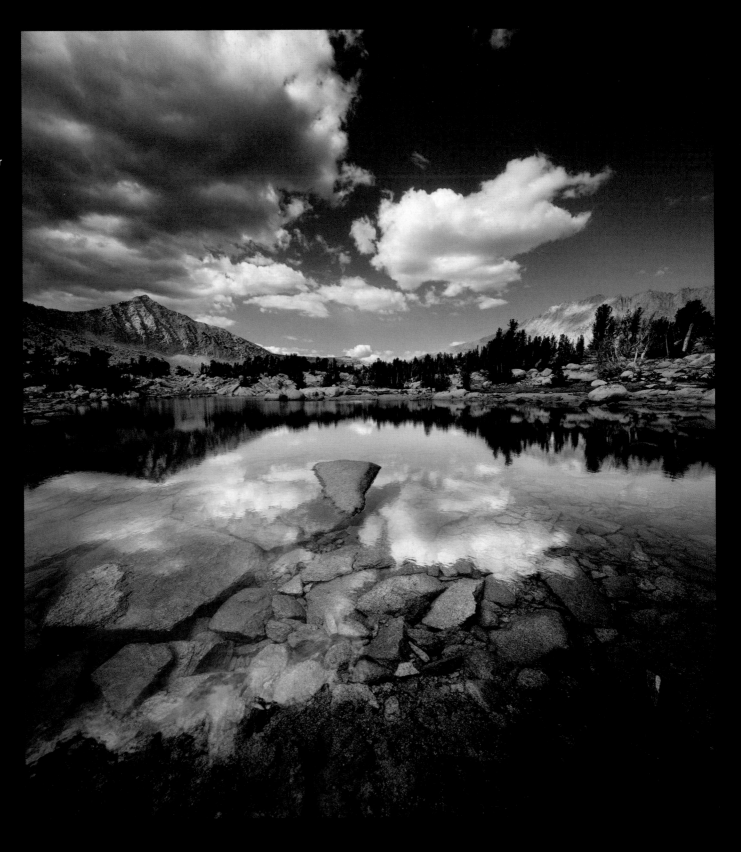

Figure 6-3: Pond in Pioneer Basin, Sierra Nevada, California.

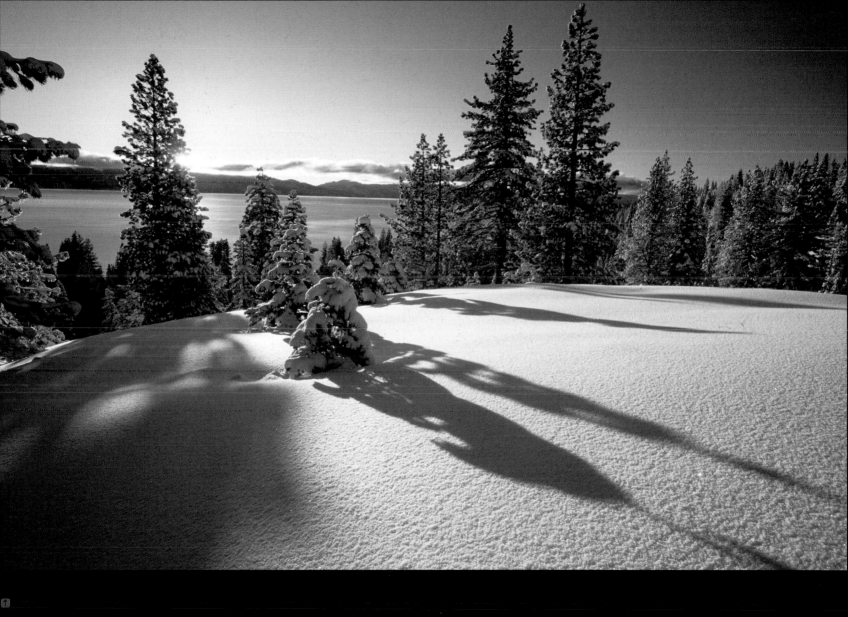

Figure 6-4: North Shore, Lake Tahoe, Sierra Nevada, Nevada.

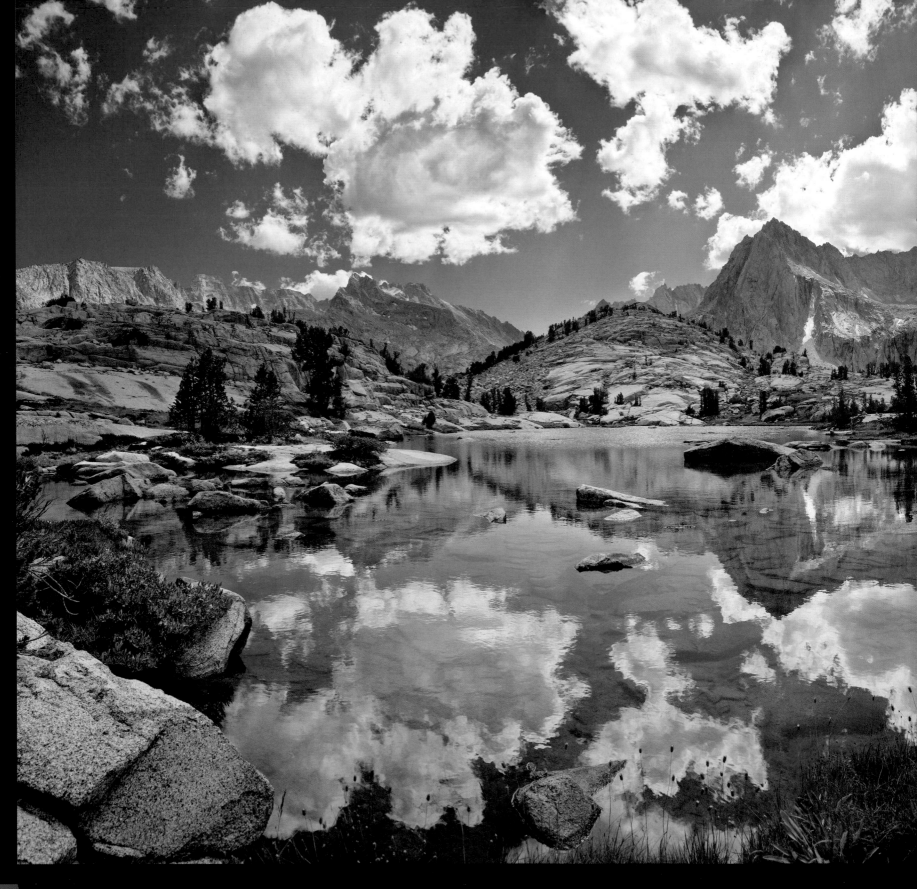

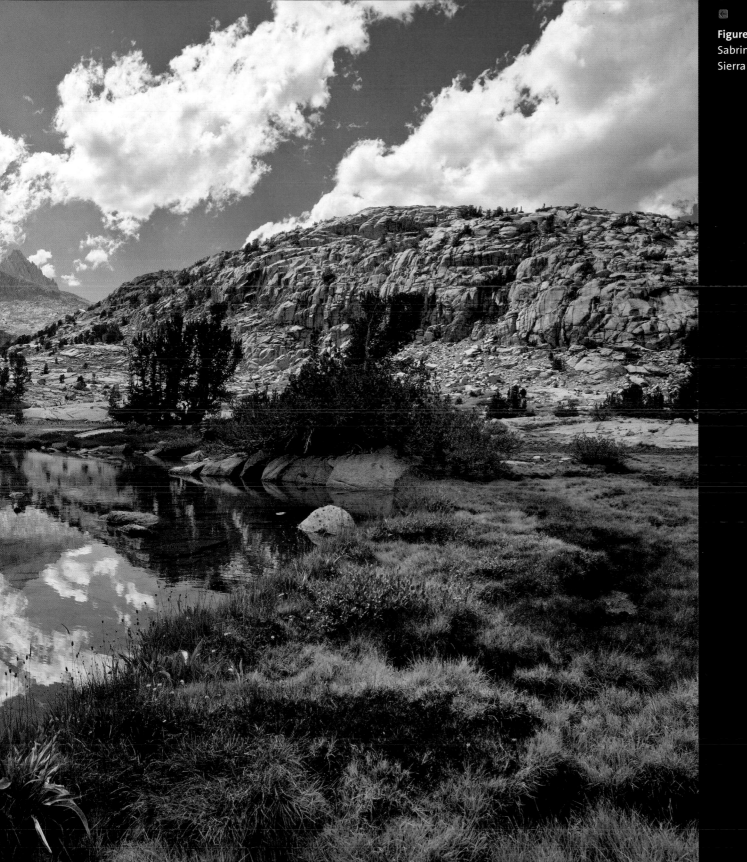

Figure 6-5: Sailor Lake, upper Sabrina Basin, John Muir Wilderness, Sierra Nevada, California.

Figure 6-6: El Capitan, Yosemite National Park, California.

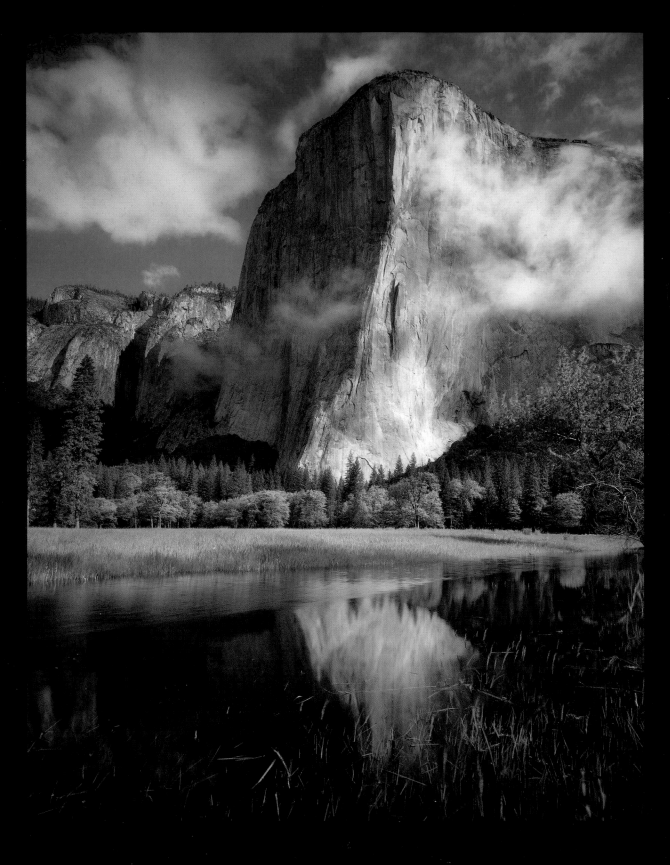

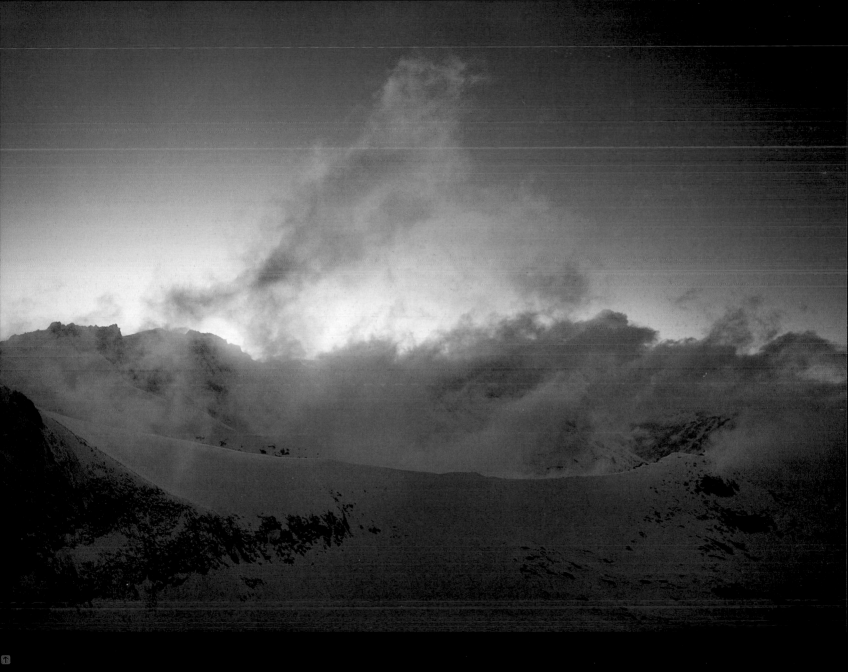

Figure 6-7: Alpine glow on clearing storm cloud, Junction Pass, Sierra Nevada, California.

Figure 6-8: The Parker Group, Sequoia National Park, Sierra Nevada, California.

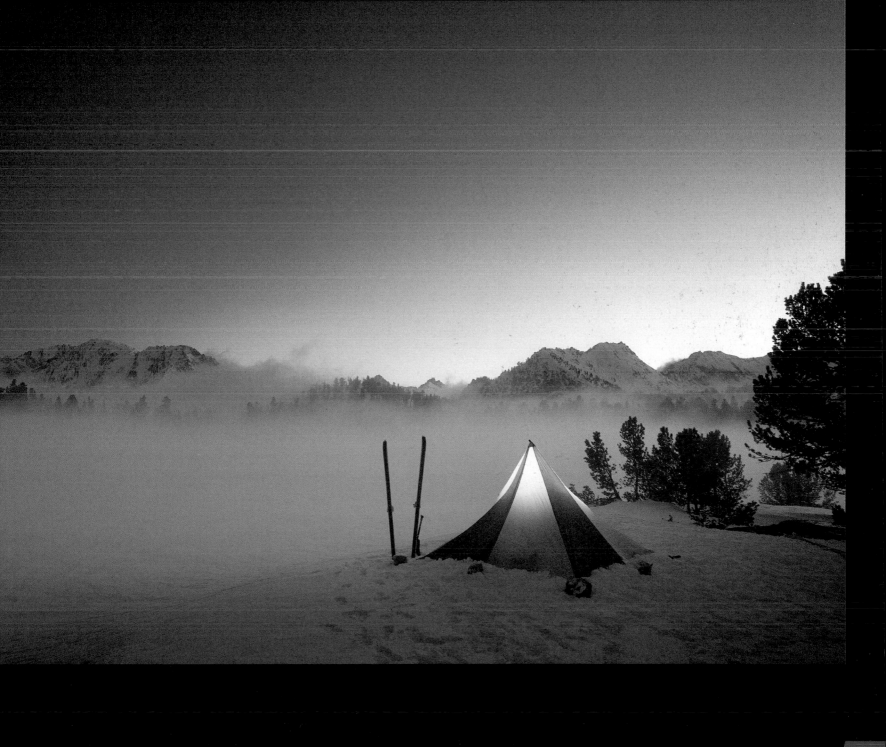

Figure 6-10: Snow melt in Big Pine Canyon, John Muir Wilderness, Sierra Nevada, California

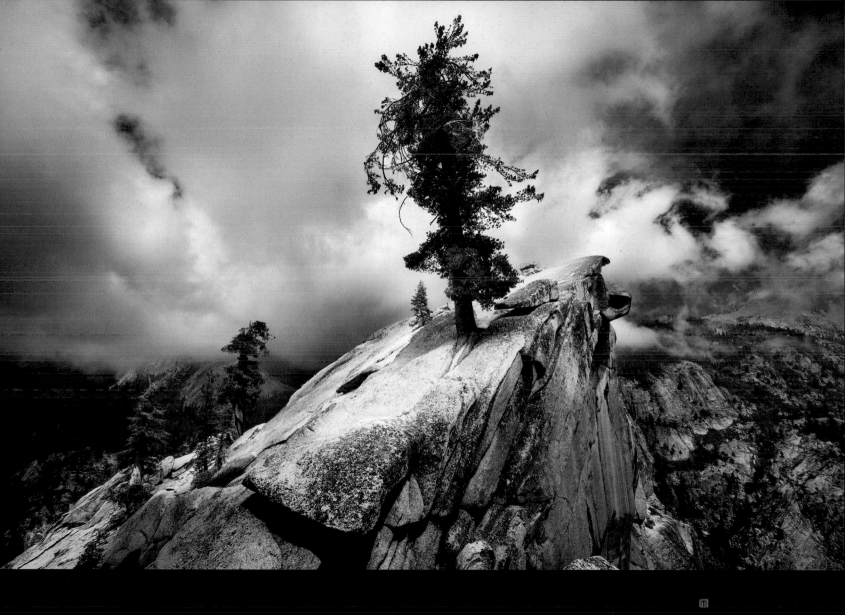

Figure 6-11: Tokopah Valley, Sequoia National Park, Sierra Nevada, California.

Figure 6-12: Fourth Recess Lake, John Muir Wilderness, Sierra Nevada, California.

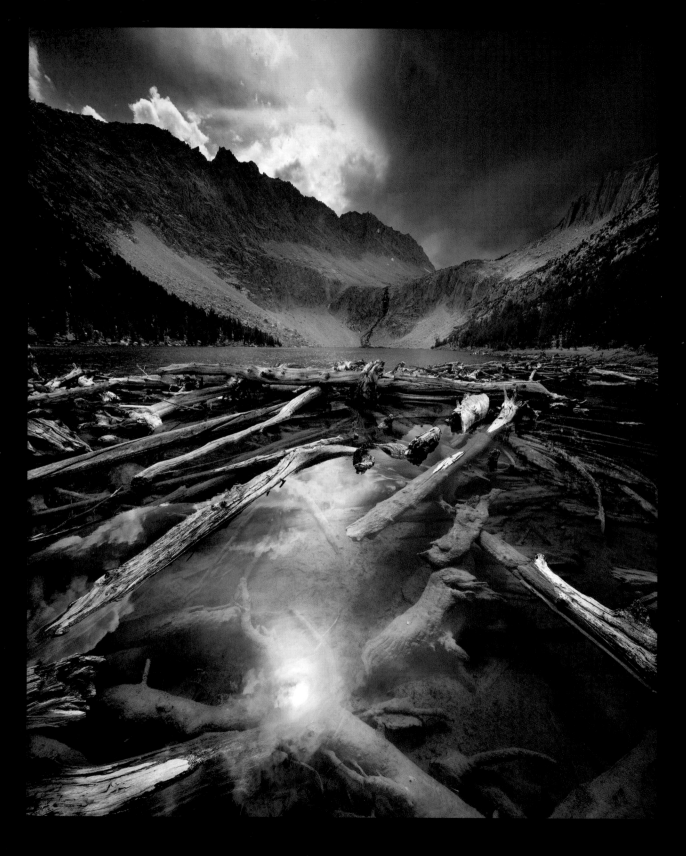

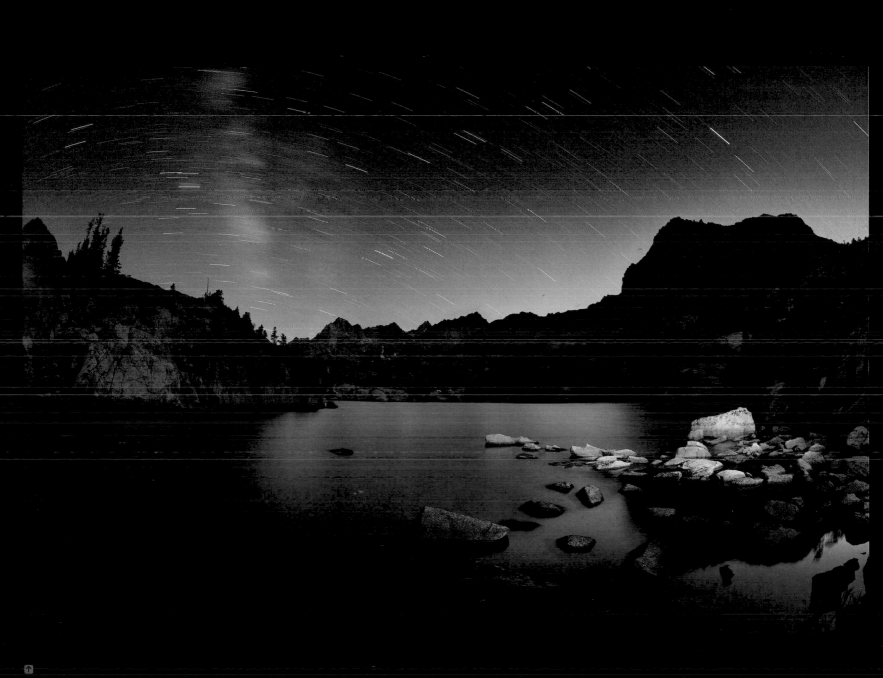

Figure 6-13: Dingleberry Lake, John Muir Wilderness, Sierra Nevada, California.

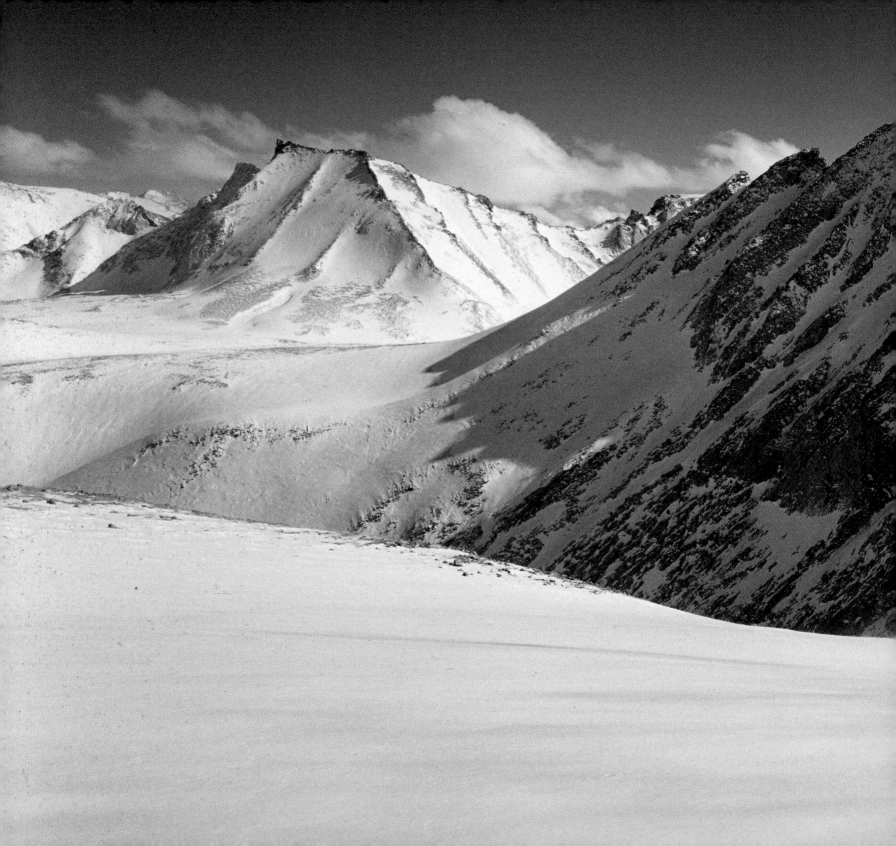

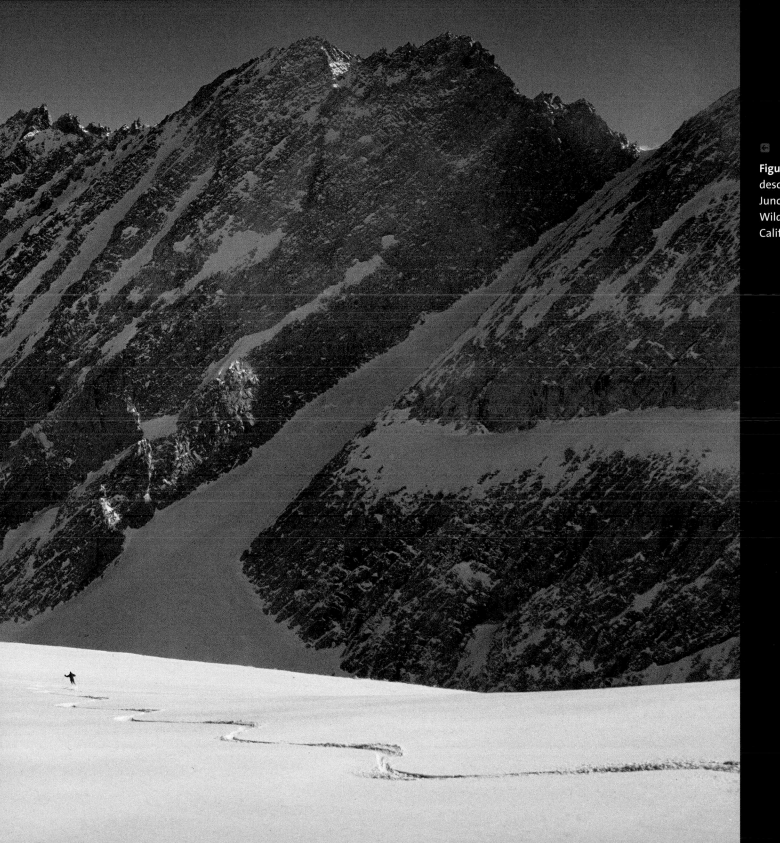

Figure 6-14: Skier descending south side of Junction Pass, John Muir Wilderness, Sierra Nevada, California.

Santa Barbara County

As I write this very sentence, the smell of the ocean is drifting into my office through the slats in the window, confirming yet again, that I should be out surfing. I was born in Santa Barbara, but even so, it took me almost four decades to finally understand just how beautiful it is. Figueroa Mountain, Santa Cruz Island, Ellwood Mesa, and Refugio State Beach might be small places on the world map, but their presence in my life is many times larger than they appear. It's a rare climate here in Santa Barbara, similar to that of Spain along the Mediterranean, but it is unique in its location on the edge of the North American continent. As I mentioned in chapter one, my grandfather took one look at the palm trees lining Cabrillo Boulevard and made the decision to stay. In Santa Barbara, I went to school, raised a family, published a book of images exclusively on Santa Barbara, and have finally come to realize I need to spend much more time looking at what has been right in front of me my entire life. I have just begun to tap into the vast diversity of the region by exploring not only the mountains and oak covered hillsides but beaches and underwater ecosystems just offshore surrounding Channel Islands National Park.

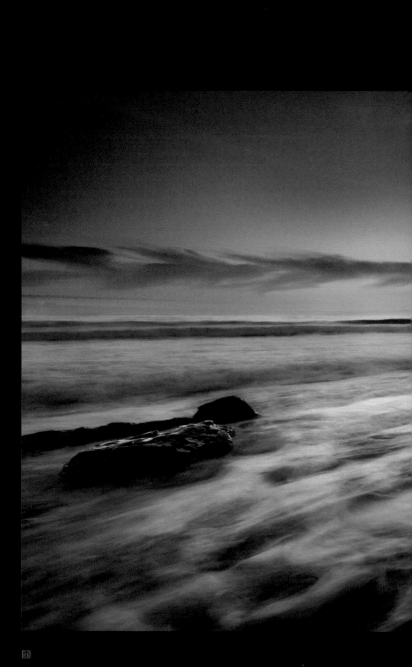

Figure 6-15: Ellwood Mesa, Gaviota Coast, California.

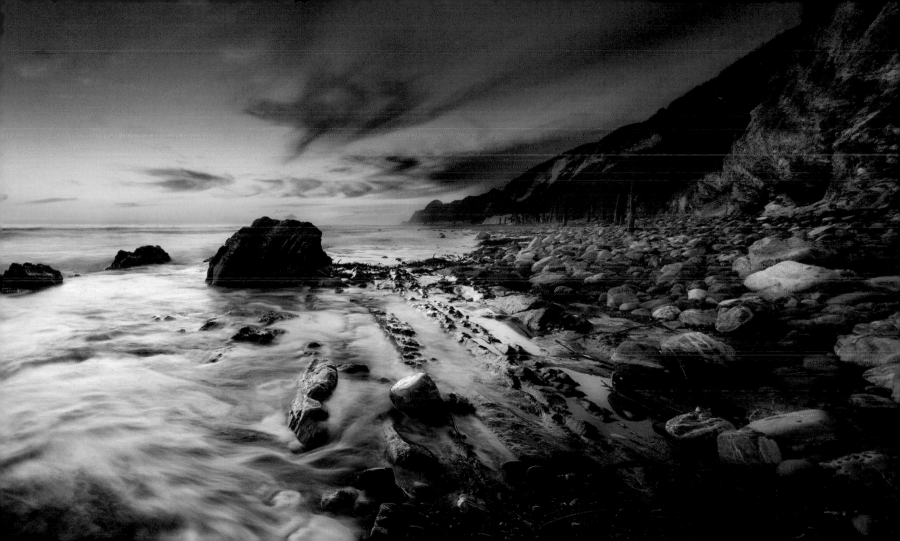

Figure 6-16: The palms that enticed my grandfather to stay in Santa Barbara, Cabrillo Blvd., Santa Barbara, California.

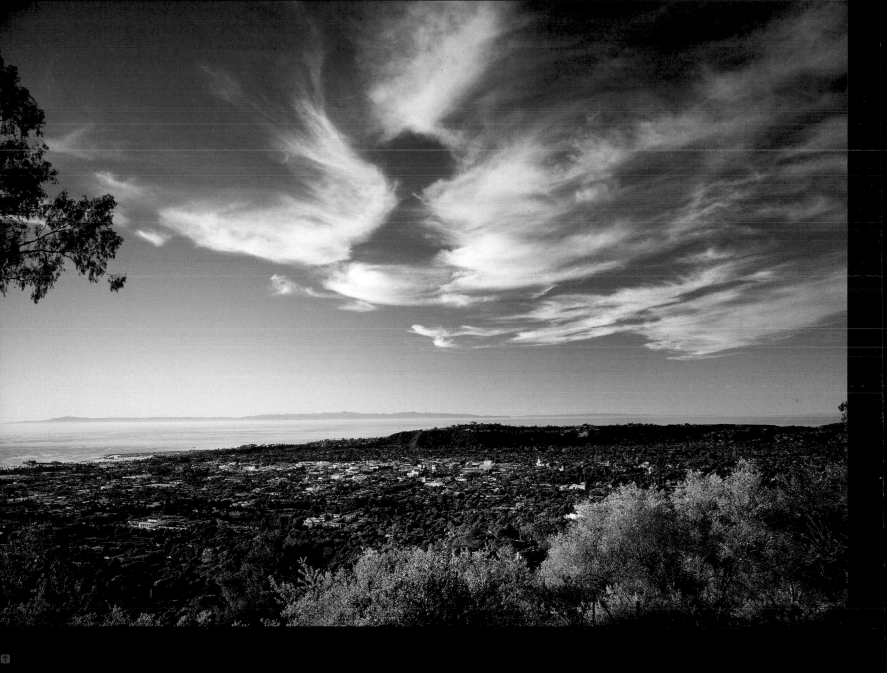

Figure 6-17: Santa Barbara, California, as seen from the Riviera.

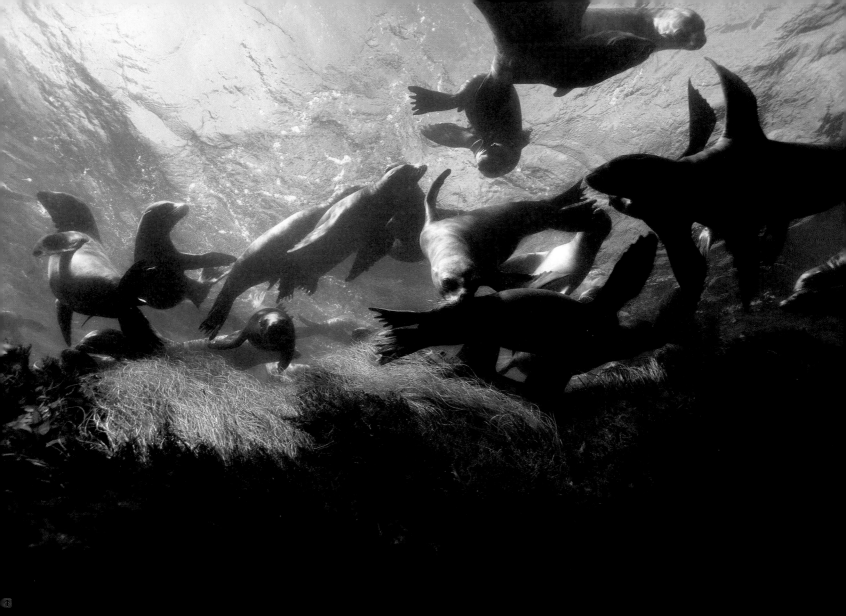

Figure 6-18: Sea Lions, Santa Barbara Island, Channel Islands National Park, California.

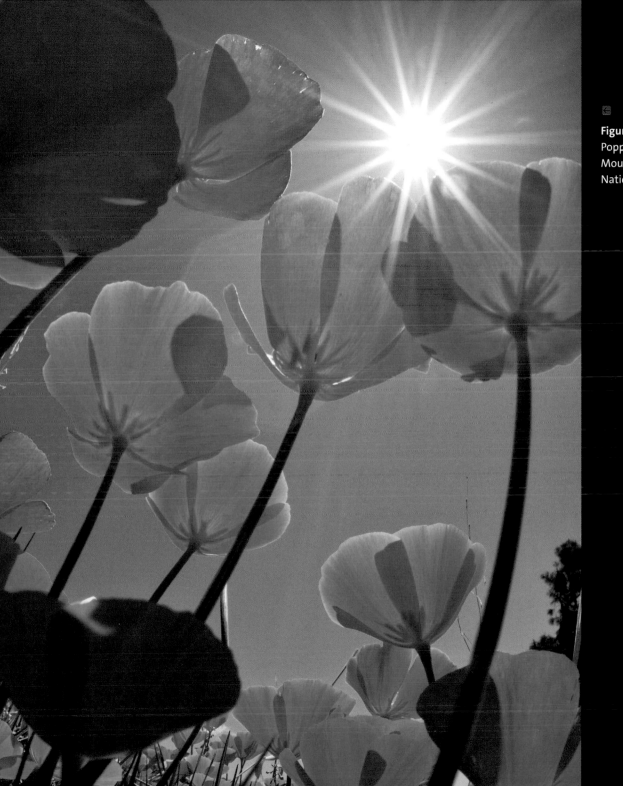

Figure 6-19: California Poppies, Figueroa Mountain, Los Padres National Forest, California

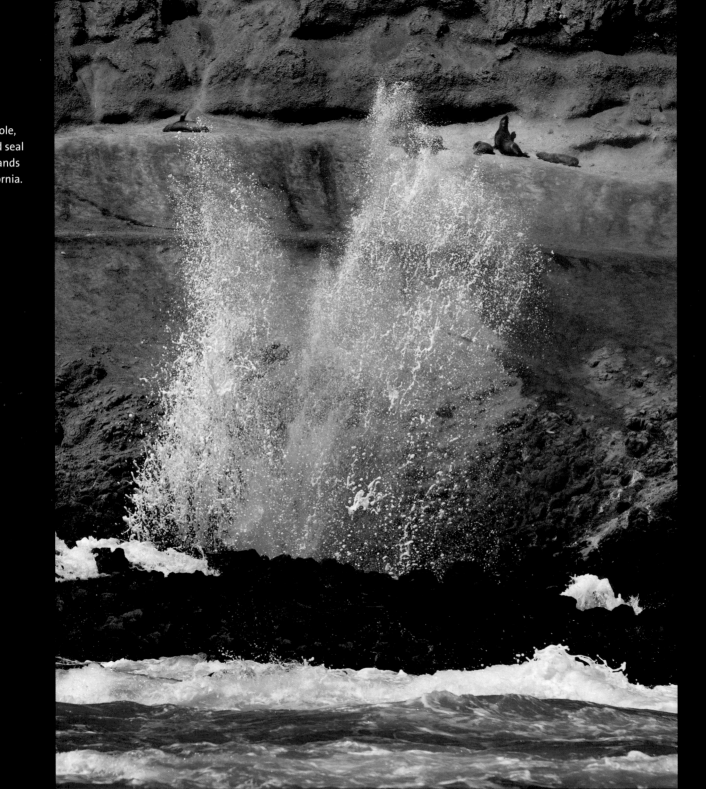

Figure 6-20: Blow hole, Santa Barbara Island seal rookery, Channel Islands National Park, California.

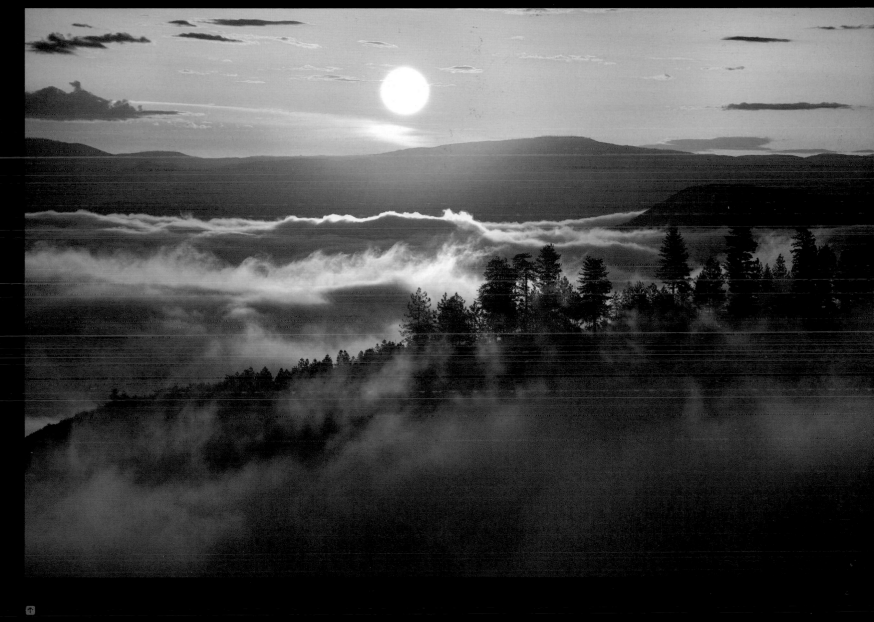

Figure 6-21: Sierra Madre Mountains, Los Padres National Forest, California.

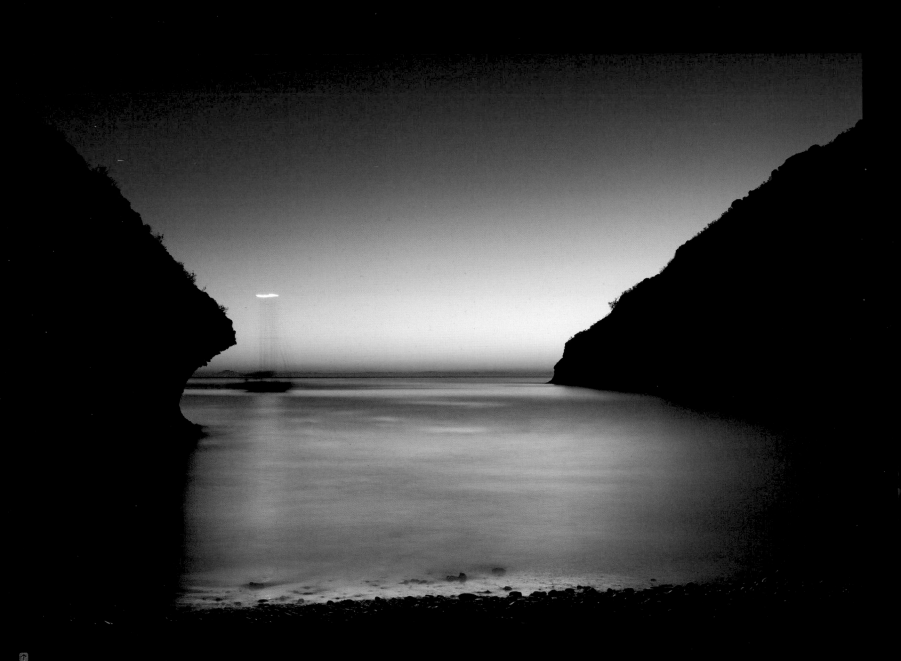

Figure 6-22: Santa Cruz Island, California.

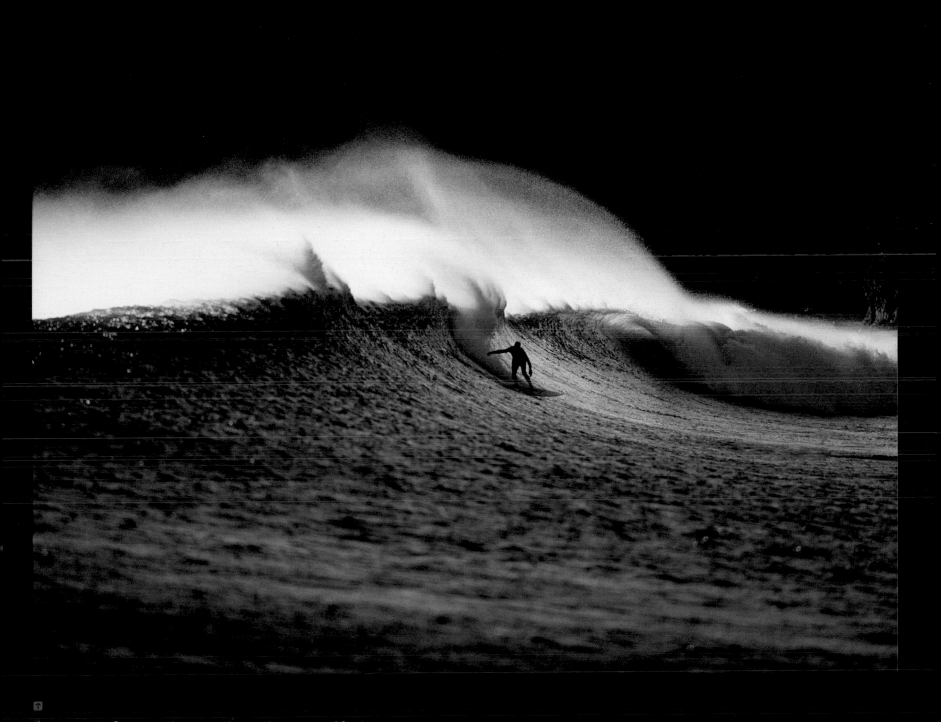

Figure 6-23: Surfing near Point Conception, Gaviota Coast, California.

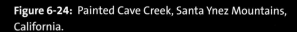

Figure 6-24: Painted Cave Creek, Santa Ynez Mountains, California.

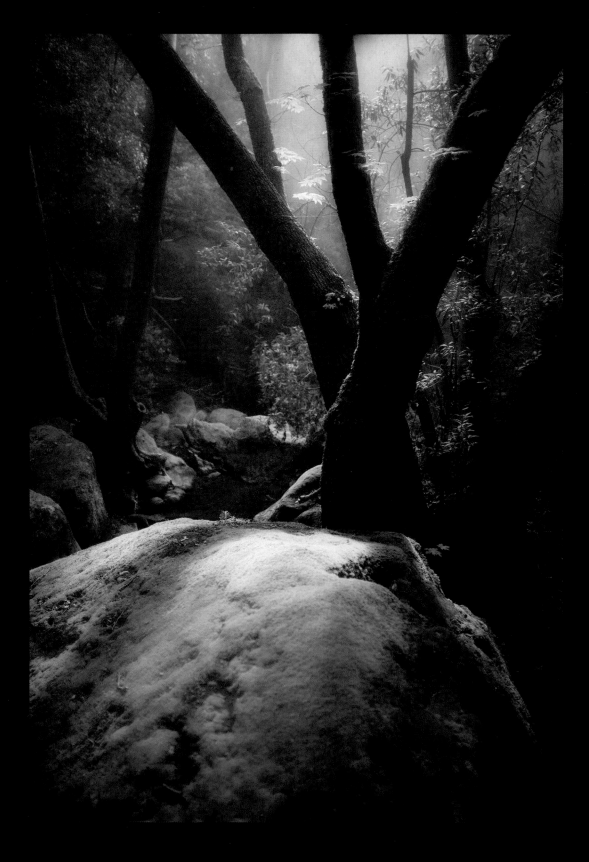

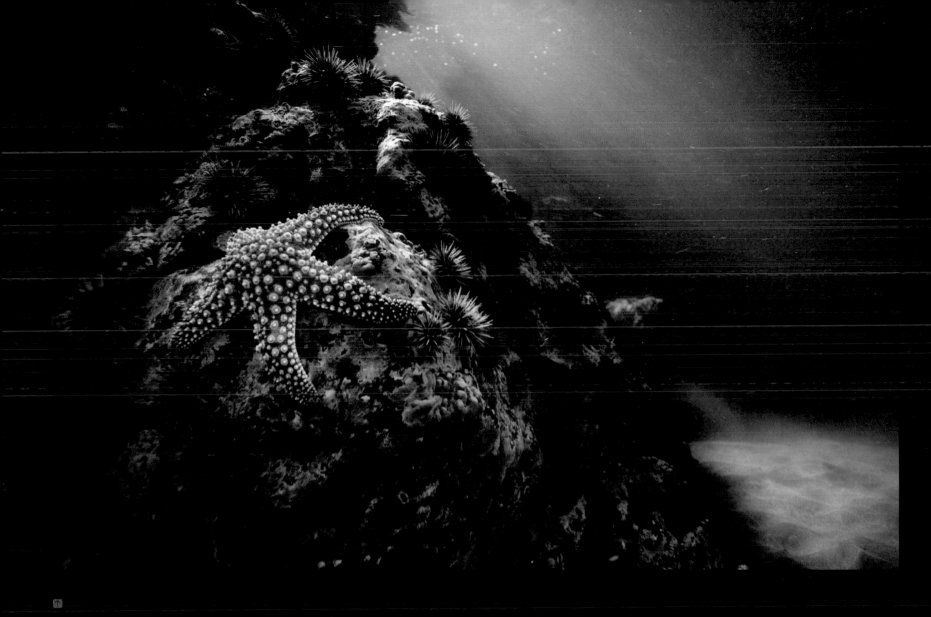

Figure 6-25: Starfish and spiny anemone, Santa Cruz Island, Channel Islands National Park, California.

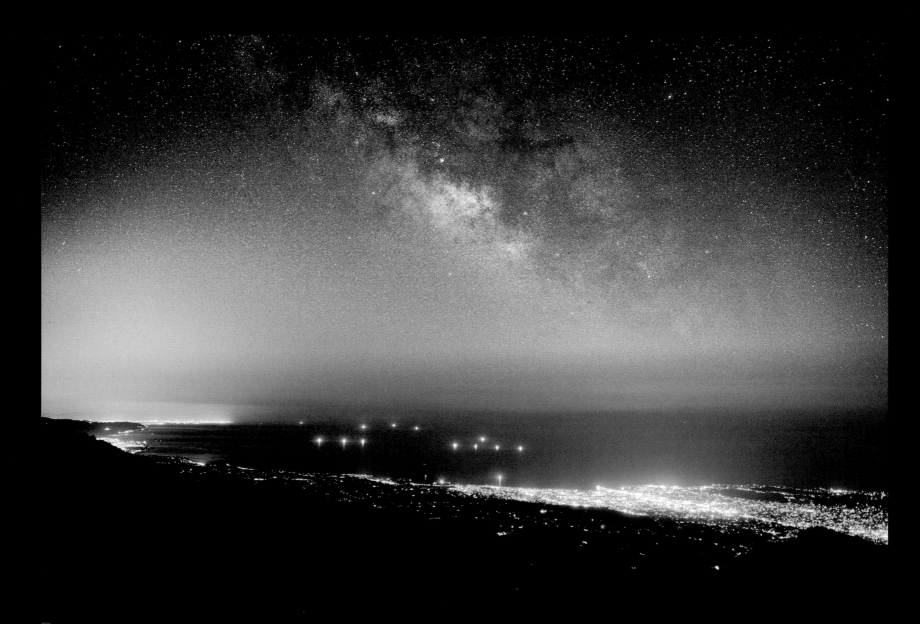

Figure 6-26: The Milky Way over Santa Barbara, California.

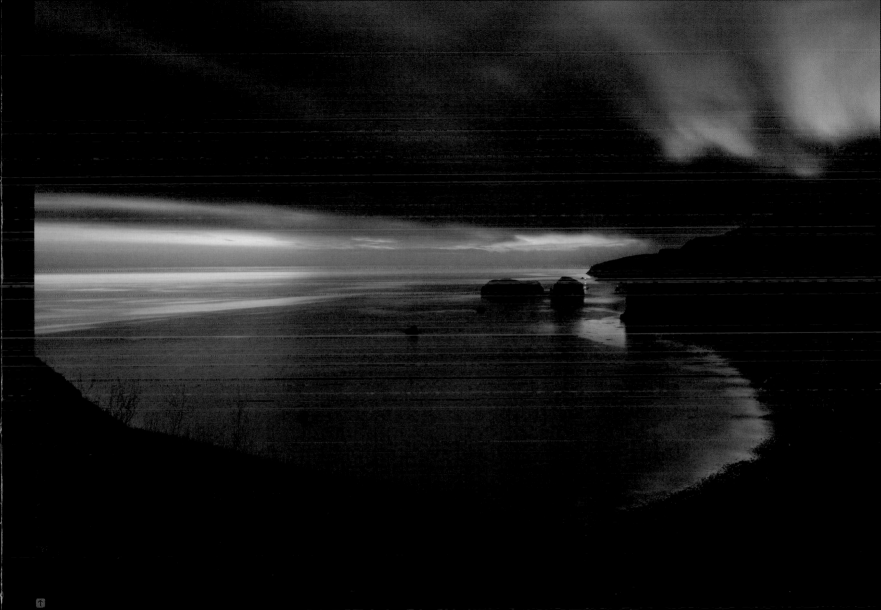

Figure 6-27: Santa Cruz Island, Channel Islands National Park, California.

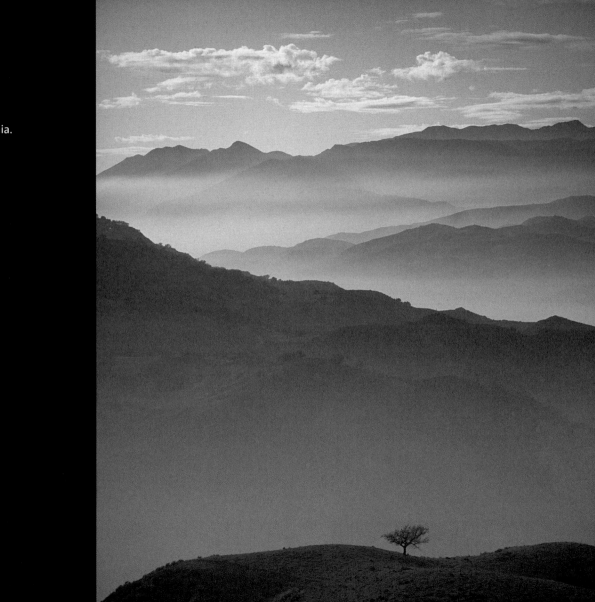

Figure 6-28: Sierra Madre Mountains, California.

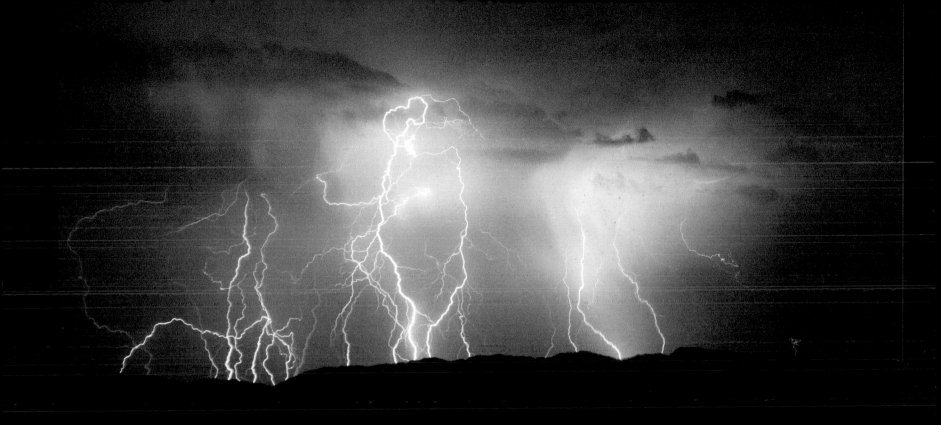

Figure 6-29: Lightning storm over Dick Smith Wilderness, Sierra Madre Mountains, California.

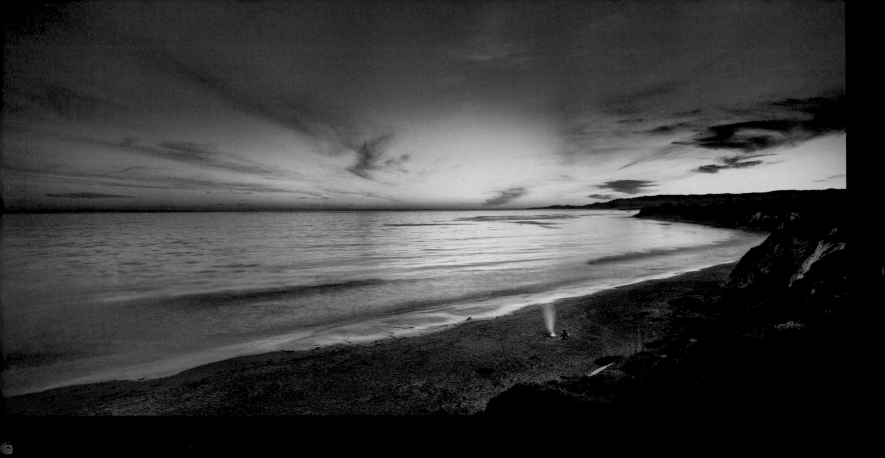

Figure 6-30: Evening fire, Ellwood Mesa, Gaviota Coast, California

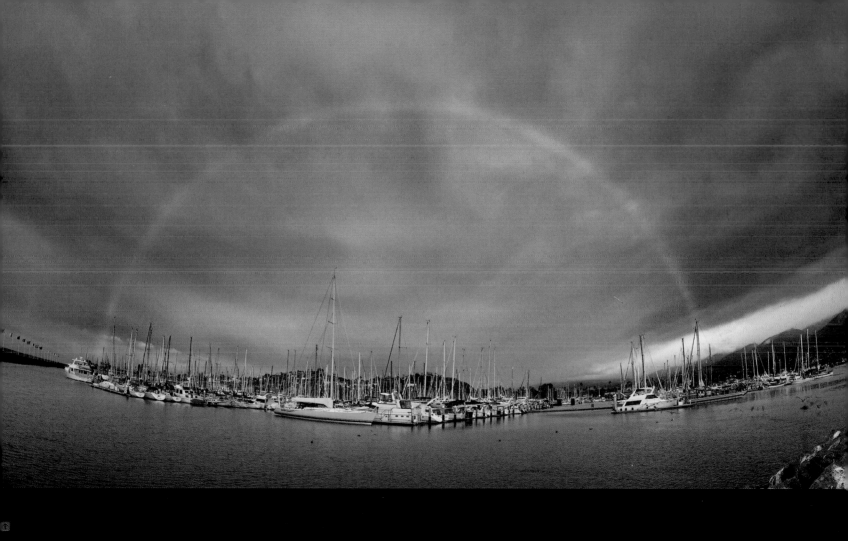

Figure 6-31: Rainbow over Santa Barbara Harbor, California.

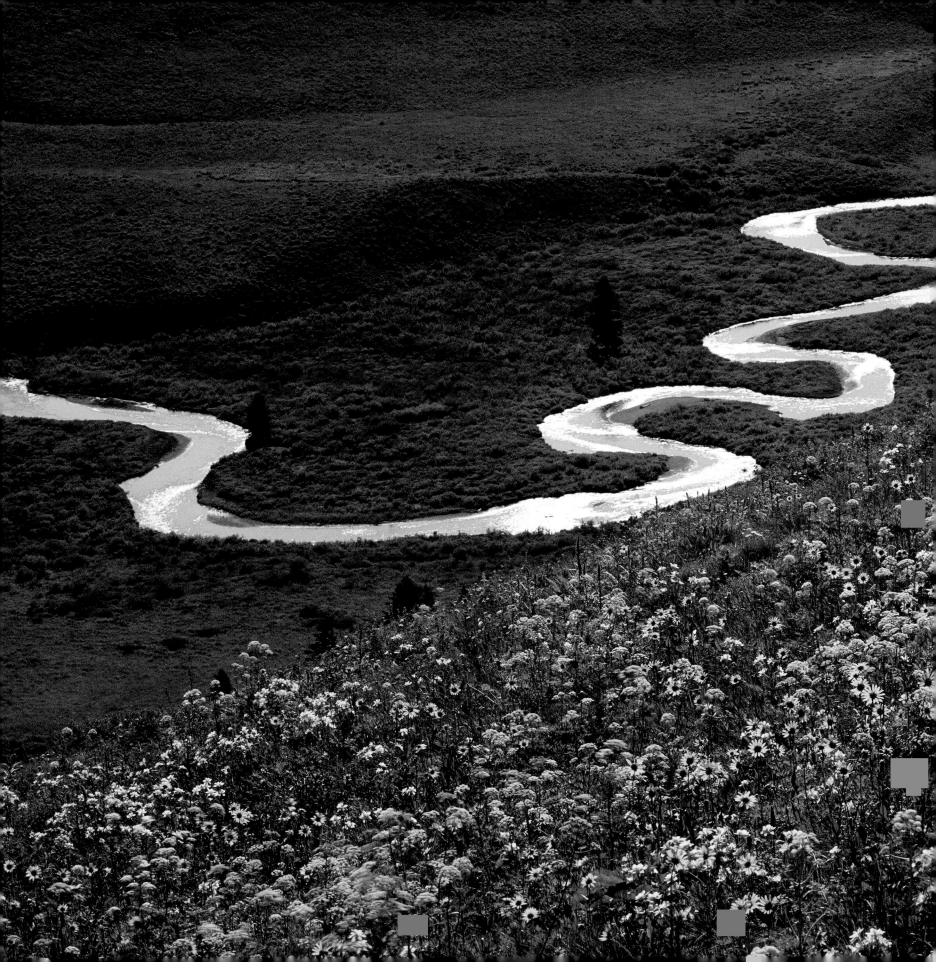

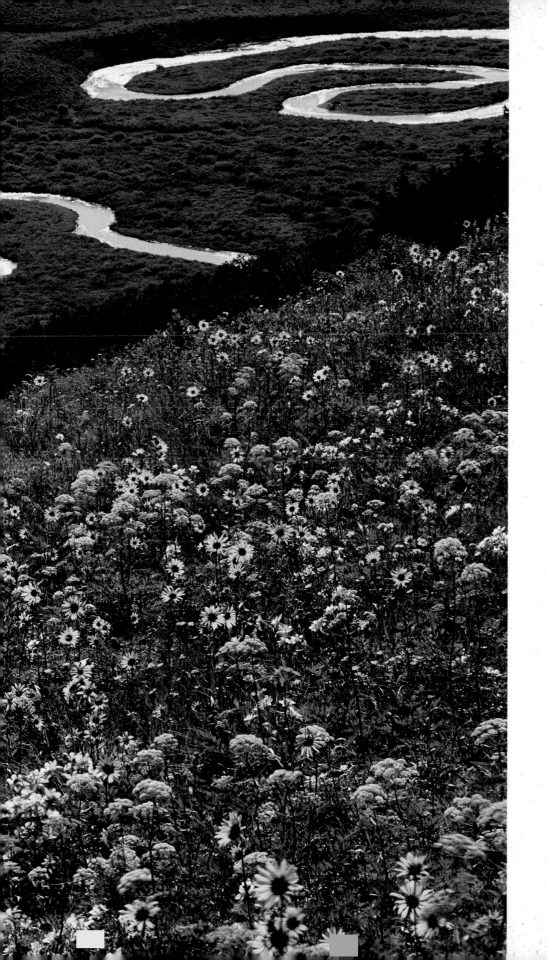

PART II
THE LESSONS

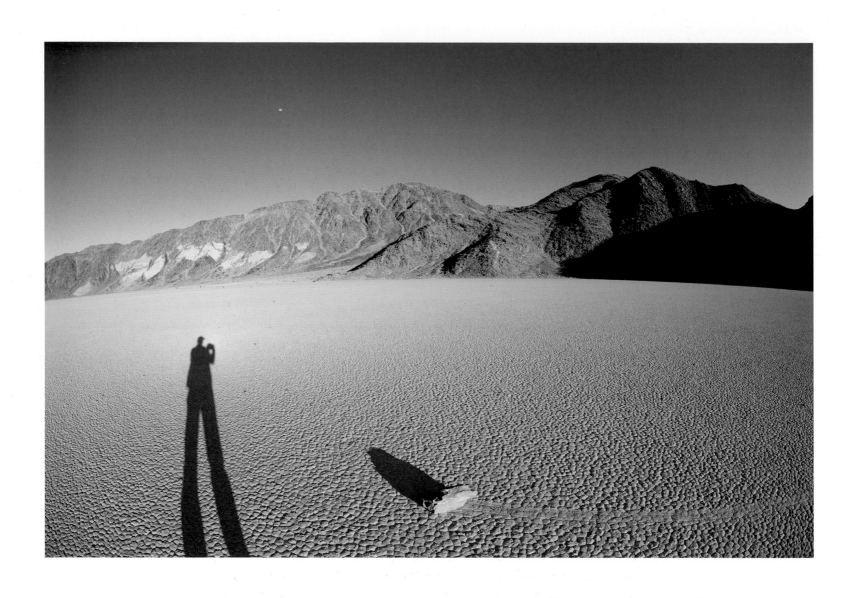

MAKING THE EXPOSURE

If photography is about capturing a bit of reality, then why do most of us get frustrated by what comes out of our cameras? The simple answer is that the problems occur because the cameras, printers, and monitors don't show the world as our eyes see it. There are a couple of terms that will help you grasp this dilemma and then figure out how to work around it. First, there is a scene in front of you and that potential image has what is called a *brightness ratio* of the scene. This is the ratio from the darkest point in the scene, probably a shadow hiding way under a rock, to the brightest point in the scene, such as a cloud in the sky. Then there is the camera's ability to record these dark areas and light areas in the scene, which is called the *dynamic range*. The trick is to get as much of the scene brightness ratio to fit within the dynamic range of the camera. Sometimes it all fits and other times only a small percentage fits. This lesson will help you determine proper exposure for an image, as well as when to apply an alternative method for capturing much larger scene brightness ratios than the camera's dynamic range.

You have walked miles through wind, rain, and deep snow with little food. Your toes are frozen and blistered; your illusions of grandeur are fading like the sun in the clouds above. But you do have your camera! Then you approach the destination and what you behold in front of you is spectacular. No words can describe the scene before you. The desire to capture it with your camera is overwhelming, pulling on your fingers like a child wanting to break into Willy Wonka's Chocolate Factory. Now it is up to you to make the technical decisions that will best record for all of eternity what you have worked so hard to discover. But lurking in the back of your mind is the fear that you will fail to capture the essential, unique beauty of what you have found, and this fear stems from your lack of understanding the instrument in your hands. This is a primal fear! This fear can freeze your intellect and reason, and confound your technical knowledge and creative strategies. The worst symptoms are forgetting you even have your camera, followed by not being able to find it in your pack. In the best-case scenario the fear will only cause partial brain freeze causing you to forget to take the lens cap off. I know: I've been there and done that!

With thousands of image possibilities in every direction—rocks below, trees to the west, swirling clouds to the north—it becomes overwhelming to take all the stimulus in and focus on selecting one perfect place to make one perfect capture

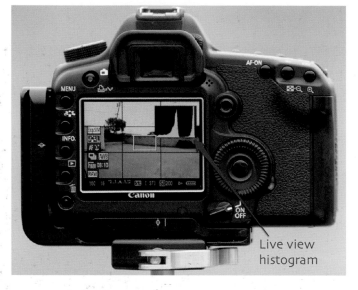

→ **Figure 7-1:** The histogram on the Canon 5D Mark II in Live View.

Live view histogram

□ **The objective should not be to capture reality, but to share your story or experience.**

that will show the world all that you are experiencing. The truth is that I have found it impossible. The reality of what is happening around me at momentous occasions is always different than what I capture with my camera. Therefore, the objective should never be to capture reality, but to share your story or experience. As I have mentioned, I break this problem down into two areas of challenge, the technical and the subjective. By understanding how to solve the technical issues, I hope to free your brain of the potential freeze so you can concentrate on the subjective, creatively.

It is possible to become more efficient at isolating your subject and, therefore, finding a compelling image when you are able to disregard all the options that don't meet your camera's technical requirements. This knowledge helps me focus, allowing me to eliminate certain possibilities that do not meet the criteria. The most important criterion on my list is *subject,* closely followed by *light,* which I also refer to as the scene brightness ratio. Since I discuss subject in other areas of this book, I want to address scene brightness ratio in this section. The scene brightness ratio will determine the feel of the image you will produce and what settings in the camera you will utilize. The scene brightness ratio will also dictate what method you will choose to capture it. Considering the scene brightness ratio of a potential composition helps me focus on one of the most fundamental aspects of photography: Light!

All the information captured by either film or digital sensors goes through a transformation. The greatest metamorphosis occurs when the dynamic range changes by either increasing or decreasing in scale. If the scene brightness ratio fits into the camera's dynamic range then your job will be to stretch it out in post. If the scene brightness ratio is far greater than the camera's dynamic range, then your job will be to compress it to fit within the dynamic range of a digital file. Imagine what your head would feel like at 30,000 feet in elevation, and than how it would feel after plunging 3,000 feet below sea level within a few moments, or vice versa! This is similar to what occurs to the scene in front of you as it goes from your initial visualization to finally ink printed on a piece of paper.

The faster I can determine what the scene brightness ratio of a scene is, the better I am at composing the subject. This information is critical in determining, on the fly, whether or not I need to capture the scene with a single exposure or multiple bracketed exposures. Basically, every scene brightness ratio will need to end up within the parameters of a digital file. To help understand what that means, here are a few facts about digital files.

A digital file is made up of 256 steps of gradation of light. Each step is considered part of the dynamic range. The darkest step, pure black, is represented by the number "0" and the brightest, pure white, is represented by the number "255". If your digital image file has pixels with a value in all the steps, then it is called a full range image. There are two different bit depths of digital files, 8-bit and 16-bit. Digital files stored in 16-bit do not have a greater dynamic range but rather more steps that define it.

I set my camera to shoot RAW files only. The advantage of shooting a RAW file is only realized if you are prepared to spend the time working on your computer with either the camera manufacturer's software or some third-party software called a RAW converter. I will be using Adobe Camera Raw (ACR) for the following lessons. If you don't want to take the time to

Regarding Contrast

customize each file, then you can set the camera to shoot JPEGS and allow the camera to determine how best to set the dynamic range.

Whether you are shooting RAW or JPEG files, the best way to capture the proper exposure while in the field is by using the camera's built in histogram. A histogram is a chart that shows you where the image data is located within the 0 to 255 steps of dynamic range. Your objective is to set the camera to make an exposure that contains as much of the data as possible within the histogram.

When I shoot with Live View on, I leave the histogram preview off and only display it once the image is taken. I do this because it usually gets in the way of previewing the composition, as you can see in figure 7-1. I usually take one exposure with the camera's meter mode set to "evaluative" and preview the image with the histogram showing. There are three metering modes to choose from so make sure you are in the correct one. If the data on the histogram is bunched up on the right, I will decrease the exposure time or increase the aperture. If the histogram is bunched up on the left, I will increase the exposure time or decrease the aperture. Nowadays you can also change the ISO until the histogram indicates the desired dynamic range. However, even with the Canon 1Ds Mark III and 5D Mark II, I use 100 or 200 ISO to reduce digital noise when making most landscape images.

Not all histograms are created equal! It is important to know that the histogram is simply a chart showing you the range of light that is present in the scene. Every time you move the camera to another subject, the histogram will change. There are two basic variables that effect the shape and position of the histogram: the contrast of the scene and the camera meter settings. Your job is to alter the shutter speed, aperture, or ISO to adjust the data in the histogram so that as much data as possible is contained within the chart.

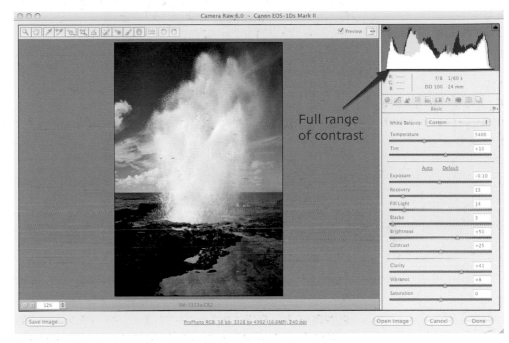

Figure 7-2: Blowhole, Kauai, Hawaii.

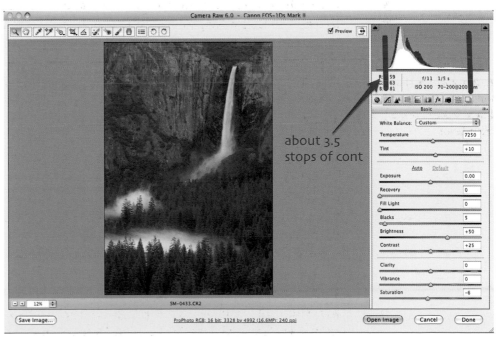

Figure 7-3: Bridalveil Fall, Yosemite National Park, California.

The sections along the range of the histogram represent stops of light. If the histogram of the image covers only three sections within the chart, then your image has only three stops of dynamic range, or contrast. If your histogram covers four spaces, then your image contains four stops of dynamic range. The important part here is to recognize either of two potential issues. First, when the data is stacked up against either end of the chart, you will want to make an exposure change. This is also true when the histogram covers all five spaces and begins to climb up either the left or right side of the chart. At this point you may want to make two or more exposures at differing values to capture the full scene brightness range. However, for now I will limit our discussion to a single exposure that hopefully contains all the data between the margins of the chart, and I will cover other possibilities in "Lesson #7: Manual HDR." Once you become proficient in the method described in this lesson, it shouldn't take you more than a few moments to derive the correct exposure. Also, remember that these recommendations are for most landscape situations. When I'm working in rapidly changing conditions with fast-moving subjects, I like to use aperture priority (AV) and let the camera do the majority of the work for me.

Here are a couple of tricky situations when making exposures:

Backlit

Most of the time, blown highlights look worse than black or blocked up shadows. In figure 7-4, the camera meter in evaluative mode made the exposure on the left. I had to manually underexpose by two stops to achieve the image on the right.

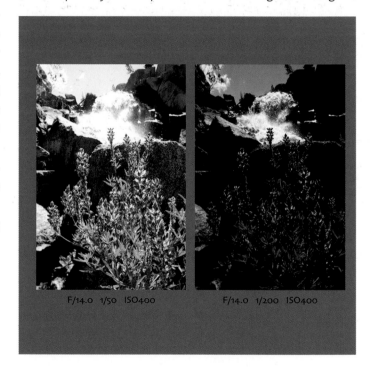

F/14.0 1/50 ISO400 F/14.0 1/200 ISO400

Figure 7-4: Upper Sabrina Basin, John Muir Wilderness, Sierra Nevada, California.

Snow or Mostly White

In this situation (figure 7-5) the camera meter is doing its job by setting the majority of the subject matter, snow, to the image's midtone. A midtone is the same as 18% grey, or in terms of density numbers, halfway between 0 and 255—about 127. Because I don't want the snow that dark, I manually overexposed the image by 1.25 stops.

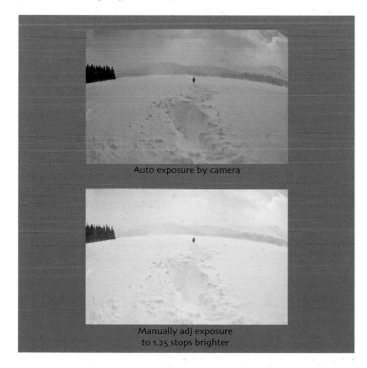

Auto exposure by camera

Manually adj exposure
to 1.25 stops brighter

Figure 7-5: St. Mary Lake, Sierra Nevada, California.

Very Low Light

This image of the Racetrack in Death Valley National Park (figure 7-6) was determined by the following method. Always remember that in low light you can use the ISO to reduce the amount of time it will take to determine your exposure time. For example, if your aperture is as wide as it will go and the exposure time is 30 seconds or longer, there is no way to determine the exposure without either using a manual meter, guessing, or changing the ISO. By changing the ISO from 100 to 1600 or greater, you are making your camera meter more sensitive. Once you determine your exposure length at the higher ISO, simply backtrack. If you determine that the exposure time is 10 seconds at ISO 1600, and you want to shoot at ISO 100, then your exposure time will become four stops longer. Since the ISO doubles every stop of light, your accurate exposure at ISO 100 for f/2.8 will be 160 seconds.

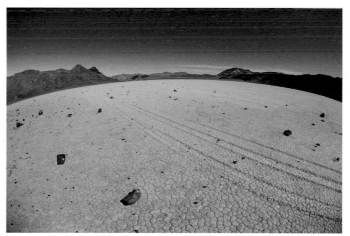

Figure 7-6: Full moon, the Racetrack, Death Valley National Park, California.

A few tips that have helped me along the way:

Use the histogram preview that shows all three color channels.

For a better look at the highlights, I review the histogram with all three color channels showing. Often, there is a single color that is clipping and the camera will not show this in the normal histogram view. This allows me to become more accurate with my exposure to determine when I have sufficient amount of data in the highlights while still keeping the exposure as bright as possible for the shadows.

Learn when and how to trick the camera meter.

To do this best, remember that whatever the camera meter is pointed at will become the midtone, which is as close to 18% gray as possible. The midtones in an image are the subject matter that best represents halfway between the brightest point and darkest point in any scene.

Utilize the technology.

I prefer to set the camera in evaluative metering mode, and change between aperture priority and manual for 99% of my work. This can be done with almost all DSLR cameras made today as well as with some point and shoot cameras. I do not use the spot meter except for a rare occasion. Center weighted metering mode is best for moving subjects that fill most of the frame. I always set the camera to manual mode when creating panos to prevent the meter from changing while moving the camera around. In this situation, if the meter were set in aperture priority or any semi or full auto mode, the exposure would change as the camera is pointed at different areas of the scene. I usually use aperture value mode when shooting hand held.

Keep it simple.

Just like an old pair of leather shoes, a camera should always feel the same when turning it on. If you remember to set everything back to your personal preferences after a shoot, then it will always be the same when you turn it back on. Canon has several ways of creating custom presets. Take the time to set these so you can become more efficient when responding to the call of sudden image possibilities.

Determine your presets.

Regarding your presets, determine what camera setting is most critical for you. For me, it's usually the aperture because the lens I'm shooting with determines my default aperture. I do this because all the lenses have a sweet spot, meaning they are sharpest at a particular aperture. Yes, aperture changes the sharpness of the lens! This sweet spot is normally two stops down from wide open but can vary from lens to lens. If your lens is f/4 then my guess for the sweet spot would be f/8. Because this makes such a big difference when enlarging image files, I have taken the time to purchase an Edmond Optics lens test chart (about $19.00 at time of writing). I place the camera as close to dead center of the chart as possible and fill the frame as best I can.

I then make exposures from wide open (widest aperture of the lens) in one stop increments until completely stopped down (smallest aperture of the lens). After downloading all the files, I review the files at 100 % enlargement in Adobe Camera Raw and determine the sharpest aperture. Additionally, this test shows many helpful characteristics of the lens beyond just sharpness, including barrel distortion and contrast. However, for the purpose of this lesson, I have listed the lenses I use and their sweet spots as follows:

- ◆ Canon 17mm Tilt/Shift f/4: sweet spot f/8
- ◆ Canon 24mm Tilt/Shift f/4 (version #1): sweet spot f/11
- ◆ Canon 17–40mm f/2.8: sweet spot f/11
- ◆ Canon 50mm f/2.5: sweet spot f/8
- ◆ Canon 70–200mm f/2.8: sweet spot f/5.6
- ◆ Nikon 16mm fisheye f/2.8: sweet spot f/8

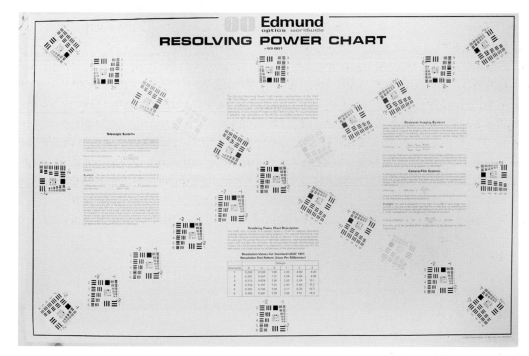

Figure 7-7: Edmund Optics Resolving Power Chart (36" × 24").

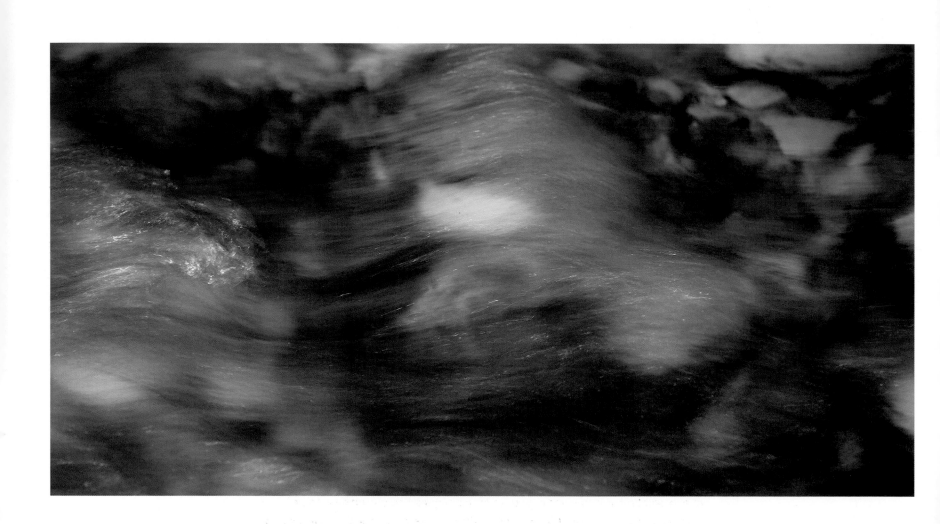

LESSON #2
THE WORKFLOW

The camera card is full, so now what?

The most certain aspect of my workflow is change. From the moment digital photography began depending upon computers, spare time became a mirage—a vapor that vanished as I wrestled with the onslaught of technical faults, glitches, and upgrades, all of which sucked more time from my life than sleep. I would like to formally add to the list of life's certainties of death and taxes a third item: Upgrades! Even so, as a culture we are obsessed with the computer, and Macintosh users even more so. Did you know that if you Google search the word "apple" there is nothing about the fruit until page 7? I admit I am no different. My workflow without an Apple computer would be like my life without my family: plausible, but boring, lonely, and difficult!

My workflow is based not only on a set of technical standards but personal values as well. Before I delve into the protocol, bear with me for a moment and consider that the exposed pixels are in a state of emergency until massaged. They lie dormant as a string of mystical code made up of the most rudimentary characters in the universe. What happens to them is dependent upon many criteria. The most influential factor in the transformation of the pixels into an image is me, the photographer. Just as the photographer influences what is captured, so too is the photographer empowered to transform these dormant pixels into a desired image.

This is where my so-called workflow begins: transforming RAW image files into final images is the priority of the lessons in this book. I hope that you take some of the recommendations and add them to your existing workflow, or take most of a lesson and add touches of your own techniques and procedures. Therefore, I want you to consider workflow a personalized set of skills, one that causes photographers to draw on and tap into a wide variety of resources in order to fashion each image as specifically desired. Understanding or envisioning what is possible can give you inspiring focus. Consequently, learning how to reach that goal or vision becomes only a matter of time. The repeatable process of turning an ordinary image into your own unique vision results in a much more efficient workflow, allowing you greater freedom for creativity and refinement. For these reasons, I consider an unprocessed RAW file similar to a sketch.

Figure 8-1: The RAW files—or the "befores".

Figure 8-2: Santa Cruz coastline, California. Final image after post-processing.

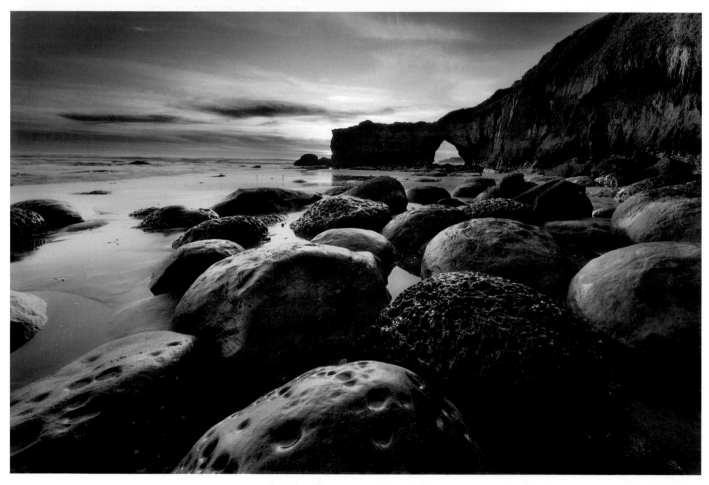

I would like to break down the process into three steps:

1. **Logging** – Logging your unedited work into an organized archive/database.
2. **Selecting the Images** – Identifying the images to process/edit.
3. **Post-processing** – This step includes everything from converting the RAW file into a TIFF or JPEG, to enhancing regions with regional dynamics and merging multiple files to control high contrast scenes.

Step 1 – Logging

Keeping track of your image files is best done first! Don't wait! Log your unedited images into an organized archive/database.

I use Adobe Bridge because I have grown accustomed to it over the years. Lightroom and Aperture can be used in a similar way. All my image files are stored on multiple external hard drives, which keeps my laptop hard drive space free for programs that I use in the field. Figure 8-3 illustrates where the files are archived as they move through the various steps of my workflow. This type of tree of folders can be created on any computer or platform.

To download my images, I use Firewire 800 card readers and portable hard drives. I never store files on my laptop, but instead organize them on two external LaCie hard drives. One drive is for the working files and the other for a backup. During downloading of the image files I use metadata templates for adding basic information to all my files. The metadata templates are found in Bridge through: File menu > Tools > Edit Metadata Template. The fields I use are shown in figure 8-4.

Lightroom also utilizes templates and I would highly recommend using these to record the location information while it is fresh in your mind when you download the images. In the field, I will take a snapshot of the interpretive signs at the location to remind me not only of where the pictures were taken but also to provide valuable information about the subject. Once all my images are stored in the necessary folders for the shoot, and all the files are on multiple hard drives, I can begin the fun part! The simplicity of this method becomes quite apparent when I return to my studio and drag and drop one folder from my shoot onto my studio hard drive (my RAID). Once on my RAID, I can then delete the images from the memory cards to be ready for the next shoot. If you are using Lightroom, you must complete several steps. First, the catalog must be exported, which creates a file that can then be imported on your

Figure 8-3: My personal logging system.

Figure 8-4: The Edit Metadata Template in Adobe Bridge.

home or office computer. Second, you need to keep the same names on all the image folders and copy all folders to your home or office storage device. Once you have imported the catalog file into your home or office computer, you will need to relocate the folders of images. This is done by right-clicking on the folder and navigating to your new location.

Step 2 – Selecting the Images

Editing images can be enjoyable, depressing, or dramatic, depending on your expectations and memory of the shoot. For some reason, I usually alter my perception of the images between the shoot time and the edit time, no matter how short or long it is. I must tell you that I don't shoot tethered and normally don't peek at any images until the night of the shoot, or in some cases, several weeks later. Therefore, my mind has time to create visual monsters or angels of the images that await my viewing. On most occasions, when shooting on assignment, I review the day's work that night. When shooting for myself, I like to wait at least a day or two. Then, when the time is right, I am anxious to get right to it.

So, here are a few tips to help you quickly get to the earth-shattering moments of finally seeing your images. I have set up my laptop with the very same configuration as my desktop in my studio, which allows some luxury of familiarity between locations. I try to standardize as much of my processing protocol as possible so I can freely accomplish as much in the field as in the studio. Even so, I usually prefer to work on large files and projects at my desk with my larger screen and comfortable chair than on my laptop. On the other hand, good times can be had editing in the field. I do have very fond memories of editing on a porch with a view, a cool breeze on my face, a drink in hand and, of course, good tunes to set the tone. On cold nights, the warmth on my lap radiating from my laptop battery is always comforting.

←

Figure 8-5: The Bridge Light Table.

My Bridge Preferences

The set-up I use in Bridge optimizes how I can view my work by setting preferences to best utilize the layout of the windows. Figure 8-5 shows my standard configuration.

This layout helps me quickly view all the images taken in one session and is called the "Light Table" view. To create this view, I have customized the default by adding, moving, and deleting a few panels. The panels can be dragged around within the program and will snap into different places. Once you perfect your layout, save it in what is called a workspace using the following path: Window > New Workspace > Workspace, then check both boxes and name your Workspace for later retrieval. I have also customized the fields in the visible metadata as shown in figure 8-6. There is a link to the Metadata preferences shown in figure 8-5.

Using the shortcut keys makes editing much more efficient. For example, use the shortcut key Cmd + G (Cmd on a Mac = Ctrl on a PC) to stack several similar images or multiple image files taken for one panoramic image. Also, I use the spacebar to quickly view only the selected image full screen, or Cmd + B to view multiple selected files at the same time. Additionally, by clicking on an image once in full screen preview, the image is magnified to 100%, which allows me to check focus. If

➡

Figure 8-6: Example of my customized Metadata settings.

I want to keep the image, I give it a star or two; consequently, all the unstarred image files are considered "seconds". As you browse through your folder of images, I recommend rating and stacking all the images you plan on revisiting. When I am done browsing a folder I can immediately identify that the unmarked image files are seconds and/or garbage to delete at a much later date. The most important part of this first round of reviewing for me is to make a quick selection of the five percent that I couldn't live without. I do this in every folder, forcing me to make a decision at that moment. I can always go back and change my mind, as I keep the seconds for years.

Place the starred images in a subfolder titled "Selects" or "Numbered," whatever your preference. Spend time on those files right away by utilizing Adobe Camera Raw. You can even do some regional corrections, HDR processing, or stitching. I view this time as productive, but every photographer has different opinions on editing or even viewing their work while

on a shoot. If I need sleep, then the in-field edit will have to wait until I have more time later in the trip or when I'm back in the studio. My goal is to get a visual of what I have created and potentially make changes or consider revisiting a location. This is the main reason I edit in the field. The only time I never preview images is when I'm backpacking, which gives me more time to photograph the stars.

Step 3 – Post-Processing

Once back in the studio I begin the majority of the creative work! Most of what I do in post-processing is done to enhance and personalize the images. I have used Photoshop for 14 years. I use three plug-ins on occasion: Noiseware, Alienskin Blowup, and Photomatix Pro. Post-processing is like polishing the china. If you create great RAW data during the capture (i.e., great light, sharp focus, good composition, etc.), then you can make the image even better in post-processing. However, the understanding that it is possible to create almost anything in Photoshop can be more damaging to photographers than anything else. I'm not suggesting that limiting creative potential is preferred, but rather, being directionless in a sea of randomly applied possibilities is worse.

If you are just beginning to study photography, start by creating images. Spend more time photographing than processing. It is true that postprocessing will improve your knowledge of taking images, but you should first learn how to make a good image that does not need any postprocessing. I recommend setting the digital camera to shoot JPEGs and letting the camera do all the processing for you. Once you have made some nice images that look good right out of the camera, then it is time to begin exploring postprocessing. There are many great ways to learn the basics in Photoshop or even Photoshop Elements. Nowadays Elements has enough tools to keep the novice happy for quite a while. When you do take the plunge into

Photoshop, I suggest learning the basics first. (I'll write about some of these tools in "Lesson #4: Massaging the Middle.")

When you begin, I also recommend learning about density numbers so you understand how a digital file is represented by those values. Once you have a grasp of how a digital file is made, then you will understand how, why, and when you can tweek it for a certain look you want to achieve. It is also important to know whether you are doing damage to the data and just how much. Learning a new tool is simple compared to learning why and when to use it.

I began by using Photoshop version 3.0. Also in 1997, I purchased a PowerPC Mac with two Data Dock hard drives, each with a whopping 9 gigs of space. The monitor was a Sony Artisan, complete with a *tube*. The whole system cost about the same as a BMW! I logged several hundred hours in the first several months alone. Since then I can estimate that I spend about 500 to 800 hours a year post-processing, which adds up to somewhere around 10,000 hours since 1997, or just under a year of actual time. Enhancing the RAW data/image is the skill, craft, and *art* that defines my final statement: I would be frustrated and discontented if I could not complete my work efficiently and as I expect to.

I feel some of my intrigue and obsession with postprocessing is due to the greater opportunities it affords my creativity. I am fortunate for the time spent learning both darkroom techniques and their inherent limits. With these older processes as a reference, I'm always thrilled to learn and apply the modern computer techniques. I make sure that my time is balanced between tinkering versus working on images. There are handsome rewards for tinkering, but with endless processing possibilities, time can be easily wasted. I can define the fine line between too little and too much post-processing by losing my focus from what I consider the planned intentions and getting lost in those "enhancement tangencies" as my mouse begins finding filters, plug-ins, and layer blending modes, which is similar to filling a plate at the buffet with more food than I can eat. Risking the possibility of wasting time, I continue to poke around in Photoshop, knowing that the long hours I have already spent in this process have forced me to look closer at the way I take pictures, which ultimately makes me a better photographer.

Post-Production Basics

Helpful tools of the trade

There are times I don't read instructions, especially for things with few moving parts or few parts period. I would rather scratch my noggin and contemplate what to do than actually pour over the pages. It just so happens that the practice of not reading instructions is not uncommon. It is also common that most people wait too long to re-roof their houses or calibrate their monitors. However, calibrating your monitor is even better than re-roofing your house. Unlike a new roof, which is only appreciated when it rains or a seagull flies overhead, a calibrated monitor is celebrated every time you open an image on your computer.

Before you go out and purchase a calibration instrument with accompanying software, I would like to set the record straight and inform you that it is really not necessary—highly recommended, but not necessary! In fact, if you learn to read density numbers, it is possible to manage a color workflow even if you are colorblind. The interesting part about digital workflow is that as important as the monitor has become in one's darkroom today, most old school, film-based photographers had to understand how to read the image file data because it was imperative to properly scan film and, way back then, monitors were too rudimentary to properly project the image. Understanding how to read the image data so that it becomes second nature takes experience along with knowledge about various tools. Because I was required to learn most of these tools to operate our drum scanner to make CMYK

eye dropper tool

click to set 3 channel view
of histogram

↑

Figure 8-7: Often-used
tools and windows in
Photoshop.

➔

Figure 8-8: Color Settings
found under Preferences.

separations, implementing the same skills in Photoshop be-
came very useful. There are several tools that I have found in-
dispensable and use even today while viewing my images on
a calibrated monitor. Ultimately, I do recommend a calibrated
monitor even if it costs extra. Figure 8-7 shows two Photoshop
windows and one tool I use all time: the info window; the his-
togram window, with all channels; and the eye dropper tool,
with a sample of 3×3 pixels.

While processing images, these may not be the only win-
dows I have open, but they are two very important ones in re-
gard to determining accurate density and color. In Preferences,
I change the color settings in Photoshop to those shown in
figure 8-8.

I have a few shortcut keys I have customized and I recom-
mend looking through these to see if there are ones that suit
your personal habits. The keyboard shortcuts are found in File
menu > Edit > Keyboard Shortcuts. I reassign "Cmd + M" to
create a Curves Adjustment Layer rather than just a Curves
Adjustment. I also change "Cmd + L" to convert Color Mode to
LAB and "Cmd + R" to convert Color Mode to RGB.

Just like in Bridge, I create a custom workspace in Photo-
shop. I recommend learning how to save your workspace so
that as it changes with your increasing knowledge and effi-
ciency, you will know how to activate it. The workspaces are
found in File menu > Window > Workspace. Once you drag the
tools you want into place, make sure you save a new workspace
and title it. You will be asked to save the shortcut keys as well.

This last recommendation is something that has saved my
hide many times: Create a multistep grayscale within Photo-
shop that can be used to check the calibration and profile of
both your monitor and printer. Often, especially on days when
solar flares knock out your computer, I recommend double
checking that all equipment is working as it should. Once you
create the grayscale in Photoshop as an RGB file, print it in RGB
mode. This will test your printer in two ways. First, the printout
should be gray. Second, all 52 of the steps should show. Once

type keys and then click accept

Figure 8-9: Custmized Keyboard Shorcuts and Menus.

Figure 8-10: Personalized Workspace.

printed, hold it up next to your monitor and compare. To do this accurately, you MUST have a proper viewing light next to your monitor. Viewing the grayscale print (or any print) next to your monitor without proper lighting it simply not worth it. Follow these steps to create your grayscale:

1. Go to File > New
2. In the dialog box chose Dimensions. I recommend the following settings:
3. Width = length of media; Height = 1/8 of width
4. Resolution: 300 pixels/inch
5. Color Mode: RGB Color 16bit
6. Background Contents: White
7. Click OK

After clicking OK you will have a blank, white canvas of your chosen dimensions.

Choose the Gradient tool and make sure the background color is set to default "black to white." You can hit the "D" key to do so. The two squares at the bottom of the tool palette will appear with black on top of white.

Click on the white canvas just inside the left border, hold the shift key, and drag right. Let go just inside the right border. Holding the shift key will keep your drag perfectly horizontal.

After letting go, your white canvas will now be perfectly gradated from left to right, black to white.

Go to Image > Adjustments > Posterize. This will default to 4 levels. To increase the number of levels, click the slider and drag right to 52. If you are only using an 8.5 inch printer I would recommend only 22 steps, just so the steps remain visible.

Figure 8-11: Background gradiant.

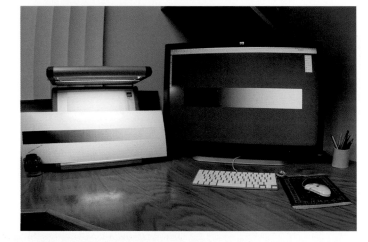

Figure 8-12: Background gradiant shown on my monitor.

Figure 8-13: As you can see here, my monitor is not efficient in showing low-end detail.

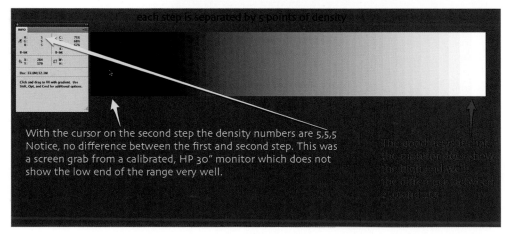

each step is separated by 5 points of density

With the cursor on the second step the density numbers are 5,5,5 Notice, no difference between the first and second step. This was a screen grab from a calibrated, HP 30" monitor which does not show the low end of the range very well.

Make sure you set your printer to RGB and not grayscale mode! By printing in RGB you are forcing the printer driver to utilize the color inks to create a neutral gray. This will reveal any potential issues you will have with your printer. If the grayscale is not *gray* then your printer could have a clogged print head or, even worse, it might not be adequate for fine photo printing. Many printers will not show a difference between the step with "0" density and the step with "5" density. In some cases there will be no noticeable difference in the steps until the third or fourth step. After printing the grayscale, I look for an even transition from dark to light because a sudden transition in the gray indicates that something is wrong with the printer or profile. Additionally, if I am having trouble with a color cast, I use this grayscale to hold next to certain color prints as a reference for neutral gray.

Figure 8-13 shows how my monitor is inefficient in low-end detail. By knowing that my monitor does not show the difference between 0–5 and 10 RGB values, I will not waste my time making those areas in my file too bright. Since the printer does show the difference between the 5 and 10 density numbers, I will usually make a proof print prior to changing those darker regions in the file. You can use this very same grayscale file for any reproduction that you plan on going to, even your favorite website like Facebook. If you decide to publish an image to Facebook or anywhere on the Internet, just make sure you go to Edit > Convert to profile within Photoshop and change the destination color space to sRGB.

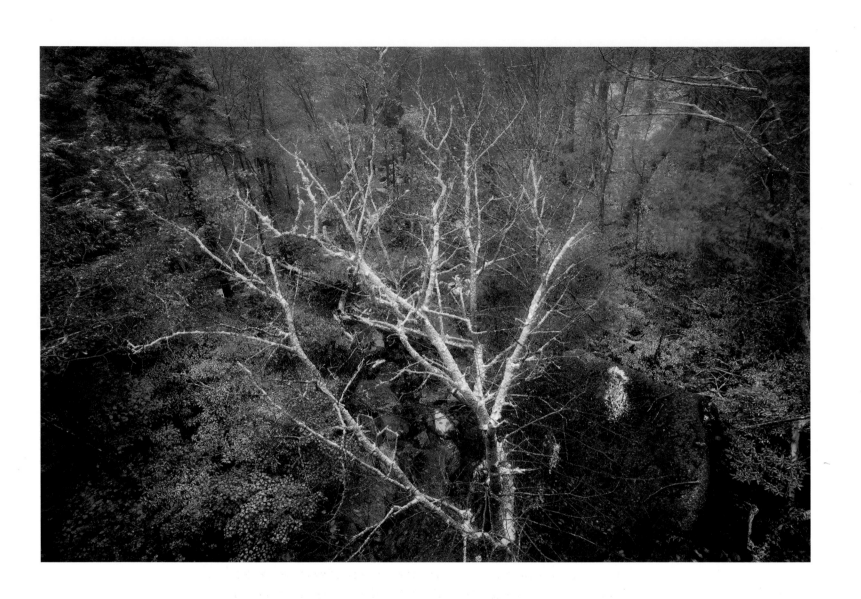

LESSON #3
SETTING THE RANGE

If the brightness range of an image fits within or just over the dynamic range of your camera, this lesson will show you the first step in post-processing. Understanding why the image data does or does not fill the span of the histogram is what this lesson is about, as well as manipulating that mountain of data so that it is best converted into the image you want.

There is a little business to take care of before we begin. There are several settings in Adobe Camera Raw (ACR) that I either change or check before I begin any work on just about every image as follows:

- The second tab in the Tools panel, Tone Curve, offers two additional tabs once selected. The first is Parametric and should be left alone. The other tab just to the right is Point and should be changed from its default of Medium Contrast, to Linear. This will change/lower the contrast of any image open, which can become a problem when you want to lower contrast in an image and forget this setting is already working by default. So, if you are like me and don't like hidden edits, change this setting and save it as a preference.

- The seventh tab over from the left, Camera Calibration, is where the camera profile is set. It is possible that an undesirable profile is set by default. The only two I have ever used are Adobe Standard and ACR 4.4.

- The remaining three defaults I change are in the link at the bottom of the dialog box where you will see a line of type stating the color profile, bit depth, and resolution. I click this link and change the default from Adobe RGB to Pro-PhotoRGB. Next, I change the Depth to 16-bit. The other remaining options, Resolution and Sharpen For, I leave alone. I never use this sharpen feature, as I never know exactly what my final print size will be.

- The last item is simply that ACR will open JPEG and TIFF file formats, but because the range has already been set by either the camera or scanner for these files there is no reason to follow this lesson. I have used ACR to edit JPEG and TIFF files for other reasons though.

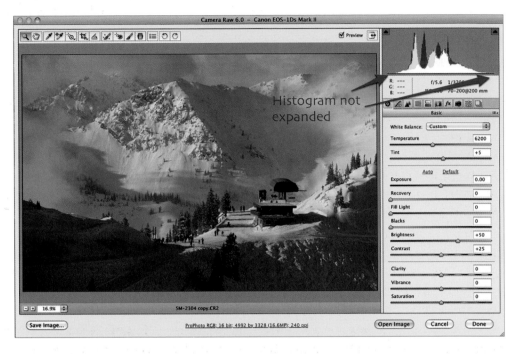

Figure 9-1: Before the white point and black points are set.

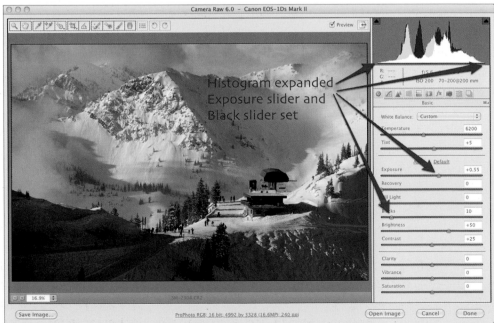

Figure 9-2: After adjusting the settings.

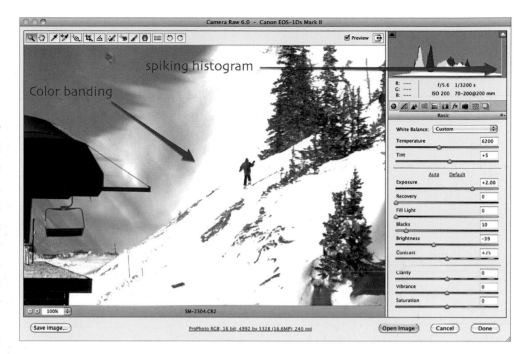

Figure 9-3: Exaggerated settings to show color banding.

spiking histogram

Color banding

To better understand dynamic range, consider it similar to a jar of cookies! Every landscape image, or image of any kind, in the form of a digital file has a dynamic range that represents the scene brightness ratio you witnessed with your very own eyes. Consider the image file is the pile of cookies and the contrast ratio the jar. Wouldn't we all like a jar stuffed full of cookies and not just half full and topped off with stale crackers? Even after exposing properly, if the white point and black point are not properly set while scanning or converting a digital file from RAW to TIFF, it is similar to leaving the jar partially empty, or worse, filling the space with stale crackers.

Setting the dynamic range is a very important step that is not that complex and should only take moments: Set the highlights, then set the black point. Done! I know there are many more slider settings and pull-downs within most RAW converters such as Adobe Camera Raw, Lightroom, or Aperture, but if this were the only step you performed in post-processing, your images would look much better. The reason for setting the white point/highlights and black point/shadows correctly is so you don't lose important data and/or that you correctly place the tonality of the image file according to how you want others to see it. Figures 9-1 and 9-2 show the same image without and with the range set.

So, what does losing important data mean? If the highlights are too bright, commonly known as "blown," there will be no ink printed on the paper or no texture or definition in those areas. If the range is not set bright enough, your image will look flat or gray. Even worse, if the highlights are blown in large areas such as clouds, banding can occur in the areas where the white transitions into gray. I have exaggerated the settings in figure 9-3 to show what banding looks like.

If you set the black point too dark, the only ink on the paper will be pure black. If you don't set the black point dark enough, the image will look flat or gray.

In Adobe Camera Raw, as well as Lightroom, there are only two sliders used to set the white point and black point:

- The Exposure slider sets highlights or the white point.
- The Blacks slider sets the black point.

The goal here is to set them as close to the limits as possible, as shown in figure 9-2.

First, hold down the Opt key and click on the Exposure slider. The screen will turn black except for blown pixels. Once again, blown pixels are completely white and hold no image data information. Your job is to move the slider left or right, just enough so there are no white or colored dots. The colored dots represent specific colors that have become clipped.

Second, hold down the Opt key and click the Blacks slider and the screen will turn white. Your job is to move the slider just enough to the left or right until there are only a few black dots. Colored dots may appear first, but you want to make at least one black dot. The dots are very small and you may need to zoom in on the area where the dots first appear, allowing you to be more accurate.

Of course there are all those other sliders with more refinements and many more cool features. Properly setting the Exposure and Blacks sliders, however, is the first major step in post-production and improving your images.

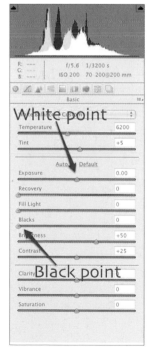

Figure 9-4: The two sliders that matter: Exposure (for highlights) and Blacks (for the shadows).

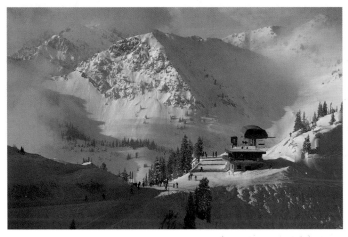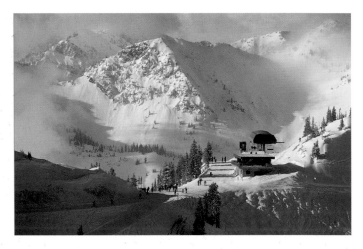

Figure 9-5: Before (left) and after (right) changing my settings.

Now that you see the difference in an image with the right tonal range versus setting the wrong range or none at all, you can begin to make additional refinements, which is what I cover in the next lesson, "Massaging the Middle." Before I go on, however, there is one very important fact I must mention. There are some images that simply don't need a white point and/or black point. In some of these cases, simply sliding the Exposure slider right until the image appears visually appealing is adequate. For example, the following two images do not require a full range in my opinion. Figure 9-6 shows what the image looks like with no actual white pixels. This illustrates that there is a difference between setting the white point and setting the bright point. Some images only need a bright point. In these situations the setting is purely a subjective choice.

As opposed to no white point needed, there are images that should not have anything close to a black point. Once again, in these situations, simply moving the black point slider until the image is visually appealing is all you need to do. For example, there was no black point set in figure 9-7. Remember, these visual subjective decisions can only be done with confidence if your monitor is calibrated and you know how the files will print.

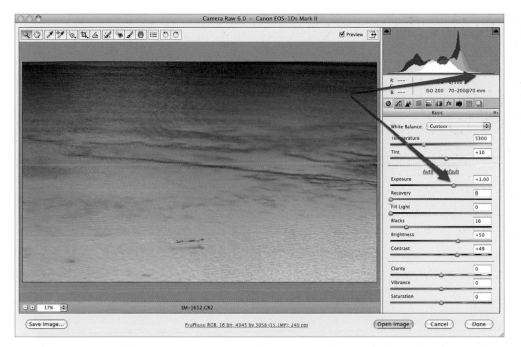

Figure 9-6: Example of an image that has no white pixels, thus no need to adjust the white point.

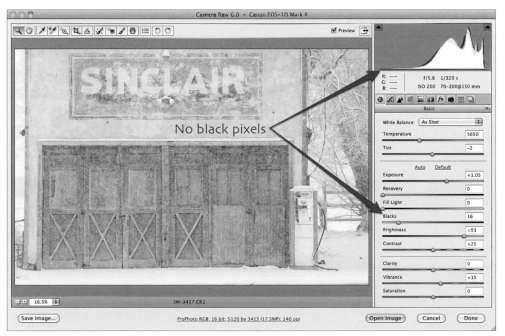

Figure 9-7: Example of an image that has no black pixels, thus no need to set the black point.

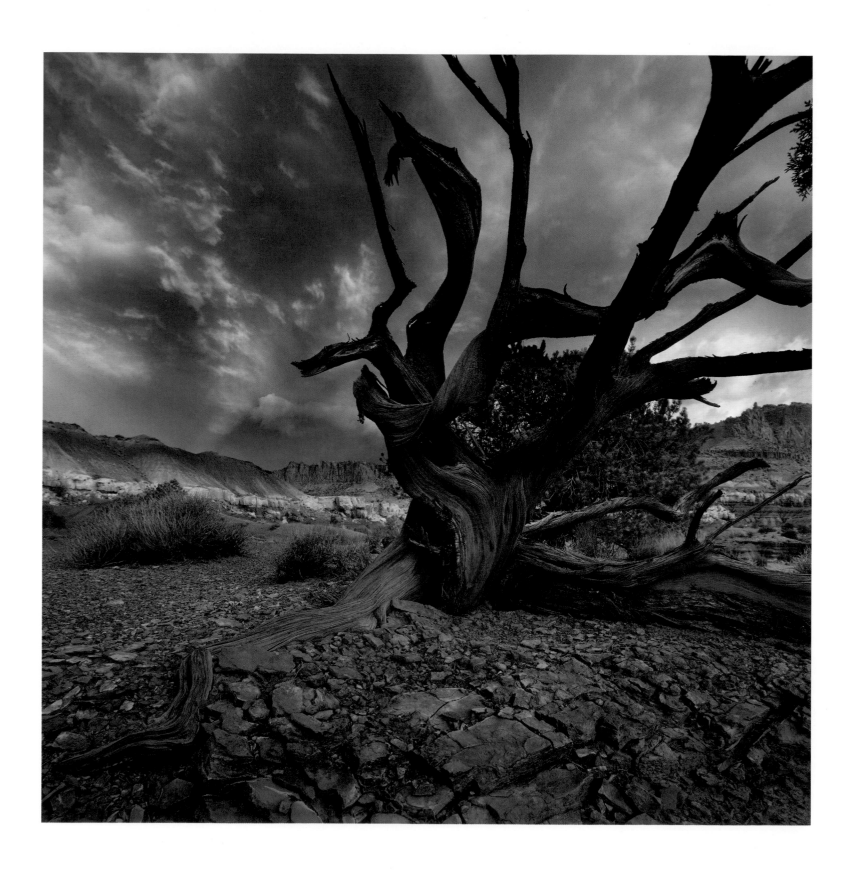

LESSON #4
MASSAGING THE MIDDLE

All Those Sliders

This lesson is about Adobe Camera Raw (ACR), but these concepts will work in Lightroom (LR) as well since all the tools and sliders are the same. This lesson in setting the range is what I consider a refinement and is, in most cases, very important. My intention for this process of converting a RAW file into a TIFF is to make a pleasing canvas which I can manipulate later in Photoshop without making drastic changes to global contrast, color, or density. The majority of the Photoshop changes are regional, which will be covered in the following lessons.

I use the following sliders to manipulate the data between the white point and black point based upon each individual image. This is one of the most important considerations in my workflow. I view each image as a separate job and never consider automating the following steps unless the lighting was exactly the same for a group of images. However, that is very rare while photographing a landscape. The only situation where that occurs is when processing panoramic image files.

- Temperature
- Tint
- Recovery
- Fill Light
- Brightness
- Contrast
- Clarity
- Vibrance
- Saturation

The first two sliders are very simple but can make people just as crazy as getting stuck in traffic. First, I would like to share some foundational information that has become some of the most valuable guiding principles on which I have relied throughout my post-processing experience.

- Each square pixel represents not only resolution but a single color value.
- All color values are made up of a combination of red, green, and blue.
- If the combination is equal, such as 50 points of red, 50 points of green, and 50 points of blue, the color value is what is considered *neutral*.
- A neutral color value appears as white, black, or a shade of gray.
- If a color value is *not* equal in all three colors, it has a color cast.
- The pixels *between* the black point and the white point can be manipulated, but once the points are set they should not be changed.
- By understanding the density numbers in a digital file, especially the neutral ones, you can manage your color workflow with hard facts rather than "guestimations."

The advantage of capturing and post-processing in 16-bit is most celebrated by the lack of banding, especially in gradual gradations such as dusk or dawn skies. I recommend keeping it simple by saving your image files in 16-bit and not converting them to 8-bit until you absolutely must, like when printing to some devices or publishing to the Internet. Just remember, if you are shooting JPEG files, they are going to be in 8-bit from the get-go and there is no reason to convert to 16-bit.

An interesting human trait is that we are great at making comparisons. However, we have a lousy memory when it comes to color. Therefore, most of us would not recall if a color had been changed until two samples were laid out in front of us side-by-side. This is why the neutral numbers in digital files help create a foundation upon which I have been able to rely for working with different colors across different monitors, printers, and even software programs.

Basically, a gray pixel is a gray pixel is a gray pixel, and should remain the same in different software applications, on a monitor, or on a printer. There are many various color test charts incorporating many values of colors including skin tones, flowers, etc. that are very helpful for standardizing device tests. I described a simple one in the last lesson for creating a gray scale. What is important for now is the understanding of how best to manipulate the sliders that I list below by using specific settings. I usually manipulate the sliders in my own order and not in the order they are presented in the program. Here is my order:

1. Exposure and Blacks sliders
2. Temperature and Tint sliders
3. Recovery and Fill Light sliders
4. Brightness and Contrast sliders
5. Clarity and Vibrance sliders
6. (I rarely use the Saturation slider)

The Temperature and Tint sliders represent all the colors and offer the user a simplified method for choosing just about any color within the color wheel to place upon the entire scene, which might be considered as a filter placed over the lens, thus applying a color cast to the entire image. Choosing what color cast you want is much simpler if you are not color blind and if your monitor is properly calibrated. If you suffer from either of those handicaps, then you will need to go by the numbers alone. To go by the numbers simply choose the Eyedropper tool in the top of the ACR window and then find the most neutral subject in the frame. This can be tricky but, fortunately in nature, there are many rocks, clouds, and dirt that are very close to neutral. Click that location on the screen and you will notice the entire image change because this made the exact spot you clicked "neutral." However, this is different than setting a neutral white point and black point, as this is only setting a neutral midtone. The scanning technician who taught me a variety of the best scanning techniques once called this activity "finding the hidden gray scales." Figure 10-1 shows the image before

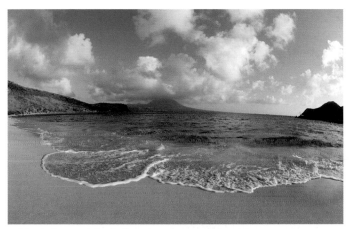

White balance, default from in-camera AWB setting.

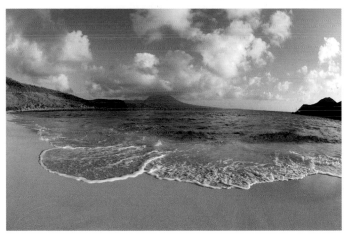

White balance set in ACR.

⬆ ⬆

Figure 10-1: Before and after setting the Color Balance.

and after setting the color balance using this method. I chose a light area at the top of the small white water, knowing this "white water" would be neutral. The important change I made was placing the warm evening cast back into the scene, which the camera was attempting to eliminate.

The Recovery slider manipulates the data near the highlights, and the Fill Light slider manipulates the data in the shadows near the blacks. My normal application for the Recovery slider is to retain some texture in and around a sun star, water reflection, or maybe a bright cloud. I do this by dragging the slider to the right 10 to 20 points. I usually don't go past 20 as it can cause the whites to go an ugly gray.

The Fill Light slider does just what it says: opens up the shadows by making those areas slightly brighter, appearing as if you used a flash fill. I usually don't go beyond 20 points as doing so creates digital noise. Figures 10-2 and 10-3 show the before and after effects of applying these two sliders.

The next two sliders are the Brightness and Contrast sliders. In the same way the Recovery slider affected the Exposure slider, the Brightness slider will affect the Exposure slider as well, if altered a great deal. *Warning: You may need to reset the Exposure slider if significant changes are made.* For now, just remember that this slider is affecting the midtones, or mainly the mountain of data in the middle of the histogram. Adjusting this setting is completely subjective. The default settings for these two sliders are Brightness = +50 and Contrast = +25. Just don't forget to double check that the point curve in the Curves tab has been changed to Linear from the default setting, or you may be doubling up on your edits. As you may notice in figure 10-3, I have the Brightness slider set to +56, so the image looks brighter. As you see, there isn't much to it!

This is a great time to use the numbers to verify your Brightness settings. Place your printed gray scale next to your monitor so you can look up where in the scale your most important subject is being placed. For example, the numbers of the sand in this image are R=139, G=127, and B=100.

Figure 10-2: Before applying the Fill Light and Recovery sliders.

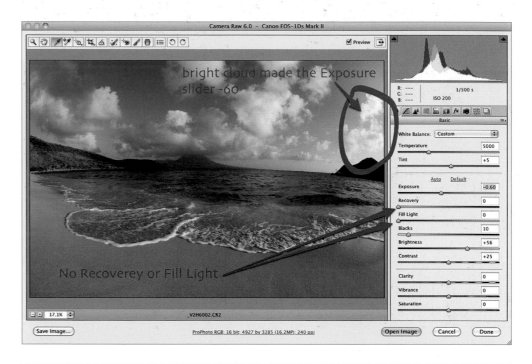

Figure 10-3: And after applying the Fill Light and Recovery sliders.

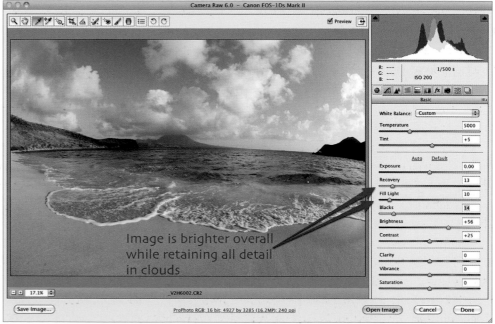

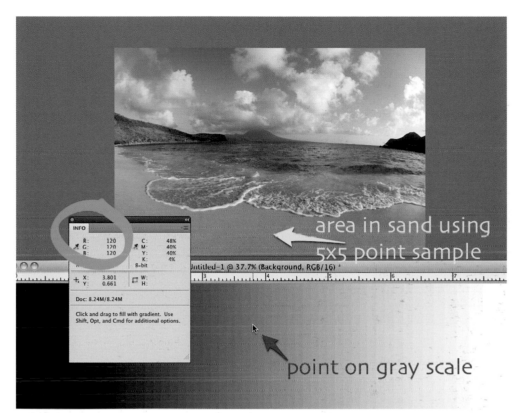

Figure 10-4: Selecting a gray point.

This data tells me there is a warm cast in the sand and that the brightness would be about the average of these, at 120 points. The bar closest to the 120 indicated how bright the sand will be when you go to print. Figure 10-4 shows where on the gray scale the 120 bar is and where in the sand I chose to sample. It helps to write the numbers on your print while you get used to using the gray scale.

Adjusting Contrast is very similar to adjusting Brightness in that it is also more of a subjective manipulation. The best advice I can give regarding these more subjective sliders is that a calibrated monitor will show you what you are actually doing. If you don't have the opportunity to calibrate your monitor, it is better to make small adjustments. I usually add contrast to specific regions later during the regional dynamics step, explained in Lesson 5. I also recommend adding only a touch of contrast until you have processed many files and people are telling you that your images look flat. At that point you will know exactly how to fix the problem. The alternative

is for people to consider you a hack who overcooked the sliders, and that is much worse!

Last and least are the Clarity, Vibrance, and Saturation sliders. Please understand that the following is my opinion based on how my workflow is set up. I am more concerned about making similar changes to what these sliders offer to regions of my images rather than globally. Having said that, the slider I use most often is the Clarity slider. This is another subjective decision, but its impact happens to be more noticeable on any monitor than the effects of the other sliders. The Clarity slider adds contrast to the mid tones, with one of the more noticeable effects appearing in cloudy skies. Figure 10-5 shows the effect of the Clarity slider set up to + 40. This defined the puffy tropical clouds and reduced the appearance of the tropical haze. This edit also added contrast to the white water on the surging wave.

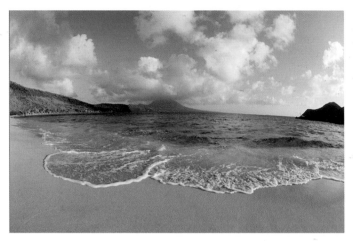 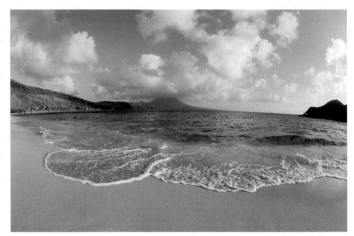

Figure 10-5: Before (left) and after Clarity had been set to +40 (right).

Two More Great Tools

So far, all the edits I have discussed have been applied to the entire image, so they are called global edits. There are two tools recently added to ACR and LR that allow you to make regional changes. They are called Adjustment Brush and Graduated Filter. These are located in the Tool panel on the upper-left corner of the ACR program window.

I use the Graduated Filter more often than the Adjustment Brush, but both can be very effective when applied correctly. The first tool I will cover is the Adjustment Brush. You must first consider what you want to change within a specific region of an image. To better understand just how and why you would determine this, I recommend reading "Lesson #5: Regional Dynamics" prior to attempting to use these two tools. The point is that these tools allow you to control the look of specific regions of the image without affecting the entire image, which is the difference between making global verses regional adjustments.

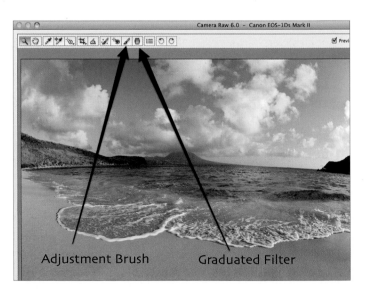

Figure 10-6: The Adjustment Brush and the Graduated Filter tools.

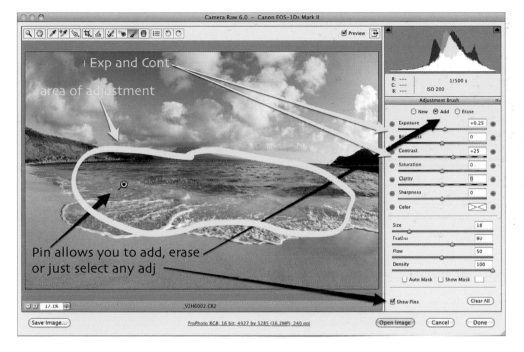

←

Figure 10-7: The image after increasing contrast and lightening the center.

Once you choose the Adjustment Brush, you will see a set of similar sliders on the right of the dialog box. These sliders do the very same things as explained in the previous section. To change the size of the Brush, move the Size slider. If you want to Feather the edges of the Brush than change the Feather slider, and so on. The most important tip I can give you is to be aware of the Auto Mask button. I normally don't rely on this feature and therefore I uncheck it. If you end up changing the Density a bit too much, there will be an ugly line around the edge of the mask that can become very difficult to remove later. Use this tool to lighten or darken regions with an appropriate sized Feather so the edges cannot be detected. Figure 10-7 shows how I added contrast and lightened the center of the image.

The Gradient Filter is very similar in that I use it to lighten or darken a specific region in the image. However, what is unique about this tool is that it is linear. This can become a split neutral density filter if applied correctly. First, determine the approximate edit you would like to make to the region you plan on affecting. You can change this again once your selection has been made. In figure 10-8 I lowered the Exposure slider to −.65. Once any size edit has been made, the Gradient Filter will preview the change live while selecting that region. Click once to set the beginning of the filter, drag over a region to feather, and then release the mouse button. Figure 10-8 shows how I darkened the sky.

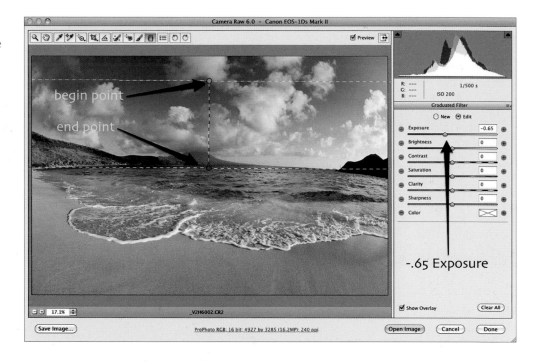

Figure 10-8: I lowered the Exposure setting and darkened the sky.

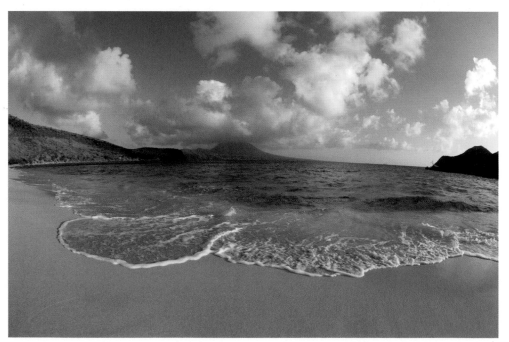

Figure 10-9: The original image with the default settings.

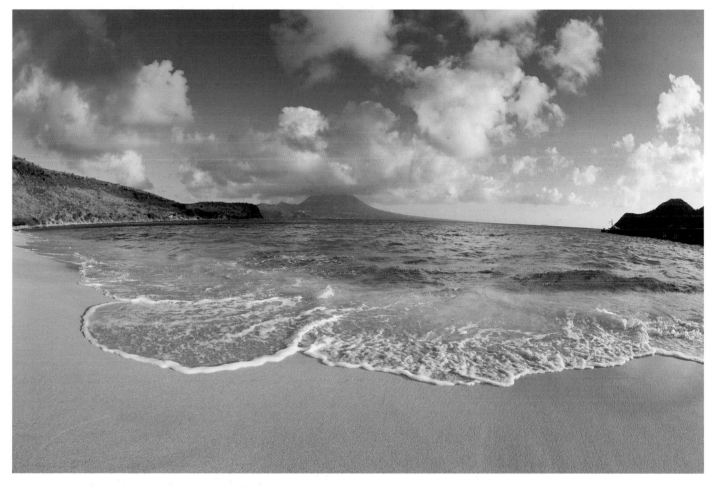

Figure 10-10: The final image showing what has been done over the course of this lesson (including setting the range as described in Lesson #3).

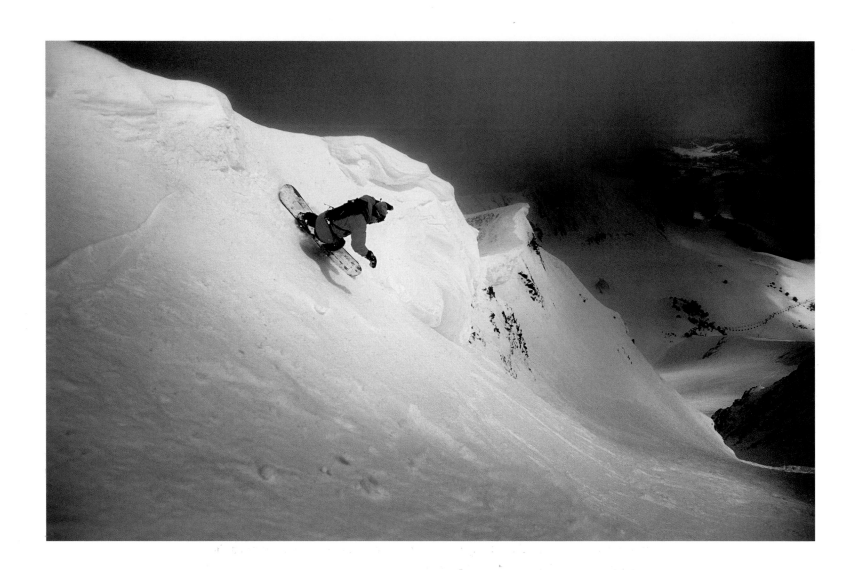

LESSON #5
QUICK MASKING FOR REGIONAL DYNAMICS

The next step in my workflow is working with regional dynamics. By setting the dynamic range for the entire scene, you create one dynamic range for the entire image, which assumes that all areas of that scene are created equal. It's similar to a restaurant serving Mexican, American, and Italian food, and using one red sauce for everything. The image results might not be as distasteful as that, but you get the idea. As you have begun to notice in the previous lessons, vast improvements can be made if edits are made to specific regions, as there are multiple dynamic ranges within most landscape scenes. I call this "regional dynamics."

The last two steps of Lesson #4 began the process of working with regional dynamics. However, there is much more to it in need of explanation. Not all scenes in the landscape are perfectly lit for a digital camera; in fact I would say that very few are lit just as I would want them. Because of this, I have also discovered that most images need regional lightening, darkening, color cast edits, and contrast adjustments. This is similar to the old dodge-and-burn methods used under an enlarger in a dark room. But what differentiates regional dynamics from dodging and burning is that I am changing the contrast within each individual region, and on occasion, altering color casts as well as sharpening. I use Quick Mask Mode for making most changes in all the various regions of any image. My big secret is that I use a combination of the Quick select tool, Soft brushes, and Gradients to make most of my selections. Many of the masks I create take only moments with the occasional tricky one taking longer due to the combination of an enormous file and a slow computer. Therefore, it's not my fault!

Consider for a moment if you were to take a picture of a scene that was perfectly lit. Imagine you had 20 assistants running around with strobes and scrims doing nothing but filling in shadows and blocking blown highlights in every scene you pointed your camera toward. Crazy, you say! But "cubic" money can make anything possible: after all, this is exactly what Hollywood does when shooting most scenes in a motion picture. Of course, I don't have the budget or the patience to make this happen in my landscape images, nor would I want to alter the natural scene so dramatically. Therefore, the question becomes this: what compromises can be made while still achieving "The Look"?

Figures 11-1 and 11-2: Before and after regional dynamics. Majors Bay, St. Kitts Island, Caribbean.

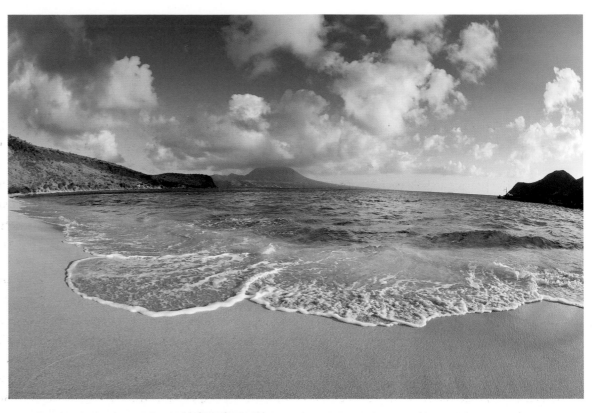

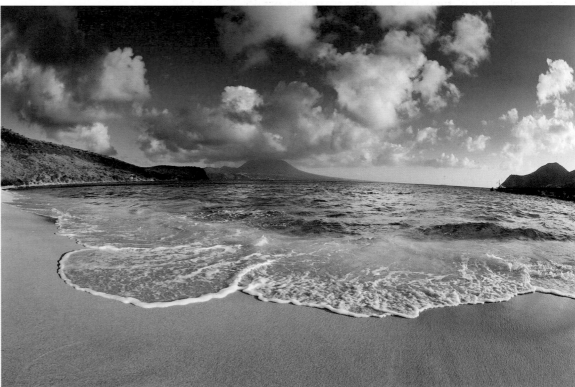

Learning to Decipher the Dynamic Range of a Scene

I have found the process to be a visual journey. The evolution starts from the moment we begin noticing light and continues to the day we can recognize and relate the scene brightness range to the dynamic range of a digital camera, paper, or computer monitor combination. That day may be many years away, or may never arrive at all for many photographers, but the more time and attention one gives to understanding the transformation of images, the better. In order to make a great image, it is not imperative that you are able to spot the exact dynamic range in a scene while you are taking a picture. Seeing the right light can be a subconscious skill that a person does not realize he utilizes, and he is only aware that he has the ability to take good pictures. If you are having trouble identifying the best shot while in the field, studying light, contrast, and dynamic range will dramatically help your composition decisions. I personally believe the training never ends, and the more we continue studying the elements of light, the more confident we become.

I have been taking photographs and printing images for more than 20 years and am fairly confident I can tell how many stops of contrast are in most scenes. I can also tell how many different regions of contrast are contained within that scene. This ability has developed as a result of the time I have spent photographing, as well as the time I have spent in post-processing. I don't like to admit how many hours I have wasted making mistakes, nor do I want to add up all the paper thrown in the trash because of poor printing. The cumulative effect of these experiential lessons is that I now possess the skill to comprehend the scene brightness ratio right in front of me. This automatic assessment of light helps me more in the field than any other technical skill.

Many photographers have asked me if I am bitter about having been schooled in film only to end up working in digital most of my career. At first I was a bit anxious, but as time has gone by, I believe my education and skills developed in film helped expedite my understanding and abilities in digital. As I mentioned, there is a difference between what our eyes see and what our cameras record. To take this comparison further, there is also a difference between the way the camera records and the way a computer projects. Moreover, there is also a difference between the way a computer projects and the way a printer prints. The majority of these variations are due to the manipulation and possible loss of data that the digital file goes through in post-processing, as I mentioned in previous lessons. Once a person begins to see various dynamic ranges in a scene without the aid of any instruments, the ability to see good or even great light becomes second nature. The key is experience with viewing the same images from conception to print!

This experiential training is all part of the journey that will enable photographers to see variations in light and other nuances in a scene that might otherwise go unnoticed. I now believe that with time and experience our minds are capable of creating "mental profiles." I like this term because for years, when digital photography was in its youth, the single answer for any type of color workflow was to create a profile. Every device in the process had to be profiled, from the scanner or camera to the neighbor's cat. These profiles were and still are important to successfully carry one's original vision through the many steps of the workflow. To rely entirely on a profiled workflow, however, can be problematic and not optimal for creating all images. In most cases, I have watched folks chase their tails (and profiles) around and around, and still never find where a problem with an image exists.

> ◻ I have found the process to be a visual journey. The evolution starts from the moment we begin noticing light and continues to the day we can recognize and relate the scene brightness range to the dynamic range of a digital camera, paper, or computer monitor combination.

> ◻ Many have asked me if I am bitter about having been schooled in film only to work in digital most of my career. At first I was a bit anxious, but as time has gone by, I believe my education and skills developed in film helped expedite my understanding and abilities in digital.

Calibrations and Profiles

Over the years, I have developed the ability to create mental profiles for specific situations in my work. These mental profiles are intrinsic correlations between what I see, what equipment I need to capture the image, and what the image will look like when reproduced in a certain way. Everything from film scanners to cameras to monitors are profiled. What is more important when relying upon such instruments, however, is that they are calibrated, or in very technical terms, "linearized." Calibrating equipment is different from creating a profile for it. First, an instrument must be linearized and calibrated. Then, and only then, will the profile work. Once an instrument is calibrated you can rely on it to give consistent results. Subsequently, making the results optimal for a specific device is the function of a profile.

A profile is usually made with the assumption that all instruments involved in the workflow are properly calibrated or, as the jargon goes, the input and output devices remain the same as originally defined. Once either of these instruments changes, it is necessary to create a new profile. Prior to the use of profiles and sophisticated calibration devices, experienced operators made critical decisions about how best to prepare a scan for a particular printer by using their experienced eyeballs. In fact, many operators became experienced in maintaining specific workflows for specific printers. The specifics included monitor settings for more accurate soft-proofing as well as unique CMYK separation densities for variable dot gain values which were unique to each printing plant. This practice could be called creating a rudimentary profile. Even though the profile was not made with instruments, the concept relied upon the operators' experience and memory. This is similar to the way I have developed an eye for seeing light that will work for specific output devices. With no way to rely entirely on instrumentation, our minds are very capable of managing such

workflows only through experience. As far as I know this is the only way to calibrate the human eye.

Fortunately, the solution to this dilemma is to keep some sort of control print available. If we are able to view colors side by side, or compare colors in some way, we will find that our eyes are extremely sensitive and accurate. It is not unlikely that most everyone will notice even the smallest color shift or luminance variation when shown two versions of an image side by side. For years, companies have been using a similar method to control similar variables in a color workflow with mechanical devices. Kodak used to call this control print the "control strip." The control strip was a piece of developed film used to compare all future test results. All the Kodak "Q" labs had to process the control strips and send them back to Kodak for inspection. If the results were within Kodak's tolerances, the lab kept its certification. If we had a control strip of everything we could see to use later while editing and printing, we could rely on our eyes more confidently. Unfortunately, although we are great at comparing, we lack sufficient accuracy in recalling what we have seen. The one strategy I have used for years to solve this problem is the grayscale as I wrote about in Lesson #2.

When I first began shooting professionally, the film I was using had a very narrow range of latitude, meaning any slight miscalculation in exposure would cause the reproduction quality of the image to suffer (along with my relationship with the client). Therefore, I learned how to properly expose 4×5 transparency film really well! Calculating the proper exposure was always tricky, but there were many different ways of solving this problem. For example, I used a spot meter and learned to point it in the proper place. Once I located the correct spot from which to take the reading, then everything worked out well. The problem was learning where that spot was in all the different types of scenes. For me, experience has always been the best teacher. After a while, I began relying on my intuition and experience rather than the light meter. My mind was

bridging the gap between the scene and the film, thus creating a "mental profile."

The other calculation I was making in my mind was choosing where to take a picture based on the contrast I see. The transparency film I was using had a dynamic range of about five stops, so if a scene had six stops of contrast, something was either going to be completely white or completely black. Even though I understood that I was only shooting scenes that fit within five stops or less, I still did not quite understand how my mind was subconsciously making decisions on what to photograph based on this dynamic range. Of course, there are other variables to consider when taking pictures besides contrast and light, but what was affecting me in a subconscious manner was just that. Because I was shooting film and forced to work within its limitations, I developed an eye for a very specific type of contrast that has taken me years to forget. Digital cameras have become the vehicle that expanded my repertoire and ability to create mental profiles.

Not only has digital allowed me to shoot in many different types of light, but I am also able to take different exposures for all the different regional dynamics of a particular scene, blend them together, and create one perfect file (which is similar to what Hollywood does, but with much less money). I will expand on this when I discuss HDR later in the book. Every time there has been a change in technology, it has become necessary for me to develop a new mental profile. For me the first one was the most arduous to create, mostly due to my youth and inexperience. It is for this reason that I am pleased to have learned to photograph with film. By working with film for as many years as I did, and by developing an understanding for its character, it was easier for me to recognize the differences and character of digital imaging. I quickly grasped its potential and more importantly noticed shortcomings soon enough to work around them.

Before switching to digital, I figure that I had exposed around 2,000 4×5 sheets of black-and-white, 25,000

4×5 sheets of color, and 20,000 rolls of medium format color film. I have no idea how much 35mm I used. This was just enough experience to develop the mental profile but not enough to bury me in film for eternity.

Figure 11-3: Before the days of digital.

After 20 years of shooting film, I made the big edit and discarded thousands of mounted and captioned chromes that were either in-camera dupes or images I never wanted to see again!

The reason I am going on about mental profiles while attempting to explain regional dynamics is because I believe our minds recall specific scenes within the parameters of our subliminal mental profile, and vice versa. Whether right or wrong, our impressions become powerful, even to the point where most photographers will swear on their lives that the colors looked just like they did *not!* Without any accurate reference for our minds to use for comparison, we simply must rely on our recollection and experience. During all the years of exposing film I gained some experience determining how

□ **Before switching to digital, I figure that I exposed around 2,000 4×5 sheets of black-and-white, 25,000 4×5 sheets of color, and 20,000 rolls of medium format color film. I have no idea how much 35mm I used.**

scenes changed from reality to film. I noticed that there was something lacking in almost every scene.

That difference between reality and image turned out to be regional dynamics. Every scene can be broken down into regions of different contrast ratios or dynamic ranges which need to be developed or expanded from the compressed state they are in. For example, the image of the tropical beach on St. Kitts (figure 11-1) shows how little contrast was actually in the water compared to what my edits created. Yes, there was a bit of light bouncing off the surface of the water causing some flare, but my eyes remember the vivid colors as in the edited version. The lower contrast of the water was different than that of the sky and sand and dark rocky cliffs. This is due to the compromise of setting a global dynamic range as we did in Lesson #3. In single exposure photography, this cannot be avoided. However, our eyes are able to change their perceptions on the fly while scanning throughout a scene, making differences in contrast and brightness appear unnoticeable. The way I use Quick Masking requires an understanding of how light affects single exposures and how it could potentially look according to our visual of the scene *taken over a period time*. The actual steps of Quick Masking are easily mastered, but the subjective determination of where, when, and how much to apply this technique takes experience and time. It is for this reason that I have taken the time to explain mental profiles and regional dynamics.

Does Your Image Need Quick Masking?

You may not realize this at first, but once you see the effects of what is possible, you will forever view your work differently. I have also found that by slightly exaggerating all the effects, I can form a target point faster. It has been helpful for me to overadjust my effects with the understanding that after making a proof print I can dial them down much easier than dialing

them up. I will expand on how to use the Layer Opacity to do just this in the following lessons. I have also come to the realization that when I am working on any image for some time, I lose my "comparo-meter." My reference point for what appears unrealistic versus what appears real is temporarily lost. What usually remedies this is taking some time away from an image. When I come back in a few minutes (or hours, or even days), I can refine the adjustments much more accurately and the Layer Opacity slider is a nice way to do just that.

Tools and items used in this exercise are as follows:

- Quick Selection Tool
- Brush Tool
- Quick Mask Mode
- Curves panel
- Layers panel
- Adjustments panel
- Curves Adjustment Layer
- Foreground and Background mode icon

There are several preferences also utilized in each tool, which I will point out as we go.

To begin, make sure your image is 16-bit. If the file is from a scanner, you may be stuck working in 8-bit. You can check a digital image file bit depth by going to the tool bar and selecting Image > Mode, and noting what is checked. If the file is in 8-bit, chances are you need to go back into ACR and change the preferences from 8-bit to 16-bit.

As I previously explained, this is the most subjective step. To help you with choosing what area to edit, consider the regions defined by subject first. In my image, there are four such regions: sand, water, sky, and mountains. Because there are nicely defined edges created by the white wash of the small wave around the sand, I am able to utilize the Quick Selection

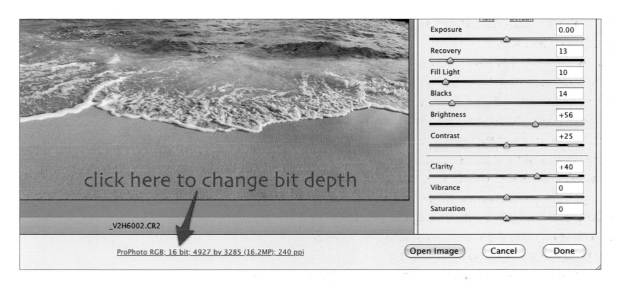

Figure 11-4: Make sure your image is in 16-bit.

Tool. I normally use this tool to select the hard edges and then enter Quick Mask Mode to refine the edge if need be.

Click on the Quick Selection Tool in the tool bar or use a shortcut key by depressing the letter W. If you use the shortcut key W, make sure that the other option, the Magic Wand Tool, is not selected, as Photoshop defaults to the latter option when using the shortcut keys.

There are several points to consider when using this tool:

- Dragging the tool over parts of the image makes the selection.
- The diameter of the tool can be changed. This increases and decreases the number of pixels it samples. This image is 4927 × 3285 pixels, so I chose a 15 pixel diameter to drag over the sand.
- The bracket keys [] can be used to change the size of the tool.
- You can add or subtract a given selection by dragging over additional image areas outside of the crawling ants. To subtract, hold down the Option key while dragging over the area you want to exclude. I often decrease the diameter of the tool while excluding small areas.

After choosing the sand, I carefully viewed the edges of the selection making sure there were no unwanted sections included. There was a bit of the white water chosen so I had to deselect those areas. Holding down the Option key, I dragged the tool over the parts I did not want in the selection. You will notice that the plus sign in the center of the tool will change to a minus while holding down the Option key.

Once I was satisfied with the sand selection, I then created a Curves Adjustment Layer.

With the Layers panel open, chose the "Create new fill or adjustment layer" icon at the bottom, and choose the Curves option, or utilize the icon within the Adjustments panel.

Figure 11-6 shows the two adjustment points (i.e., nodes) I placed on the curve while using the "pointing hand." It also shows that I moved them both down—first, one lower and then the other—which added contrast and color contrast to the selection.

This somewhat mystical panel called Curves does not have anything to do with the shape of a human figure. What it does show very well is the shape and location of all the data in the image file. It is ironic that the Curves panel will always start out straight: it's up to you to add the curve!

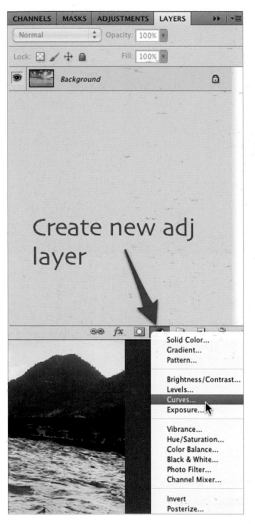

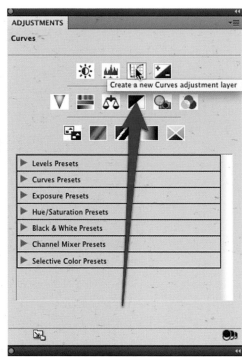

Figure 11-5: Create a new Curves Adjustment Layer.

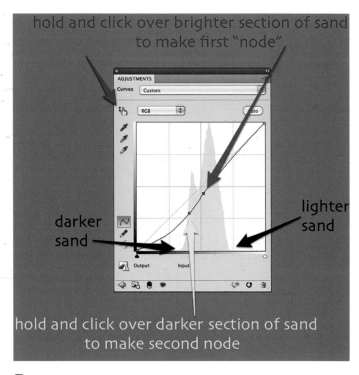

Figure 11-6: Creating a second node on my Curves Adjustment.

There are a few considerations when working in the Curves panel:

- The panel is designed to work with the Histogram, similar to ACR and LR. By depressing the Option key and clicking the small triangles on the bottom of the graph, you can view any out-of-range pixels in both left/black and right/white.

- The default positions of the nodes represent both the black (lower left corner) and white (upper right corner) of the image file.

- The default position is always on the RGB channel. Individual color channels can be chosen by clicking on the drop-down at the top of the graph.

- The visible histogram will represent only what is selected in your image. In this case, it is just showing the sand.

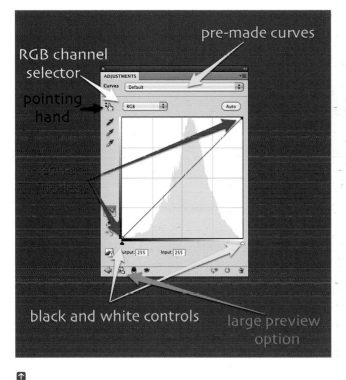

Figure 11-7: Considerations when working in the Curves panel.

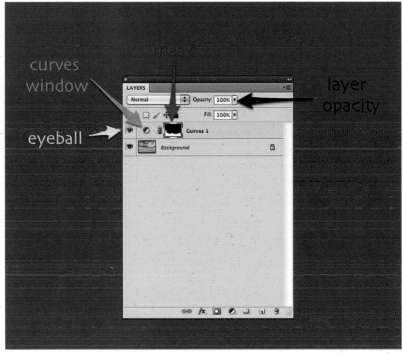

Figure 11-8: After working in the Curves panel, you will see it as a new Layer.

- The "pointing hand" icon is helpful for identifying what part of the image is located on the curve in the graph.
- There are predefined Curves to choose from under the Curves drop-down window at the top of the panel. I highly recommend looking through these if you are not familiar with this panel. It will give you a good idea of what is possible by noticing where the nodes are to create the effect on the image.
- One node on a Curve can only lighten or darken the overall density of the area. With two nodes selected, contrast can be increased or decreased. The steeper the slope between the nodes, the more contrast; conversely the flatter the slope, the less contrast. You will notice I dragged both nodes down and made the curve slightly steeper between them. This made the sand darker and added contrast.
- I rarely add more than three nodes. Doing so will create unwanted flat or steep sections in the curve, which may add or decrease contrast in the image where you may not want it. In this case, my theory is to make another Quick Mask/Selection to edit that region only.

Once I have completed my work on the sand in the Curves panel, I click on the Layers panel and there will be a Curves Adjustment Layer just above the background layer (figure 11-8).

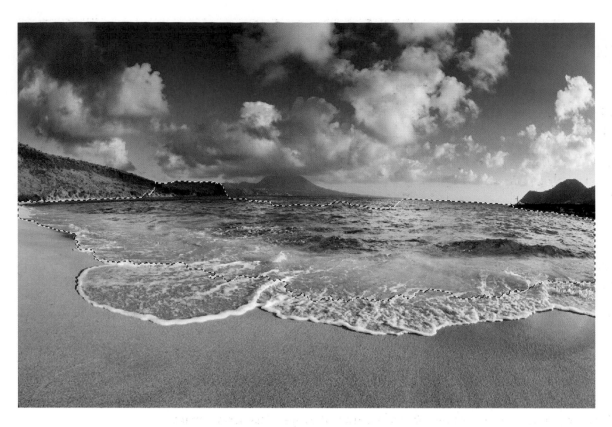

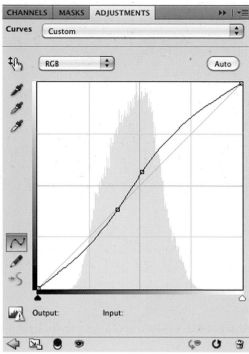

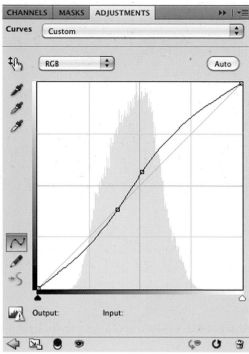

Figure 11-9: The Quick Selection Tool in use.

Figure 11-10: The edit I made to the curve on the water selection. This is a simple S-curve made to add contrast.

Here is some information you should know about the Layers panel:

- You can toggle the layer on and off by clicking on the "Eyeball" icon to the left of the layer.
- You can reopen the Curves panel by double clicking the icon just right of the eyeball, or by keeping the Adjustments panel open.
- You can reload the mask by holding the cursor over the mask rectangle and command/alt + clicking.
- You can change the Layer Opacity located at the top right of the panel.

My next move was to select the water. Once again I used the Quick Selection Tool, since there is one hard edge on the horizon between the water and sky, which the Quick Selection Tool will easily identify due to the difference in densities between the regions. With a slightly larger diameter of 25 pixels, I dragged the tool over the entire water region from left to

right and then back again, moving down over part of the sandy water. Figure 11-9 shows the selection.

I deselected the area on the mountain by using the Option key and dragging the Quick Selection Tool over just that area. Next, I added more water to the selection by simply dragging the Quick Selection Tool over that section of the ocean just below the distant volcano. Once my selection was complete, and the crawling ants were still crawling, I created another Curves Adjustment Layer by using the same icon at the bottom of the Layers panel or within the Adjustments panel.

The next step is to feather the lower section of this mask within the area of the sandy wave. I clicked on the black and white rectangle visible in the layer (the Layer Mask) to activate it and then selected the Brush Tool.

There are a few considerations when using the Brush Tool:

- The Brush Tool can be activated with the shortcut key B. Make sure one of the other tools within that selection

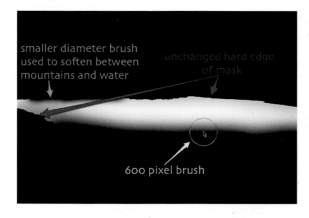

smaller diameter brush
used to soften between
mountains and water

unchanged hard edge
of mask

600 pixel brush

Figure 11-11: Here you see the mask after I painted over the edges of the mask where I wanted it smooth.

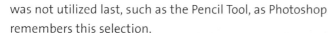

Figure 11-12: The image with the two Curves Adjustment Layers active.

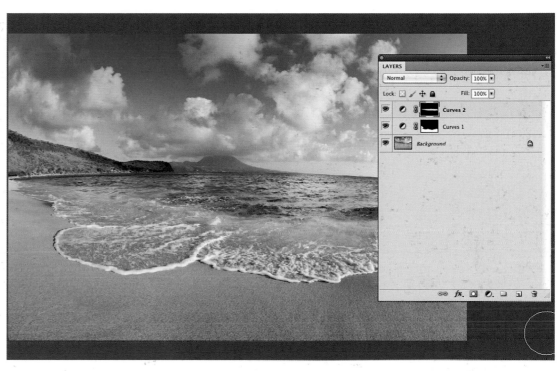

was not utilized last, such as the Pencil Tool, as Photoshop remembers this selection.

- The bracket keys [] can be used to change the diameter of the brush.
- The Hardness can be changed to define the edge of the brush. This setting as well as the size adjustment (Master Diameter) can be found by right clicking over the image area when the Brush Tool is active. These preferences can also be found in the upper left corner of the screen.
- To add to an active mask, the background color must be white. To paint away part of the active mask, the background color must be changed to black.
- To alternate between adding or removing, or black and white, I use the X key. This can also be done by clicking on the curved arrows just above the squares at the bottom of the Tools panel.
- The Opacity of the Brush can also be modified by using the numbers on the keyboard, for example, 5 = 50%, and so on. This can also be done by clicking on the Opacity drop-down window at the top of the screen.

With the Brush Tool selected and the Layer Mask active, I make sure my background color is white. This allows me to *paint away* the mask. I also adjust the Hardness of the brush to 0%, which creates a nice soft brush that is gradated from the center to the outside edge. For this image, I chose a 600 pixel diameter that was just large enough to taper the hard edge of the mask within the region of the water.

My next move was to select the sky. Once again, I used the Quick Selection Tool since there is a well-defined edge between the sky and mountains and water. I dragged the Quick Selection Tool over the entire region of the sky, moving all the way from left to right in one large stroke. Once the crawling ants were active, I then created another Curves Adjustment Layer by clicking on the icon at the bottom of the Layers panel.

My next move was to remove some of the mask where the top center of the sky became too dark. I chose the Brush Tool, lowered the Opacity to 10%, and enlarged the diameter of the Brush to 1000 pixels. Next, I clicked the X key to change my background color to black. This allowed me to be able to

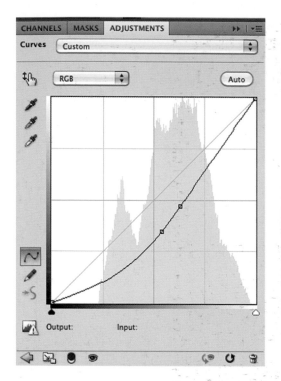

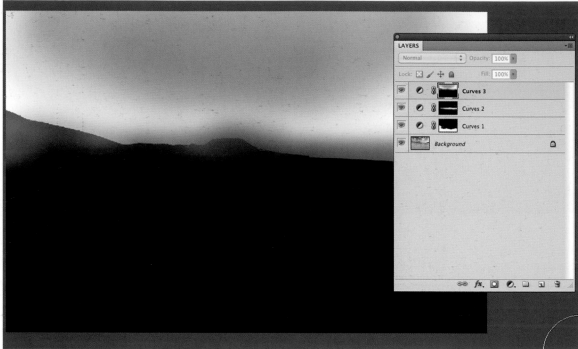

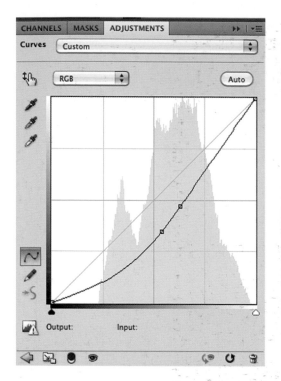

Figure 11-13: The move I made to darken the sky. The only reason for the second, higher node is to very slightly increase contrast.

Figure 11-14: The mask after my edits with the Brush Tool.

remove parts of the mask. I clicked the rectangle/mask in the Layer to activate it.

With these settings, I was able to paint away the area that is too dark. My method was to use a very low Opacity and repeat brush strokes. For example, when 10 % Opacity is set, the first stroke removes 10 % of 100 %. The following stroke removes 10 % of 90 %, and so on. This allows me to incrementally make the edits. The reason for this method is that our eyes are extremely sensitive to variations in gradations, especially when viewing skies. By making many sensitive brush strokes with a large soft brush, I am able to notice mistakes as I go. If I take too much of the mask away in one area, I simply click the X key, which reverses my background color, and then I add a stroke or two. I usually go back and forth many times to perfect these types of edits.

My final move was to lighten the mountain on the right. My logic behind this move was that I wasn't as concerned with showing more detail in the region as I was in lowering the apparent overall contrast of it. The lower half of the mountain was actually hidden by a rusty old pier that was being used to dock a ferry. By removing what I thought was a visual black

hole, the general feel of the scene became slightly more three dimensional since distant regions never have as much contrast as foreground regions due to the atmospheric haze.

This happens to be the simplest of the selections. I chose the Quick Select Tool, changed the diameter to about 15 pixels using the bracket keys [], and made one stroke in the shape of a circle through the middle of the mountain and pier. When the crawling ants appeared, showing that my selection was perfect, I then created another Curves Adjustment Layer by clicking on the icon at the bottom of the Layers panel. Figure 11-15 shows the mountain, the Layer Mask, and the Curve Adjustment made. Notice that there is only one node since all I wanted to do was increase the luminosity.

It was time to view all my changes and determine if I had gone overboard on all or some of the layers by making something too dark or simply going in the wrong direction. I like to view my image in a certain way: I click the Tab key to remove all the tools from the screen and click the F7 key to open the Layers panel by itself. I also like a darker background than the default.

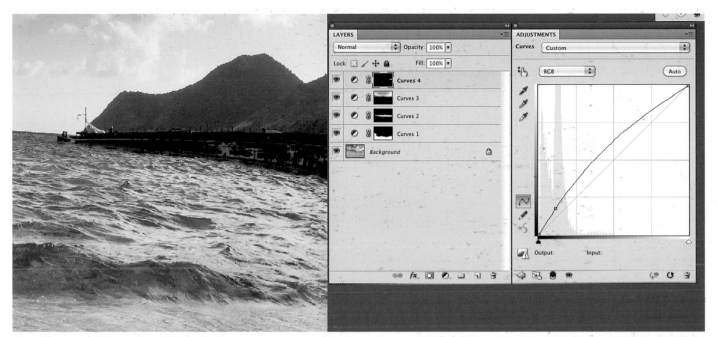

Figure 11-15: The "mountain", the Layer Mask, and the curve adjustment made.

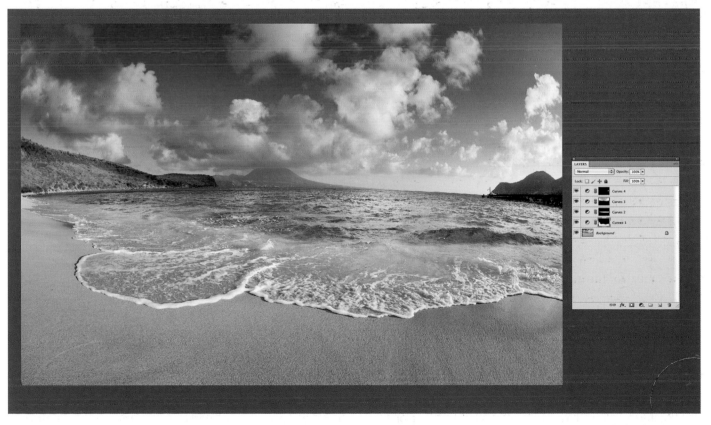

Figure 11-16: I'm now ready to save my file as a TIFF.

First, I need to change the screen mode by clicking the shortcut key F. This toggles through the three options: no background, gray background, or black background. When in the gray background, right click anywhere within the gray background and choose the option "Select custom color" at the bottom of the list. In the RGB fields, type in 56, 56, 56. This will make a darker gray background, which is my personal preference. You may want to make this a different shade; however, it must be neutral. You can always change this back to the default.

And finally, I size the image so it takes most of the screen, leaving room for the Layers panel only. The objective here is to be able to toggle the various layers on and off, checking for mistakes or marveling at the incredible work I have just completed. I hold down the Option key and click the bottom eyeball icon in the Background layer to turn all the layers on and off together. This gives me a quick reference to review all my changes. Next, I begin turning each layer on and off, previewing the edits and deciding if I need to reduce the Opacity of the layer. The only reason I would reduce the Opacity of the layer is if I have added too much contrast or color in one particular edit. If I am satisfied with the edits, I save the file as a layered TIFF.

Here is an overview of using the refinements we have discussed:

Selecting Regions

Defining where and how to use regional dynamics in your image is difficult. One simple tip to remember is to break down your image into regions of different contrast and color. This is usually determined by different subject matter as well. For example, a mountain will usually be a different region than the sky, and a waterfall will usually be a different region than the surrounding forest.

Making Selections

Most of the time the Quick Selection Tool will work at different diameters to grab the desired region. Don't forget to use the Brush Tool to soften the edges of the region where it needs to blend into the surrounding region. It is also very helpful to bypass the Quick Selection Tool and begin brushing your mask manually. Just remember to enter Quick Mask Mode (type Q); set your background color to black (type D); and once the red mask is made, exit Quick Mask Mode (type Q again). Once you see the selection you want, you can make a Curves Adjustment Layer.

Note: Another option that can work on some images is to utilize the Masks panel. Once you have a selection made with the Quick Selection Tool, chose the Masks panel and soften the edge by sliding the Feather slider right. The only disadvantage of this feature is that it affects the entire edge of the selection rather than specific areas. But this can work effectively on certain images!

Regional Color Cast

I also alter the color within certain regions only. To do this in the same region where I already have a contrast or density change, I normally make a completely separate Layer just for the color. This way I can adjust the Opacity of each change independently, even if they are within the same region. First, reload the selection by following the steps in the following tip on "making opposing adjustments" then simply make an Adjustment Layer on that mask.

Making Opposing Adjustments

Oftentimes I want to make one region of an image lighter and the opposite region darker. To accomplish this, I simply reload my original selection and inverse it. Then I make another Adjustment Layer to change the density. This can be done

by simultaneously holding the cursor over the Layer Mask and typing the option/alt key. You will notice that the cursor changes to an outlined hand. Now click the mouse and voila!, the selection is reloaded. Next, choose File menu > Select > Inverse. The final step will be to make another Adjustment Layer on that selection.

Painting On an Existing Mask

Once you have altered a region in an image (e.g., added contrast), it is simple to add that adjustment to additional regions in the same image. I often do this when I realize later that certain areas look better with more contrast. To do this, first choose the Layer Mask in the Adjustment Layer by clicking on it to activate it. You will notice the border becomes thicker. Now choose the Brush Tool and begin painting anywhere in the image. Remember that you can lower the Opacity of the Brush to add subtle amounts of contrast as well. I usually toggle back and forth between adding and subtracting the adjustment by typing the X key to switch between foreground and background on the fly.

Naming Your Layers

When making more than several Layers, especially when they represent multiple changes to the same region, I recommend naming the Layers so you easily recall what specific change each layer represents. Simply double click on the word next to the icon within the Layer and a text box will appear where you can assign a name to the Layer.

Layer Opacity

After you have made a change to your selection by either adding or subtracting contrast, changing color balance, or darkening or brightening, I recommend changing the Opacity of the entire layer. Making your change somewhat overstated in the first place allows you to refine your change very simply with the Layer Opacity slider. This is found at the top right of the Layers panel. Just make sure you have the appropriate layer selected.

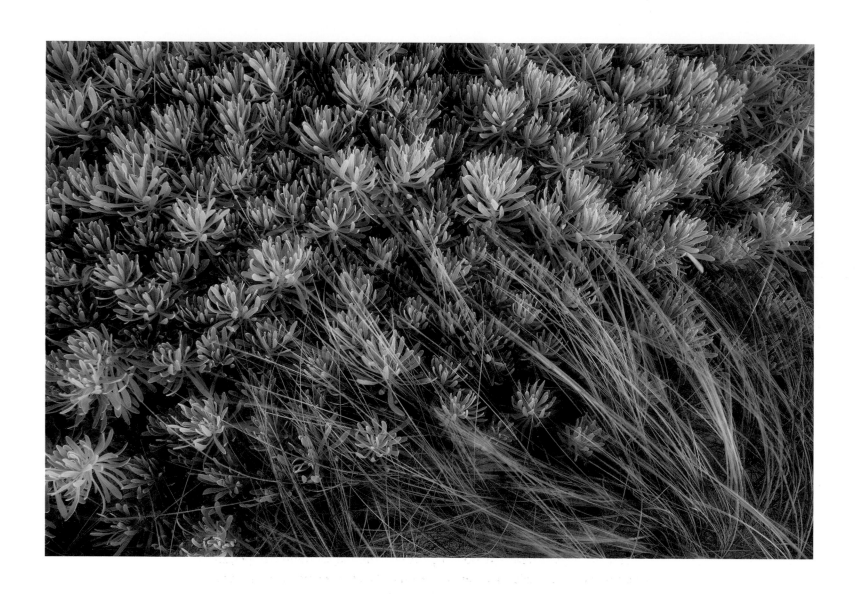

LESSON #6
REAL COLOR

There is a constant battle raging between my eyes and my mind. Have I saturated the colors too much? Have I added too much contrast? Is the image believable? Does the image illustrate what I really want to say or am I just trying to "Wow" the viewer?

Refining the color is the last step in my workflow, and it is a very quick one. I do sharpen all files, but I only do so to copies of the original file to be published to specific locations. Creating a digital file without refining the color reminds me of an expensive sports car with no wax—shiny but not what it could be. If I have done everything correctly up to this point, my image will reflect my original intentions, and in most cases will look nothing like the RAW file. Nevertheless, the big question remains: does the image look as good as it could? Before you can answer that affirmatively, the final touch you must complete before sharpening is to make the colors appear as you want.

The reality is that the colors don't have to be real, just believable, and even that is not necessary all the time. I mentioned in the lesson on regional dynamics that I like to make changes that slightly exceed my intentions and then use the layer opacity to tune the edits down at the last moment. I perform a similar procedure with the colors. I convert the RGB file into LAB, and then increase the color saturation and dial the amount down later when the file is back in RGB. Most of the time I need to make a proof print prior to making the final decision.

I print images for several reasons: I get to hold the image in different light, and I judge the contrast, color, and luminance. When I have the time to do this step, I take it. I may let a day or two go by before making final decisions about the color and contrast, and I don't bother concerning myself with the sharpening until the very last step. Although the lesson in this chapter has several fairly simple steps, it will not tell you how much is too much or too little. The answer to that question is dependent on the image itself and on personal preferences. First, I offer a few examples to explore this dilemma prior to the lesson.

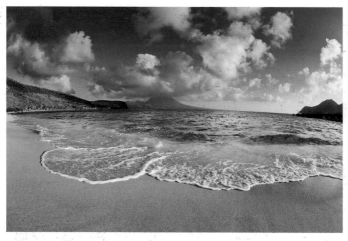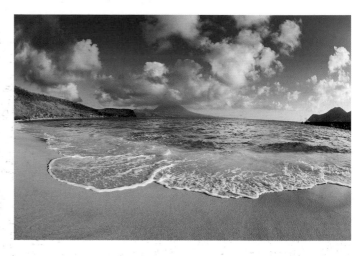

Figures 12–1 and 12–1a: This image illustrates the file as it appeared following the regional dynamics lesson. The second image shows the final version after applying the steps in this lesson.

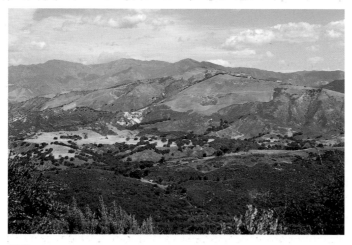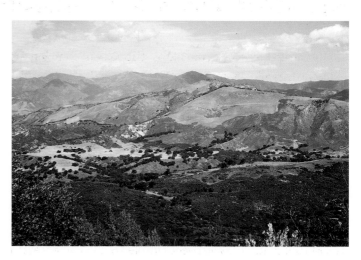

Figures 12–2 and 12–2a: Examples of images taken with Fuji Velvia film (left) and a Canon 1Ds Mark II camera (right).

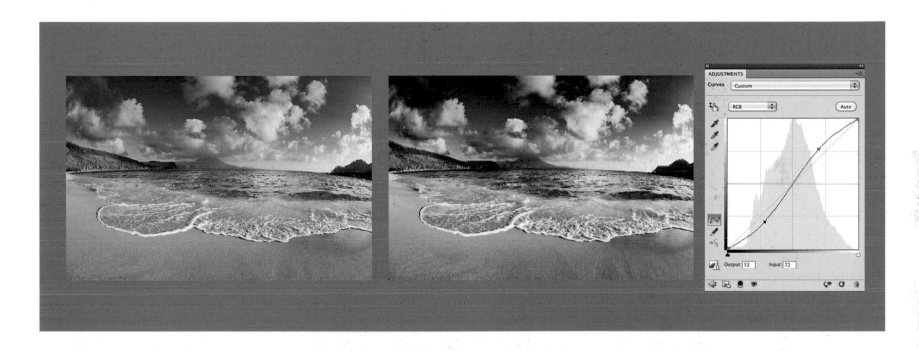

Figure 12-1 illustrates the file as it appeared following the regional dynamics lesson. Figure12-1a shows the final version after applying the steps in this lesson. When I began using a digital camera, I was so focused on resolution issues that the unadjusted colors were acceptable only because I didn't know any better. After comparing drum scans with digital files over and over, I finally realized resolution was not the only element that would make a difference in the final image.

Figure12-2 (film) and Figure 12-2a (digital camera) are examples of images taken with Fuji Velvia film versus a Canon 1Ds Mark II camera, respectively. The files were only processed to the point where a white point and a black point were set. This allows the original global contrast to be seen. I also set the same neutral gray point, or midtone, in both scenes to the small shed on the ridge. Notice the difference in the green bushes in the bottom of the frame and the density in the sky and mountains.

The results for these images were the same with the Hasselblad and Nikon cameras, which I believe are due to the difference between the technology of the sensors in the digital cameras and the emulsion of the film. Kodak and Fuji invested in a lot of research and development in creating color contrast in their film emulsions. In fact, Kodak worked hard on limiting the color contrast to maintain accuracy while Fuji went in the opposite direction, creating Velvia, which added significant color contrast. Color contrast is only one factor that creates the differences though. The other factor is the way light is captured by a drum scanner versus a charge-coupled device (CCD) or complementary metal–oxide–semiconductor (CMOS) sensor in a digital camera. A quality drum scanner utilizes three photomultiplier tubes (PMTs), which capture each of the three colors independently. This very precise method of capturing the full color spectrum allows for greater color contrast in the final scanned file as compared to the colors generated by a CCD or CMOS sensor in most digital cameras today. If someone creates

Figure 12–3: Adding contrast to the RGB curve also adds color contrast.

Figure 12–4: Drag bottom of Curve to the right, changing the Input from –128 to –90. The image will turn green.

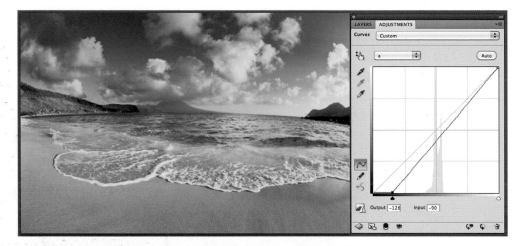

Figure 12–5: Click on the diagonal line in the upper quarter section and drag up until the center of the diagonal line is over the exact center of the grid.

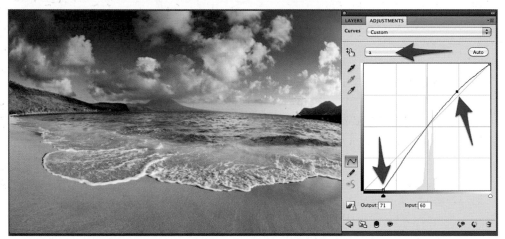

Figure 12–6: The colorful state your image will now be in after the adjustments.

a digital camera with three PMTs let me know! The truth is there are ways to create the intended color contrast with a digital camera file, and that is what this lesson illustrates. This method creates contrast in the colors without adding contrast to the luminance. Figure 12-3 illustrates how adding contrast to the RGB curve also adds color contrast.

The only way to convert from RGB into LAB color space is without Layers, therefore the first thing I do is duplicate the image. Once I make my changes to the duplicate image, I will convert it back to RGB and drag it back onto my original document as a layer.

With the file in LAB color, flatten the Layers, assuming you have made Adjustment Layers for regional dynamics. Here are the steps:

1. Open a layered TIFF file and then from your Menu Bar go to Image > Duplicate.
2. Menu Bar > Layer > Flatten Image.
3. Menu Bar > Image > Mode > Lab Color.
4. Menu Bar > Layer > New Adjustment Layer > Curves.
5. In the Curves panel, click on the Channel drop-down. Select the "a" Channel and make the following adjustments.
6. Drag bottom of Curve to the right, changing the Input from −128 to −90. The image will turn green.
7. Click on the diagonal line in the upper quarter section and drag up until the center of the diagonal line is over the exact center of the grid.
8. Now select the "b" Channel from the drop-down and make the same adjustments.

Figure 12-6 shows the new very colorful state your image will now be in after the adjustments. I use the remaining steps to dial down the colors to my liking. I usually refine it with the very same moves used in Quick Masking and regional dynamics. First, if the colors are too saturated overall, just select the Opacity of the Layer and decrease the overall effect until the

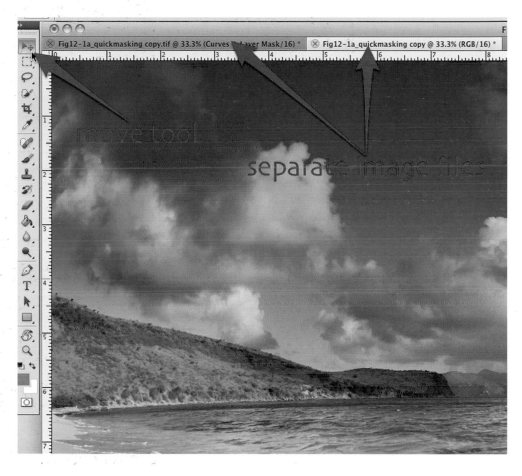

result is pleasing to your eye. Second, if you want to only reduce the colors in regions, select the Brush Tool and begin painting away the areas where you think the color is too saturated.

These last steps are to flatten the Layers, convert the image back to RGB, and drag it onto the master file:

1. Menu Bar > Layer > Flatten image.
2. Menu Bar > Image > Mode > RGB Color.
3. Select the Move Tool from the tool bar or type the letter "V".

Figure 12–7: The two files are joined here, so you will need to drag them apart before you drag the duplicate on top of the master.

Figure 12–8: The LAB Layer should be on top.

Figure 12–9: The image after my final two edits.

Depending upon which window view you are in, you may need to toggle the view. Just make sure to click the letter "F" until the images appear side by side. If the two files are joined as shown in figure 12-7, you will need to drag them apart before you drag the duplicate on top of the master.

Once you have the images identified and the Move Tool selected, grab the "copy" you just worked on and drag it away from the other. This will allow you to drag it back onto the master file. Here's how:

1. Click and hold down the Shift key and then drag and drop your image onto the master file.
2. You should have a master file with the LABcolor change as a Layer on the top.
3. If the LAB Layer is not on top you may need to drag it there.
4. Here is what your Layers panel should look like on the final master document.

Figure 12-9 shows my final two edits. First, I decreased the Layer Opacity to 50% to globally reduce the amount of color

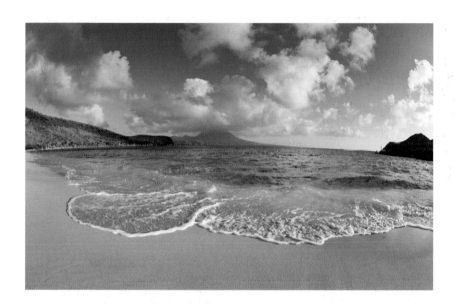
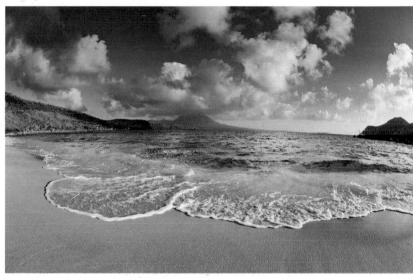

saturation and contrast. Second, I created a Layer mask on the LABcolor Layer and painted away the LABcolor Layer in the sky. Because the color blue usually becomes too saturated, I normally dial this way down. I selected the Layer mask, chose a Brush Tool with a large diameter, and changed the Opacity of the Brush to 50%. I then made two passes over the sky, changed the Opacity of the Brush to 30% and made one pass over the sand. Figure 12-9 shows what the final image looks like and the mask I made.

Here is a summary of the steps explained above:

1. Duplicate master file.
2. Flatten duplicate file.
3. Convert duplicate file to LAB.
4. Adjust both "a" and "b" Channels to add color.
5. Flatten duplicate file.
6. Convert duplicate file back to RGB.
7. Drag duplicate file back onto master file.
8. Edit mask and or Layer Opacity to satisfaction.

What you should do now:
Make a print!

Figure 12–10: A comparison between the RAW file and the final image.

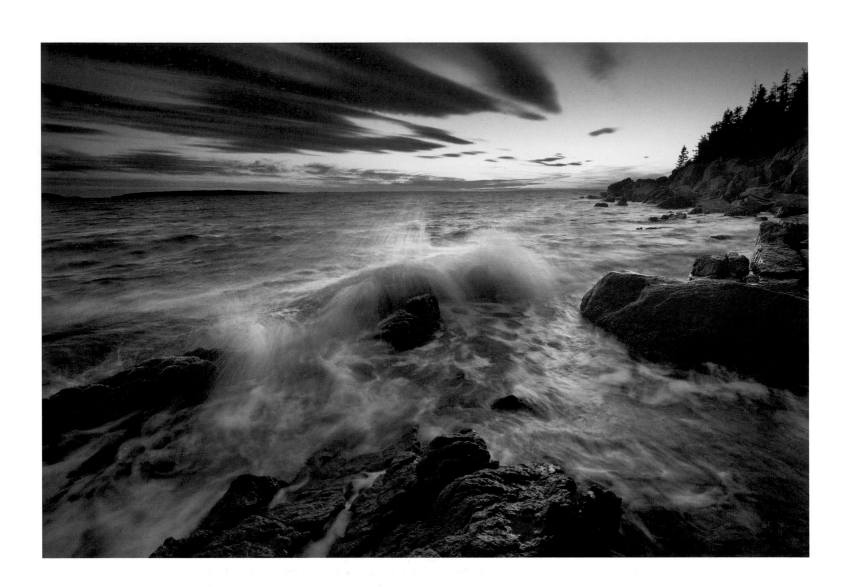

LESSON #7
MANUAL HDR

What does HDR Mean:
Hyper Digital Reflexes or High Dynamic Range?

How fast can you operate your camera? In some more popular photo-landscape locations, the chatter of professional digital SLR cameras clicking away causes the local woodpeckers to swivel their heads in confusion. If you don't understand what these photographers are doing, they can look as though they have become delirious with altitude sickness and are compelled to photograph imaginary elephants running through the scene. What is really happening is this: Each photographer is taking a panoramic image with multiple bracketed exposures for each of the scenes and has the camera set to take the three exposures in motor drive. If the photographer is fast enough and spins the camera following each burst to the next scene in the pano, then the impression by a casual viewer is that he is taking entirely too many exposures of the very same scene! If the photographer is not perfectly clear about why and when it is best to use multiple bracketed exposures for HDR imaging, then he might be driven to take every single picture with this technique and thus appear a bit obsessive.

Manual HDR: Is There Any Other Way?

Although there are many software applications that can automate the process of combining all these exposures into a single file, the problem can be twofold. For starters, the only inspired vision of any scene by the photographer becomes limited if he bases that entirely upon what he is able to achieve with the options offered within the software. The biggest objection I have to using HDR software is that, in the process of combining the bracketed exposures, pixels are transformed into trouble because they lose their single luminance and color values, and can become unnatural in appearance.

The particular manual method I prefer for HDR imaging is distinct in that none of the pixels you spent so much time, money, and effort to create ever get destroyed. Furthermore, there is a great deal of information contained within just

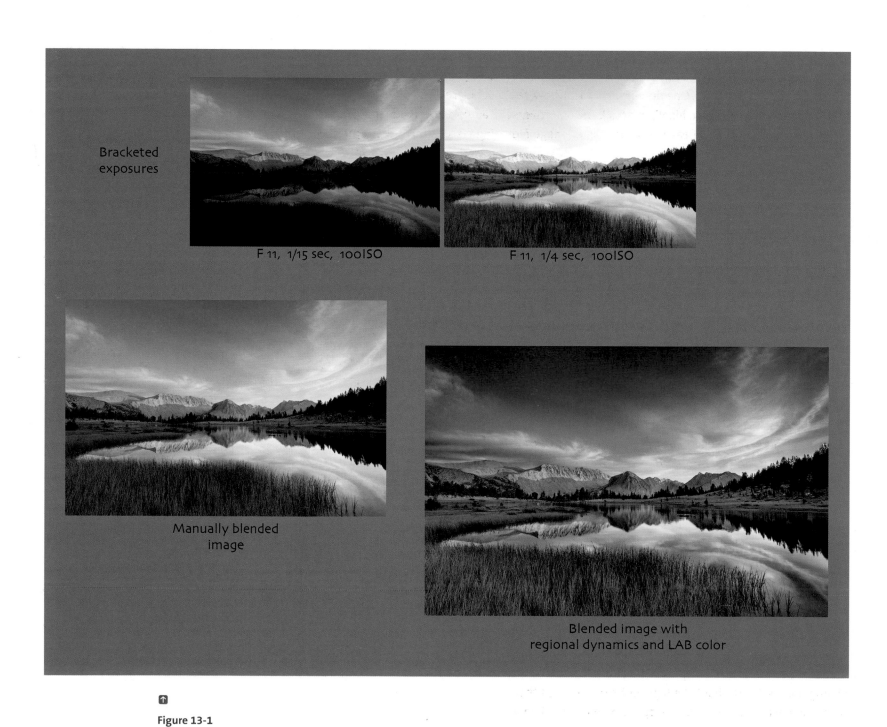

Bracketed exposures

F 11, 1/15 sec, 100ISO

F 11, 1/4 sec, 100ISO

Manually blended image

Blended image with regional dynamics and LAB color

Figure 13-1

two "properly exposed," bracketed exposures. In this exercise, you will learn how to take two good exposures and merge them together in Photoshop. One file will contain shadow detail and the other will contain highlight detail. The objective is to combine the best parts of each into one master image file or HDR image.

HDR vs. SBR

For some reason, the term HDR has been used to define many things. HDR is simply an acronym for "high dynamic range!" As stated previously, there is a difference between the terms "dynamic range" and "scene brightness ratio" (SBR). The SBR is what you see when you are taking the picture. The dynamic range is what amount of that SBR the camera can record. Consequently, it seems appropriate to use the term HDR to define the image created by multiple combined bracketed exposures, which is how I refer to it in this book.

Digital cameras have a dynamic range of between 4 and 5 stops of light. Many landscape scenes have an SBR far greater—even up to 15 stops on occasion. When you take a single image of such a scene, the camera will clip either the highlights or shadows, which means that there will be no image information in those clipped areas. Dark areas such as shadows will become solid black or light areas like clouds will become solid white, showing no gradations. Gradation is what makes landscape images look stunning!

Shooting for HDR Images

I shoot my manual HDR images a bit differently than most photographers. I first shoot the highlight exposure and then shoot the next exposures in two-stop increments until I have a file that has captured the darkest shadows about one stop over exposed. This means the data in the histogram will begin at the first bar from the left. The number of exposures required varies depending upon the extent of the SBR. What I call the "auto-magic" method uses the camera's built-in auto bracketing feature, but creates three exposures each time. However you accomplish it, the most important consideration is that you capture the highlights and the shadows with two stops between the exposures. This lesson illustrates how to combine two image files into one. Once you have mastered this, adding additional bracketed files for darker shadows or midtone gradations will be no problem.

The term "bracketing" simply means taking several shots of the same subject with various camera settings, in this case the shutter speed.

Camera Settings and Setup for Manually Exposing HDR

For best results, follow these guidelines when shooting:
- Use a tripod!

Set the camera to:
- Manual focus
- Manual exposure mode
- Auto white balance
- Evaluative metering mode
- Highlight warning on
- Capture RAW files

Camera Settings and Setup for Exposing HDR with Auto Bracket Feature

For best results, follow these guidelines when shooting:
- Use a tripod!

Set the camera to:
- Auto exposure bracketing on with 2 stops variation
- Motor drive or continuous fire or 2 sec timer
- Manual focus
- Aperture Value (AV) exposure mode
- Auto white balance
- Evaluative metering mode
- Capture RAW files

Capturing the Scene Manually

Your first exposure will be the *highlight exposure* (HE) and is the most important one. The second exposure will be your *shadow exposure* (SE).

Determine the proper exposure for the highlights by using the camera's built-in histogram. Read the manual if you need to find out how to turn it on while you are previewing an image. The histogram represents your image's dynamic range, from dark to light or from left to right. You can use the histogram to review your exposure, and to see if you clipped either the shadows, highlights, or both. The highlight warning will "blink" the areas of the image that are overexposed. You can also refer back to the Lesson #1 for details on how to best calculate the HE.

To determine the HE, view the image with the in-camera histogram showing. If there is any data climbing up the right wall of the chart, you need to shorten your exposure time. Once you determine the proper exposure for the scene (just for the highlights), the mountain of data should end to the left of the lower right corner of the graph. Now that you have the highlight exposure, you need to take the shadow exposure. This step is very simple. Change your shutter speed for two stops of additional light. For example, if your exposure time for the highlight image was ¼ of a second, your exposure time for the shadow image will be 1 second. If the shadows are still clipped (i.e., on the histogram the mountain of data is climbing up the left wall), then take a third, fourth, or as many exposures as needed until there are no clipped shadows. The goal here is to start with an exposure with good highlight values and end when you have reached an exposure with good shadow values—with two stops between each exposure.

I normally set my aperture to the sweet spot of the lens for starters. Without going into detail regarding aperture, I suggest just using the old rule of thumb, which is two stops down from wide open. For example, if your lens is f/4, then use f/8. I also refer to this in Lesson #1.

Capturing the Scene with the Auto Exposure Bracketing Feature

This is usually very simple and only requires the occasional override. If your camera is set to the default bracket order, the first exposure will be normal followed by the underexposed and then the overexposed exposures. The first exposure determines the success of the three brackets in the very same way a normal single exposure determines the quality of the final image. If you simply point and click the three brackets all the time, there will be occasions that the overexposed file is not over enough and the underexposed file is too dark. I find that often I must compensate the three exposures by one stop. In order to do this, most cameras offer a way to compensate the AV setting. Most of the time one stop brighter compensation will suffice. Also note that it is handy on Canon cameras to set the timer to 2-second delay. This will allow you to take your

hand off the camera once the shutter has been depressed and the three exposures will be activated following the 2-second delay and then stop following all three brackets.

Combining Your Exposures

After you have the series of images you want, here are the steps to combine your images:

STEP 1 – Combining two exposures: Select two RAW images in Bridge or Lightroom, and either open into Adobe Camera RAW (ACR), or if in Lightroom, choose Develop. The objective in this step is to balance the color between both exposures. (Note, if you have three exposures taken from the AEB method you will need to determine the best two exposures to use. It could be the –2 and normal for example.) To make life easier, I suggest using the same settings on the Color Balance and Tone sliders for both HE and SE files. There are many philosophically diverse methods for figuring the correct color balance of an image, but I would like to keep this simple for now and suggest that you use the camera defaults for the HE. Simply copy those settings into your SE settings. In Lightroom with both files selected, edit the one file for the color balance and then click Synchronize. In Bridge with both files opened in ACR click Select All and then Synchronize. If you are an advanced user and understand why you would want to set these differently, go for it!

In ACR it should look like figures 13-2 and 13-3.

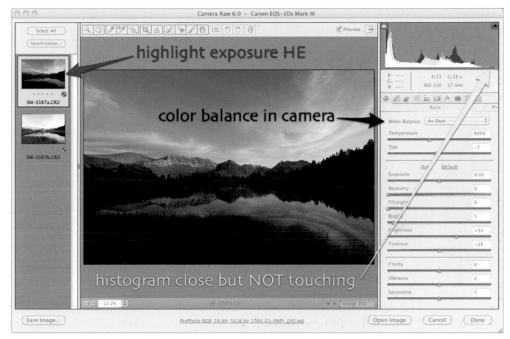

Figure 13-2

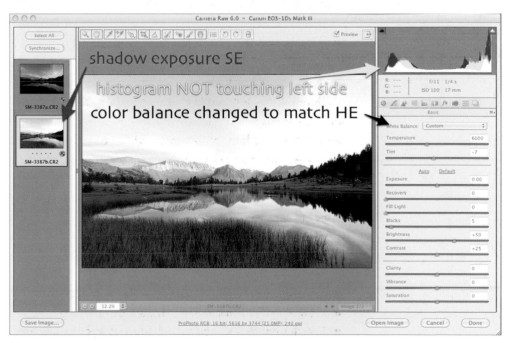

Figure 13-3

199

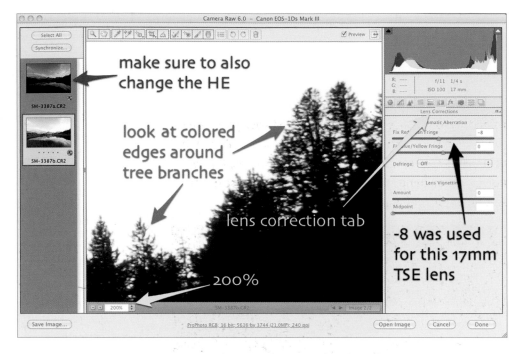

Figure 13-4

STEP 2 – Adjusting the highlights: Select the HE and adjust for the highlights by using the Exposure and Recovery sliders. When adjusting the highlights, hold down the opt/alt key and click on the slider at the same time. This turns the image all black except for any areas of the image that have no detail. Now move the slider back and forth until there are as few colored or white dots as possible. The colored dots show where clipping occurs (meaning no detail) in a certain color, and the white dots show clipping in all colors. The objective is to limit the number of these dots, thus showing detail throughout the entire image. Remember, the closer the in-camera exposure is, the less you will have to use the Exposure slider.

If you have moved the Exposure slider to –.50 or farther, and there are still colored or white dots, move the Recovery slider to the right. This slider works the very same way as the Exposure slider. Click and hold down the opt/alt key at the same time to show black screen. Again, try to eliminate as many dots as possible without moving this slider past 15.

STEP 3 – Adjusting the shadows: Setting the SE is done the very same way as adjusting the HE, but this time you'll be using the Blacks and Fill Light sliders. Again, hold down the opt/alt key to see the white screen. This time it will show you all the pixels

that have no light at all. If the dots are colored, then there is one color that has no value or detail brighter than absolute black. If the dots are black, then all three colors have no detail brighter than absolute black. I recommend sliding the Blacks slider right until there are a few tiny black dots. If your image is very dark, then you can move the Fill Light slider to the right to brighten up the darker tones of the image. I recommend not moving this past 15. The farther you move it, the more potential there is for image noise.

For this exercise, you can leave all other sliders alone. However, you may want to make some additional personal changes as you become an advanced user.

Additionally, you can check for any chromatic aberrations in this step by clicking on the Lens Corrections tab and removing any colored rims around areas such as silhouette trees or branches. In Lightroom select Detail. I always enlarge one of the corners of the file to 200% in order to better view the colored edges or aberrations. The setting will vary depending on the lens used, but normally I correct for a Red/Cyan Fringe by moving the slider left to around –15. It is rare that a lens requires any adjustment to the Blue/Yellow Fringe, but you never know.

STEP 4 – Loading files into Photoshop: This step will create one Photoshop file with two layers. You can do it manually, or have either Photoshop or Lightroom create this file for you.

STEP 4a – Manual method in Photoshop: Open both images in Photoshop. Select the Move Tool. While holding down the shift key, drag the HE on top of the SE. This will line up the two files pixel for pixel.

STEP 4b – Bridge: Select both image files and choose Tools > Photoshop > Load Files into Photoshop Layers. This automatically loads the two exposures into one layered Photoshop file.

STEP 4c – Lightroom: Select both images and click the File menu item Photo > Edit in > Open as Layers in Photoshop.

Note: Making selections in Photoshop is very complex. Although there are many books on the subject, I recommend the book by Katrin Eismann, *Photoshop Masking and Compositing,* as well as other Rocky Nook books such as *Practical HDRI, 2nd Edition* by Jack Howard, *The HDRI Handbook* by Christian Bloch, and *Photographic Multishot Techniques* by Juergen and Reiner Gulbins.

Now you're all set to begin combining your two exposures. This is where the magic happens.

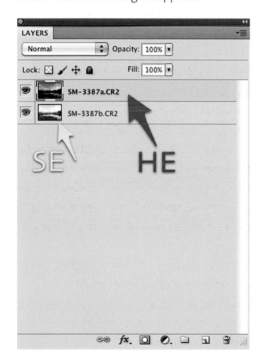

Figure 13-5

STEP 5 – Masking with well-defined edges: This first method is used for images that have a subject with a well-defined outline, which is often the horizon. Select the Quick Selection Tool in your Tools panel, which is the fourth one down.

The objective in my example is to select just the sky. Click and hold down the Quick Selection Tool while brushing over most of the sky. You will notice the selection being made as you brush. (Also refer to Lesson #5 for more information on

using this tool.) Once you have completed your pass, release the button and watch the magic of this great tool. Depending on your computer, this may take a few moments, but when done, the marching ants will appear around your selection as seen in the sky in figure 13-6.

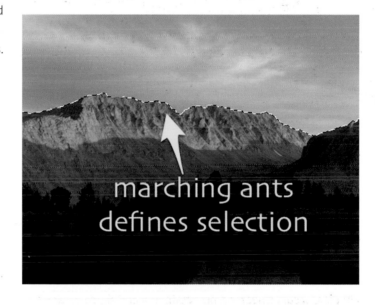

Figure 13-6

Figure 13-7

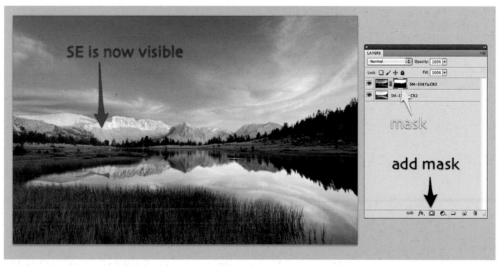

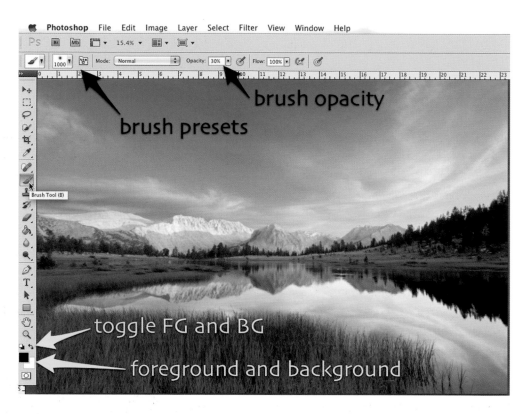

➡️
Figure 13-8

Click the Add layer/vector mask button located at the bottom of the Layers panel. This is another very cool moment for a first timer! By clicking this, a mask of the selection is made, revealing the SE below. Initially, it can be difficult to understand what is happening. Consider both of the images, which are layers, to be pieces of stacked paper. The HE is on top. When you make a mask on this top Layer and erase it away, it is like tearing the top sheet of paper away so you can now see the sheet of paper below.

STEP 6 – Using Brushes for softer transitions: The objective in this step is to blend the two exposures together so that no one will ever be able to detect that you did so! There is another option in Photoshop called Refine Mask located within the Masks panel or found in Select > Refine Masks. I normally do not use this tool because it makes the same gradation around the entire selection and I like to alter the gradation in differing regions. The slider found in the Masks panel called Feather does work on certain scenes. There are times I start with this step

then refine with the Brush Tool. For the Brush to work properly the following settings are important.

Brush Settings

- Choose the Brush Tool, and then click on the Brush Preset picker in the upper left corner of your screen.
- Click the Master Diameter slider and slide it so that 1000 pixels is shown. This diameter will actually depend on the resolution of your file.
- Click the Hardness slider just below it and slide it all the way to the left so that it reads 0%. Be sure to click on the blue down arrow located adjacent to the pixel size of the Brush so that the window closes when you are done.
- Change the opacity of the Brush to 30%, which is where I usually start for this step. I change this as I blend different files and in different areas.

(For more info on using the Brush Tool, refer to Lesson #5.)

Foreground and Background Colors

The next detail you will need to check is the Foreground and Background Colors.

- First click the tiny squares to set the Opacity of the Foreground and Background Colors to white and black. (You can also click the D key to set your colors to default.)
- Click the slightly larger squares so that white is on top.

Now that your Brush is set, let's get to work. Remember that we're going to paint the mask, not the image itself, so make sure the mask is selected and not the image.

You should have the Brush Tool selected, the diameter set to about 1300 pixels wide, and the background color set to white. Make a test drag over your image below the sky. Notice that wherever you painted with the Brush it revealed where the image was below by 30%.

- Change the Diameter of the Brush by clicking the bracket keys []. The left bracket makes the Brush smaller, right bracket makes it larger.
- Change the Opacity of the Brush stroke by clicking numbers on your keyboard: 5 = 50%, 2 = 20%, and so on.
- Clicking the X will switch your Foreground and Background Colors.

This is one of the more enjoyable steps I perform in post-processing images, maybe because it feels like painting, or maybe I am used to it. The more practice one has, the more enjoyable it becomes. If you're having trouble, go back over the steps, and make sure you've done the following:

- The mask is actively selected in the Layers Panel.
- Your HE is on top and your SE is on the bottom.
- You have the Brush Tool selected.
- The Background color is set to white.

It can also help to lower the Opacity to 10% and make many brush strokes gradually until the desired density is achieved, adding and subtracting until all is blended. For example, I like to go back and forth by using a shortcut key X. This toggles your Background to Foreground and vice-versa. Since you're only painting the mask, all changes can be reversed. If you painted out too much, just switch the Foreground and Background Colors and paint over it!

For this image I began with one stroke left to right with the Brush set to 30%. After making this one stroke, I noticed that the density of the mountains was not as dark as I liked. I made another two strokes in the very same position.

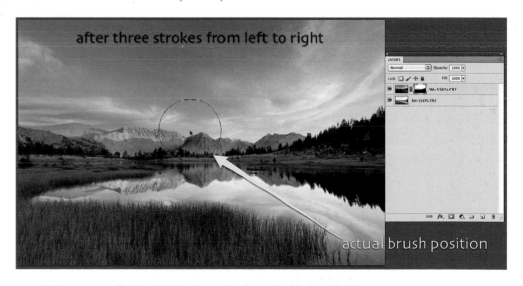

after three strokes from left to right

actual brush position

This is a good time to enlarge the area at the edge of your mask to look for parts that were not perfectly selected by the Quick Selection Tool. Figure 13-10 shows an area of the mask that protruded into the mountains. To create a smoother blend, I make a few more passes with the Brush Tool at 10%, switching back and forth between Foreground and Background with the X key. By doing this, I am eliminating the hard edge of the mask and maintaining the proper density. Figure 13-11 shows how the blended mask appears following these brush strokes.

Figure 13-9

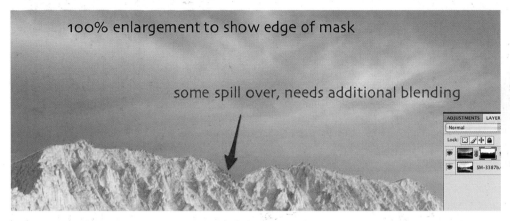

100% enlargement to show edge of mask

some spill over, needs additional blending

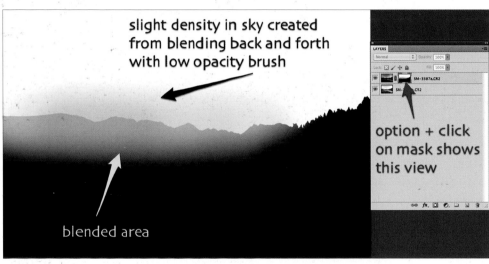

slight density in sky created from blending back and forth with low opacity brush

blended area

option + click on mask shows this view

Figure 13-10

Figure 13-11

Figure 13-12

Now the fun part begins! This image is ready for regional dynamics. I consider this blended image similar to a RAW file. I may need to set a black point and white point while in Photoshop, or I can save this file as a flattened TIFF and open into ACR. The most important part of understanding this process is knowing what density the blended areas should be, which in this case are the mountains. Judging how much contrast, dark, or light a region should be is subjective and takes experience to determine. There is no book that will ever be able to explain what *your* image should look like. Now you know some tools to get you started in the process of blending. Get some tasty ingredients, throw them in the proverbial blender, and flip the switch.

Figure 13-12 shows the additional Curves adjustment layers and the masks I made to further alter this image. The white areas in the layer masks identify the regions that were affected by each Curves adjustment layer.

I named each of the Curves adjustment layers so I could later recall where the changes were made. Therefore, all the layers with regional names were Curves adjustment layers.

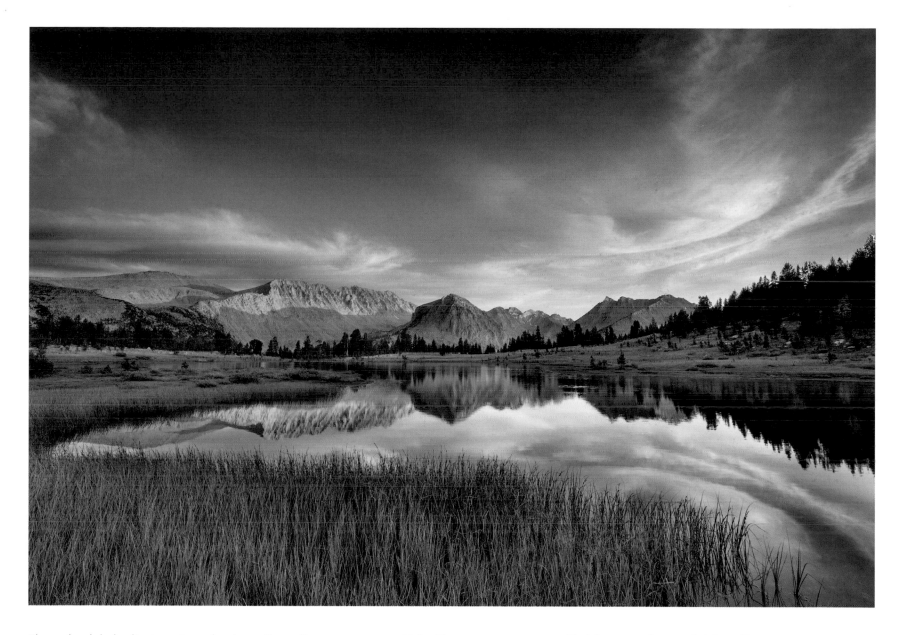

The only global adjustment made above the yellow arrows was my very first edit, which I named "global color." The adjustments made to each of the titled regions were made with Curves to alter contrast and density.

My last step in editing this image was performing the LAB-color adjustments, which is the layer on the very top identified by the green arrow. (I explain this step in Lesson #6.) I also added a layer mask to the LABcolor layer to remove some of the color in certain regions—the areas of the mask that are gray.

The final result is shown in figure 13-13.

Note: There are some scenes that have much more intricate detail and require a different tool than the Quick Selection Tool. For selecting the highlights in these types of scenes where, for example trees protrude up into a sky, I use the Color Range tool. This is located in Menu Bar under Select > Color Range. This tool allows you to select any specific point in the image by clicking with the eyedropper. The selection can be further refined by sliding the Fuzziness slider to expand or shrink the chosen pixels. Once your selection is made, simply follow the remaining steps in the above workflow.

Figure 13-13

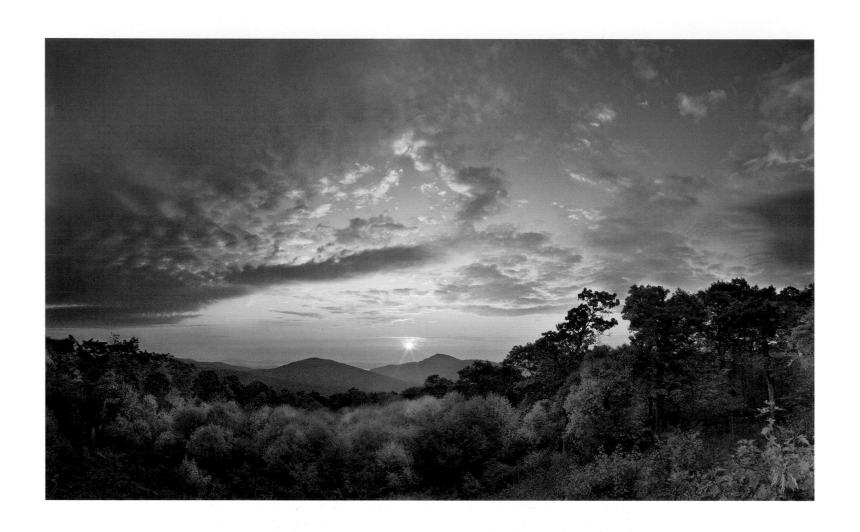

LESSON #8
MORE HDR

High dynamic range imaging must be the most fascinating and complex digital process in vogue today. To simplify matters, I believe there are two basic approaches: surreal and real. I will not discuss the philosophical pros and cons of both approaches, but I wish to simply expand on my Manual HDR lesson with two more approaches that handle scenes with a lot of intricate detail that cannot be masked with the Quick Selection Tool. Many scenes are complicated and don't offer clean lines between the highlights and shadows and midtones. Therefore, it is very difficult to manually mask each region to blend together using the technique explained in "Lesson #7: Manual HDR."

This lesson is actually the simplest of all! I must point out, however, if you don't understand the limitations of scene brightness ratio or the dynamic range of a digital file, this section will make about as much sense as a tofu burger does to a Labrador Retriever. Most photographers have heard of HDR by now and have also come to the conclusion that it can be extremely frustrating to achieve the look they want when using this technique. To better understand HDR it is best if you first feel confident about your abilities to maximize one single image file. If you know the limitations of single image post-processing, you will better understand the advantages of multiple image processing.

After following one of the hundreds of tutorials now available online, it is possible to produce HDR-looking images with zero understanding of dynamic range. But just following the trail of peanuts, as they say, does not teach you much in the end. What I hope you have learned in the lessons thus far is the knowledge to maximize all the incredible information contained within just one or two image files from a digital camera. What I want you to learn from this lesson is a more efficient path to understanding the benefits of processing images where the scene brightness ratio is well beyond what the dynamic range of a digital camera is capable of capturing in even two exposures.

As I have mentioned throughout this book, I prefer to capture landscapes that appear so surreal in reality that no surreal processing is required. Therefore, I have focused my attention, and this book, on realistic looking landscape images. This does not mean I dislike surreal appearing imagery, but only that I wish to master one approach before the other. With that in mind, "Lesson #7: Manual HDR," is

great for scenes where there are fairly well defined regions that can be masked, and when you desire a realistic impression. The challenge arises when masking areas with a lot of detail. I basically use one of two methods for handling scenes with a scene brightness ratio greater than one single exposure can retain and with a great deal of detail:

❯ Quick and Easy Manual Override
❯ Auto Pixel Smashing with Photomatix or CS5 HDR Pro

□ I prefer capturing landscapes that appear so surreal in reality that no surreal processing is required.

Like a warm fire, high-quality printing usually draws the viewer in close. If you want to enrich this experience and make the approach worthwhile, then manually overriding the auto features in software is always necessary, at least in my opinion. There are very few times the final file created by either Photomatix Pro or HDR Pro have no adverse effects on either moving subject matter or regions with extreme scene brightness variations. If it is your desire to make Photomatix Pro or HDR Pro work optimally, the more information (i.e., bracketed exposures) you provide to the software the better the output will be. However, there are two issues with this method: Moving subjects will pose a problem with alignment in post-processing, and it can look very odd in the final image if the subject is not properly aligned.

The more exposures you shoot of one scene the more time it takes, even with new, fancy gizmos that automatically take as many bracketed exposures as you wish. As the time it takes to capture all the bracketed exposures of one scene increases, the potential for subjects being out of alignment also increases because any moving subject, including tree branches, will become an issue. Therefore, the only truly good subject for this type of scene is one with no or few moving parts. Please remember that many great HDR images have been made with no regard for the concerns I have brought up. If the halos and ghosting around moving subjects does not take too much

away from a viewer's experience of the image, than these are not issues.

Throughout this book I have discussed how an image should tell a story. This means that to accurately tell that story a particular style of processing is usually required. If you know several ways of processing an HDR scene, you will have more options to choose from when deciding upon the final look and feel of that scene.

Choosing which technique for which image, as well as utilizing your very own approach to any of these lessons is preferred. With this in mind, I have been experimenting with manual HDR techniques for some time. I have come to the conclusion that each scene requires its own unique technique. The difference may be minimal but nevertheless unique.

This final lesson is not simply to show you exactly how to achieve a certain look, but also to show you two particular variations on a theme. More importantly I hope to inspire you to develop your own methods to achieve the look and style you are after.

Quick and Easy Manual Override

1. Open two differently-exposed files (4 stops apart) from the same scene into two Photoshop layers (figure 14-1).

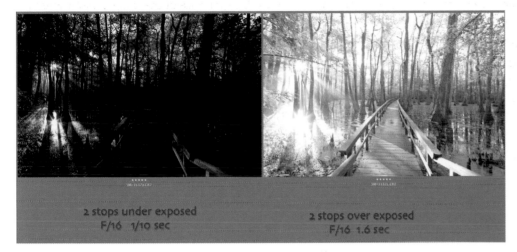

Figure 14-1

2 stops under exposed
F/16 1/10 sec

2 stops over exposed
F/16 1.6 sec

2. From Bridge, highlight the two files and choose Tools > Photoshop > Load files into Photoshop layers.
3. Also, if you have handheld the auto bracketed exposures, it will be better if you add one more step in this post-processing method. Highlight both layers in the Layers panel and then chose Edit > Auto-Align Layers. This will align your images as closely as possible and hopefully eliminate any ghosting.
4. Select the darker image (usually on top), and change the Layer Opacity to 50% (figure 14-2).

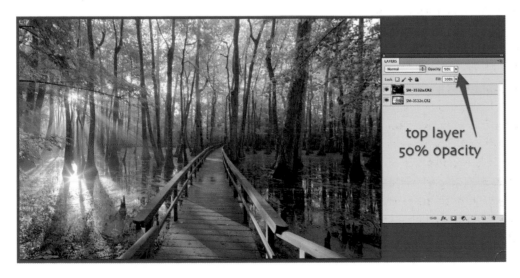

Figure 14-2

top layer
50% opacity

5. Add some midtone contrast, usually with an S-curve in the Curves Adjustment Layer (figure 14-3).

Figure 14-3

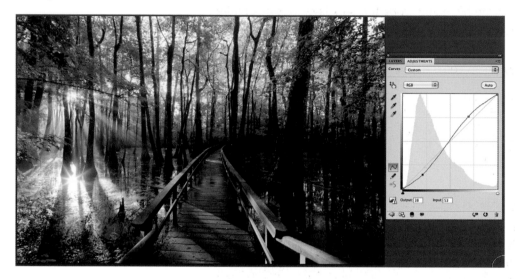

6. Make a layer mask on the top dark layer and begin painting away in the dark areas with a soft Brush (figure 14-4).

Figure 14-4

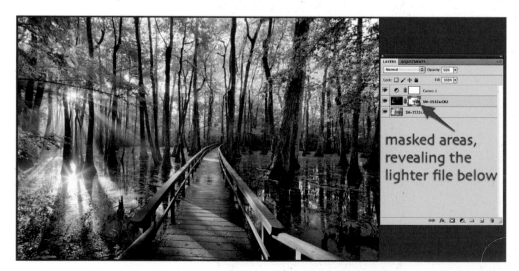

It can be that simple—or if you have more time, keep following along!

Additional Steps If Desired

1. If the image needs more detail in the highlights, copy the dark layer (2 stops under exposed one). Use the Comd+J keys and drag it down below the lighter layer (2 stops over exposed one).
2. Change the Opacity of that layer back to 100 % (figure 14-5).

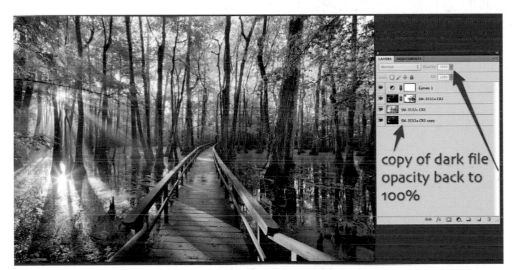

Figure 14-5

3. Paint away the layers above to reveal the darker highlights of that bottom darker layer, but only in the highlights. Remember this means you might have to paint away the same spot in both layers (figure 14-6).

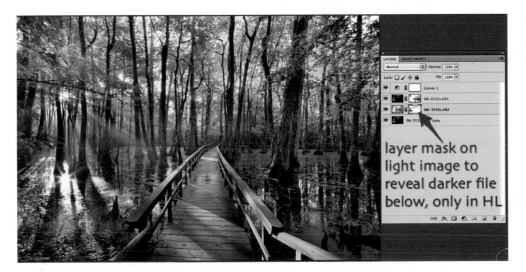

Figure 14-6

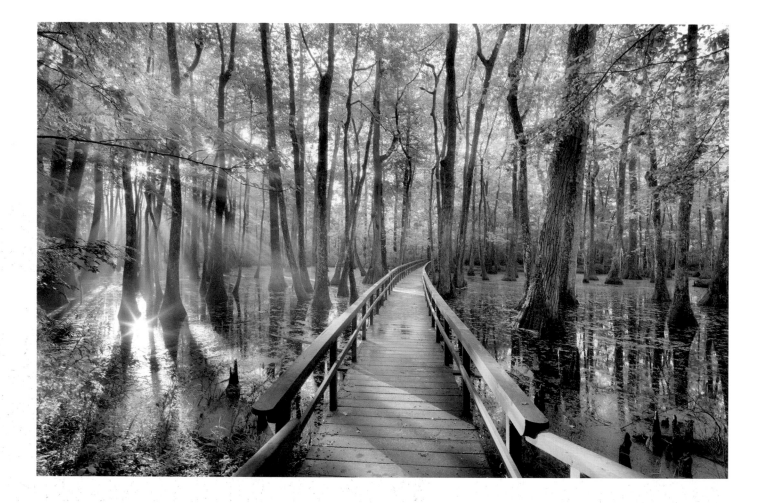

Now that the high dynamic range of the scene has been blended into one file, additional regional dynamics can be applied. I usually add these additional layers to the top of the stack, thus keeping the other layers just in case I want to change something later (figure 14-7).

When exposing for HDR images I stress a few important factors. First, you need to set your camera to auto bracket three images and adjust the variation between each exposure to two stops. If you want to handhold the camera while exposing the three images it helps to set the camera to motor drive. I usually use the two files that are 4 stops apart when utilizing the Quick and Easy Method. These are the −2 and +2 exposures.

The nice thing about shooting the scene in auto bracket mode is that you will have enough information within the three bracketed exposures to utilize all three of the HDR methods shown in this book: Manual blending, Quick and Easy blending, and Auto Pixel Smashing.

Auto Pixel Smashing with Photomatix or CS5 HDR Pro

The term "Auto Pixel Smashing" is the name I have coined for this process, so you won't find any mention of it in Photoshop or Photomatix.

HDR Pro is the new and much improved HDR feature in Photoshop CS5. Prior to HDR Pro I only used Photomatix Pro for blending bracketed exposures into one final image. But now, HDR Pro offers solutions similar to Photomatix Pro for creating HDR images. Both have multiple sliders used to make global image adjustments including many sophisticated refinements that can be very helpful.

⬇

Figure 14-8

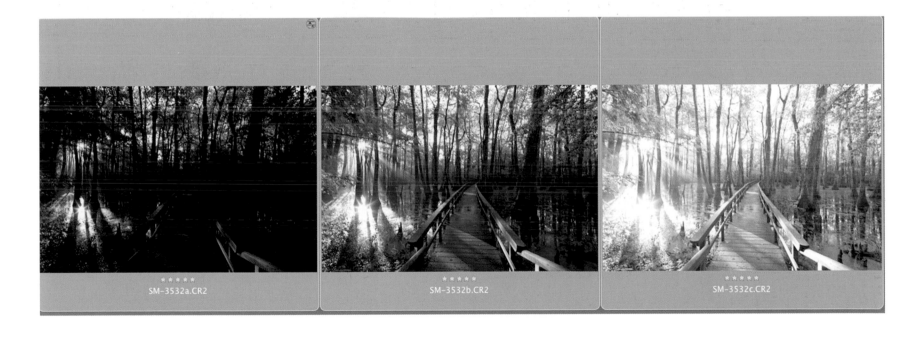

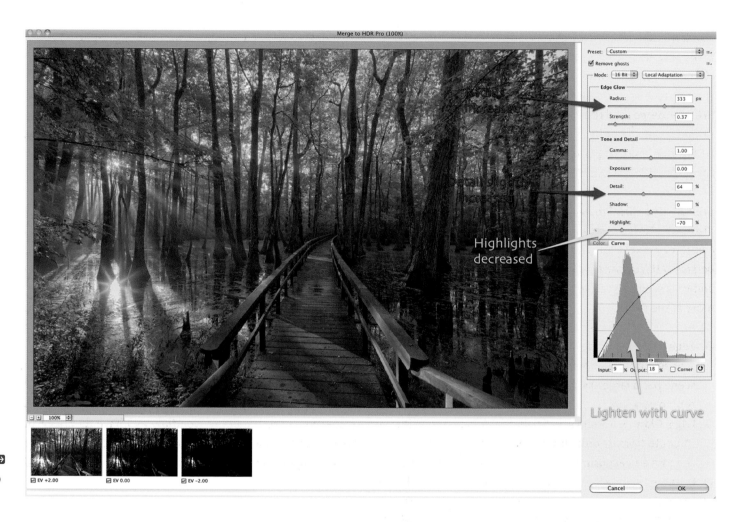

Figure 14-9

Here are the steps for the Auto Pixel Smashing method in Photoshop CS5:

STEP 1 – HDR prep: Highlight the three files in Bridge or Lightroom and perform the following two steps: remove any chromatic aberrations, and adjust image detail with sharpening and noise reduction. (For more info on removing chromatic aberrations review Lesson #7 under the section "Combining Your Exposures.")

Regarding Sharpening and Noise Reduction, I always make modest adjustments with more attention being made to the Noise Reduction. For both LR/ACR, within the Detail pull-down/ tab, I slide the Amount slider (that is found below Sharpening) to 35, and the Luminance slider (found below Noise Reduction) to 20. Now sync the settings to the other selected images. If using Bridge/ACR you will first click Select All and then click Synchronize. In Lightroom, since you will be in the Develop tab, you will click the Sync button. This will make the exact same changes on all three files. In both programs there is a dialog

box that asks what you would like to sync, so chose Sharpening and Noise Reduction. These two adjustments will help eliminate halos and improve image detail in the final HDR file.

STEP 2 – Merge the files: With the same three files highlighted: in the Bridge menu bar select Tools > Photoshop > Merge to HDR Pro. In the Lightroom menu bar select Photo > Edit in > Merge to HDR Pro in Photoshop.

STEP 3 – The HDR Pro Panel: This step can alter the outcome drastically. The HDR Pro panel is wonderful if you make edits to create a new RAW file. *I never attempt to make the image look perfect in this dialog box!* These sliders need to work together, and vary scene by scene. Here are a few adjustments I make most of the time:

- ◉ **Edge Glow > Radius** – I keep Edge Glow > Radius higher on scenes with detail everywhere, such as this scene. If the scene has a large sky, for instance, than I decrease the setting to very low.
- ◉ **Edge Glow > Strength** – I usually reduce Edge Glow > Strength from its default position by about 50 percent.
- ◉ **Gamma** and **Exposure** – I don't move Gamma or Exposure.
- ◉ **Detail** – I call Detail the surreal slider! In order for this to make a difference, you must have the Edge Glow Radius above 0. I usually don't move this much beyond the default as it will add unnatural detail, although this could be your favorite slider if you are aiming for that surreal look.
- ◉ **Shadow** – On darker scenes, I slightly increase the Shadow slider.
- ◉ **Highlight** – I decrease the Highlight slider for the following reasons: If you made your files utilizing AEB while shooting, the image will appear dark here. To compensate, I increase the brightness in the Curves tab, which then blows out the highlights. To adjust for the blown highlights I then darken them with the Highlights slider. I make my Curves

adjustment in the Curve tab located next to the Color tab as seen in figure 14-9. *Note: If you include a bracketed exposure that is +3 to +4 stops from normal, than you may not need to lighten the overall image as described in this step. This is especially true in backlit scenes!*

- ◉ **Color Tab** – In the Color tab, I always set the Vibrance and Saturation sliders to 0 because I will be adding contrast later in Photoshop which will bring out colors to my liking.
- ◉ **Remove Ghosts** – The last consideration in the HDR Pro panel just happens to be located at the very top, Remove Ghosts. This function can be very helpful if there are any moving subjects within the scene. The normal situation where I don't check this is when everything in the scene remained stationary or the subject is of a large sky with very smooth gradations. I have noticed some banding in large gradations with this checked.

Now it is time to click OK.

STEP 4 – Finishing touches: I regard this file as a RAW file which is now ready for the entire workflow as I have described in the previous lessons. This means setting the range in ACR or LR, Massaging the Middle and Regional Dynamics, followed by Real Color.

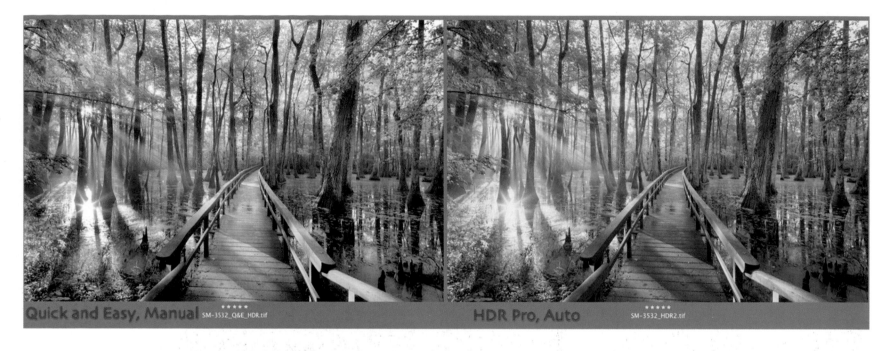

Quick and Easy, Manual SM-3532_Q&E_HDR.tif

HDR Pro, Auto SM-3532_HDR2.tif

⬆

Figure 14-10

➡

Figure 14-11

One Final Tip

Figure 14-10 shows the two versions—the Quick and Easy, Manual method and the HDR Pro, Auto method— side by side, illustrating how close you can make the outcome with totally different methods.

If it's raining outside and you are analyzing the differences between the two methods, take one more step and combine these two into one final image, masking the best parts of each image together.

Figure 14-11 shows the layer mask I created to combine the best of both versions. You can see my adjustments in the Layers after combining the two files. You notice the HDR Pro version is on top, and the black regions of the mask is where the Quick and Easy version is showing through.

Figure 14-12 shows the final image.

I view HDR imaging as the Wild West—no rules apply! As with so many aspects of photography and the arts, technique should serve a purpose: I try to consider this my only rule.

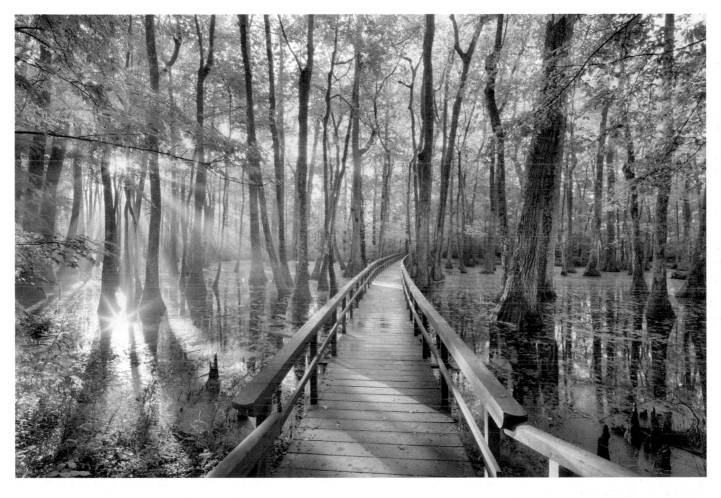

Figure 14-12

THE FIRST TWO GENERATIONS OF MUENCH PHOTOGRAPHERS

Josef Muench was born in Bavaria in 1904. At the age of 11 he received his first camera and began a lifelong interest in capturing nature on film. He arrived in the United States with his brother in 1928 and eventually settled in California.

In the 1930s, Monument Valley remained virtually unknown (except to the Navajo) until Muench took some of the most memorable photographs of it beginning in 1936. He returned over 350 times to photograph there. In 1938, he met with the editor of *Arizona Highways Magazine* who ran Josef's photograph of the Rainbow Bridge National Monument. Not long after, Muench's name became synonymous with *Arizona Highways Magazine* where he worked for more than 50 years, using mostly his 4×5 camera.

Later he also photographed in Africa, Alaska, Asia, Canada, Europe, Hawaii, the Rocky Mountains and beyond. The unmanned Voyager Expeditions, launched in 1977, included his photo of a snow-covered Sequoia redwood taken in Kings Canyon National Park. Josef Muench died in 1998 at the age of 94, but his legacy remains.

David Muench, an innovator in landscape photography, has said that nature is his greatest teacher. Son of the founding father of color landscape photography, Josef Muench, and father of Marc Muench, David contributes to the world of photography by illustrating the beauty of the land. Best known for his unique view of the American western landscape, he has presented us with the clear lakes and wild rivers of this country for more than 50 years. Muench's formal schooling includes Rochester Institute of Technology, University of California at Santa Barbara, and Art Center School of Design in Los Angeles, California.

No permits or plane tickets were contemplated when Muench first traversed the western landscape with his adventurous parents. His father photographed while his mother, Joyce, wrote about their experiences. The family would travel from their home in Santa Barbara to the eastern Sierras, still one of David's favorite places, or to the deserts of the Southwest, taking airboats up the Colorado River or animal pack trips deep into the canyons.

William Conway, the former president of the Wildlife Conservation Society, praised David as one of the most "prolific and sensitive recorders of a rapidly vanishing natural world" while setting the standard and raising the bar for color landscape photography. David was commissioned to provide photographs for 33 large murals on the Lewis and Clark Expedition that hang in the Jefferson Expansion Memorial in St. Louis, Missouri. His work is widely published in more than 60 books and publications.

EPILOGUE

Imagine a camera that could record an image that so perfectly replicated reality no one would dispute its accuracy; it could be called the "reality camera." And now imagine a printer that could reproduce the image taken by the reality camera with such accuracy that no one would dispute its accuracy; it could be called the "reality printer." Now imagine they cost only $100 each. Crazy you say? I believe the crazy part would be how many people would hack them!

Look around at the images you see published in magazines and on the Internet. Most are post-processed to fulfill our fantasies rather than our desire for reality. There is no doubt that photographers often get caught up in a race to capture viewers' attention in a sea of competition. The tricks and methods available continue to multiply so that the photographer's job should be simpler. The truth is, creating great images is difficult no matter what tricks are available.

Viewers' eyes are educated at the same rate at which technology expands post-processing limits. If you are only following this race to get ahead of the viewers' expectations, you will be running a perpetual treadmill. When I read the book *Positive/Negative*, by photo critic Bill Jay, I was reminded that photography can be about much more than intermediate trends based only on temporary emotions. Photography is more, and in its best light, captures and presents issues that have either been around since the invention of dirt or reveal something entirely new. Photography has captivated so many people for so long because of the diversity in our opinions, lives, emotions, and faiths.

If you really like photography, get as many tools in your perpetual tool belt as you can. Don't let reality hold you back, but rather let it inspire you to share your version.

Marc Muench
January 2011

INDEX OF FEATURE IMAGES

Cover – Sunrise, Verilloin Cliffs Wilderness, Arizona

Part 1 – Hiker on rim overlooking Marble Canyon, Arizona

Chapter 1 – Sierra Madre Mountains, California

Chapter 2 – Vermillion Cliffs Wilderness, Arizona

Chapter 3 – Aspen Ski Mountain, Colorado

Chapter 4 – Colorado National Monument, Colorado

Chapter 5 – Capitol Reef National Park, Utah

Chapter 6 – Tioga Pass, Sierra Nevada, California

Part 2 – East River, Colorado

Chapter 7 – The Race Track, Death Valley National Park, California

Chapter 8 – Glacier National Park, Montana

Chapter 9 – Grandfather Mountain, North Carolina

Chapter 10 – Juniper, Capitol Reef National Park, Utah

Chapter 11 – The Big Couloir, Big Sky ski mountain, Montana

Chapter 12 – Sea grass, Anguilla

Chapter 13 – Bass Harbor Light, Maine

Chapter 14 – Skyline Drive, Shenandoah National Park, Virginia

For more information about the images in this book and for updates to the lessons, visit the book's companion website at **www.rockynook.com/explore**.

To order signed copies of the book, custom prints, and more please visit the website **www.muenchphotography.com**.